Transmission Arts

Transmission Arts

ARTISTS & AIRWAVES

Galen Joseph-Hunter,

with Penny Duff and Maria Papadomanolaki

New York, New York

In association with free103point9

Transmission Arts: Artists and Airwaves is published by PAJ Publications, P.O. Box 532, Village Station, New York, NY 10014.

PAJ Publications is distributed to the trade by Consortium Book Sales and Distribution: www.cbsd.com

Publisher of PAJ Publications: Bonnie Marranca

Cover and book design by Susan Quasha

This publication is made possible in part with a grant from Furthermore, a program of the J. M Kaplan Fund, and public funds from the New York State Council on the Arts, a state agency.

Library of Congress Cataloging-in-Publication Data

Transmission arts: artists and airwaves / edited by Galen Joseph-Hunter, with Penny Duff and Maria Papadomanolaki.
 p. cm.
Summary: Features 150 artists notable for their sonic, visual, and live works spanning early radio experiments of the 1880s up to the present. The volume is organized in sections dealing with performance, composition, installation, broadcast, public works, and interactive network projects. This publication places "transmission arts" in historical context, laying the groundwork for the definition of a new art genre.
ISBN 978-1-55554-151-4
1. Transmission arts. I. Joseph-Hunter, Galen. II. Duff, Penny. III. Papadomanolaki, Maria.
NX456.5.T73T73 2010
700.9'04—dc22
2010030253

First edition, 2011

Printed in the United States of America

CONTENTS

Broadcast: Radio and Television 75

Public Works, Interactive Networks, and Tools 117

An investment in public access to the transmission spectrum is intrinsic to the engagement of airwaves for artistic purpose. Transmission art often emerges from an interest in spectrum regulation and a critique of the limited public access that exists for experimentation with electronic communication. Not surprisingly then, transmission artists have deep roots in media activism and share concerns regarding corporate control of the airwaves. In the mid-1990s, media activists converged in the U.S. in response to the Telecommunications Act of 1996. Seen as an irresponsible leap in the wrong direction, this deregulation lifted the cap on the number of radio stations that could be owned in a single market, paving the way for a staggering level of corporate consolidation.

The originator of *Transmission Arts: Artists & Airwaves*, free103point9 was established in 1997 as a microradio collective in Brooklyn, New York. The founders of free103point9 were among thousands of participants in what became known as a microradio movement across the U.S. Microradio refers to low or micro-power radio transmission, which is unlicensed. The term became widely used in the mid-nineties when media activists performed acts of civil disobedience by broadcasting without a license to demonstrate the importance of making low-power FM radio available to communities, as an alternative to a corporate monopoly of the airwaves. Influenced by these efforts, in January 2000, the U.S. Federal Communications Commission (FCC) created a low power FM radio service. Commonly referred to as LPFM, these low power licenses were made available to non-commercial entities to create community stations in mostly rural areas.[3]

Concurrent with the success of LPFM, free103point9 witnessed members of its community of microradio broadcasters shift their practice from micropower broadcast to conceptually rigorous transmission-based projects utilizing the radio spectrum as an artistic medium. In 2002, free103point9 transitioned into a nonprofit organization focused on cultivating and defining a new genre: transmission arts. Grounded in an art-historical context that celebrates the avant-garde,

a genealogy of contemporary transmission-based projects includes Futurism, Hörspiel and radio theatre, post-war electronic music and composition, Fluxus and Happenings, early video collective projects, and telecommunications art. The works cited in this volume are both historical projects conceived within this lineage, as well as contemporary works informed by these important movements in art history.

In the early decades of the twentieth century, works created under the umbrella of Futurism celebrated noise, speed, and experimentation. Improvisation with and about machinery and technology were commonly explored. Luigi Russolo's Futurist manifesto "The Art of Noise" (1913) classified "noise-sound" into six discrete groupings including thunderings, whistling, murmers, rustling, percussion with common objects, and vocal noise produced by people and animals. Eight years later, Velimir Khlebnikov's manifesto "The Radio of the Future" prophesied an evolution of the medium where text, images, scents, and even flavors could be communicated through broadcast. In what is perhaps the first conception of transmission art, Khlebnikov also envisioned a future where radio would emit ethereal art exhibitions.[4]

Similarly interested in the synesthetic possibilities of radio, the first Hörspiel was broadcast in Germany in 1924. Translated literally as radio play, Hörspiel uses sound effects, music, and dialogue to embolden the imagination of its listeners. In both an ironic and self-reflective exercise, Hans Flesch's *Zauberei auf dem Sender* (Radio Magic) describes a radio station's struggle to present a program on the air through a compendium of dialogue, noise, and experimental music. Hörspiel was slow to be embraced in the U.S. In the mid-nineteen eighties FM stations KPFA (the country's first community-supported radio station) in Berkeley and WDR in Cologne united with assistance from the Goethe Institute in San Francisco to produce *Hörspiel USA*, a series of nine programs presenting twelve Hörspiele never before heard in the U.S.[5] The series demonstrated a broad definition of radio theatre that encompasses works

situated within traditional definitions of theatre, as well as theatrical works driven by poetics, performance, and sound art.

In 1935, the German electronics company, AEG, unveiled the first audio tape recorder at the *Berlin Radio Show,* an international radio exhibition occurring regularly since 1926. This device would make a considerable impact on electronic music, placing new tools in the hands of musicians, composers, and engineers. After World War II, artists began using the tape recorder to produce works that employed a new method of composition called *musique concrète.* Pierre Schaffer, the French musician and theorist, popularized this technique in 1948, in Paris, with his *Cinq études de bruits* (Five Studies of Noises), a series composed solely for tape. In the years following, works by Karlheinz Stockhausen and John Cage, among others, pioneered the use of real-time media, including radio, as a viable instrument in composition and performance. Cage's work, in particular, which privileged chance operation and nonmusical instrumentation in conceptually-driven composition over musical aptitude, serves as a primary influence on the contemporary artworks cited in *Transmission Arts: Artists & Airwaves.*

Cage's Experimental Composition classes at The New School for Social Research in New York City from 1957 to 1959 served as a fertile ground for the convergence of early practitioners of the avant-garde, including Jackson Mac Low, George Brecht, Dick Higgins, and Allan Kaprow. Lithuanian-born artist George Maciunas, who was also at The New School, became a propelling force of Fluxus as a movement rejecting intellectualism and "artificial art" in order to promote "living art," "anti-art," and to elevate the ordinary.[6] In a resounding illustration of these priorities, transmission works often embrace live, ordinary media in order to reveal a present moment in time without being beholden to a specific location or instance. For example, in Keith Sonnier's *Scanners (Quad Scan),* a series of radio scanners are installed in an exhibition space and tuned to emergency frequencies such as police communication. The transmissions received in this work's first installa-

tion, in 1975, vary considerably from installations in recent years, and in each instance the installation takes on social awareness and critique.

In an explicit act of social engagement occurring with the anti-war movement in the U.S. in the late 1960s and early 1970s, artists gained access to portable video equipment. (Sony's Portapak, the first portable half-inch video recording system, became commercially available in 1967.) Often working as collectives, video artists saw a radical opportunity in transmission media as a tool that might at long last realize democratic cultural and global communications networks. Collectives like TVTV (Top Value Television) and the Videofreex produced subversive works that challenged corporate media and exposed a corrupt political system. In the 1980s, global communications experiments connected a broad network of international video artists. Satellite and other telecommunications technologies promised new possibilities of live and remote collaboration. In recent years the ubiquity of wireless devices tied to the Internet have once again inspired artists interested in communication networks. In a consistent thread, independent and community media is revered as a means to combat a dystopian political, social, and creative climate.

Communications technology and activism working together to ensure public and artistic access to the transmission spectrum provide the foundation from which the transmission art genre emerges. While not a comprehensive inventory, the following introductory pages highlight many of the inventors, activists, and organizations whose work laid the building blocks for the artists featured in this volume. Like the works encompassed by the genre, transmission art's lineage is anything but linear. Inventors were making large, often simultaneous, strides in wireless technologies in the mid- and late-nineteenth centuries. Over a hundred years later, the microradio movement of the 1990s empowered a wave of radio practitioners and activists dedicated to a specific cause: providing the public with licensed access to their own airwaves. In the arts, organizations sought to foster the emerging genre of transmission art.

Air Design (Inventors)

Abbé Giovanni Caselli: Pantelegraph

Abbé Giovanni Caselli (b. 1815) was an Italian physicist and inventor of the first fax machine prototype. Caselli began to research different ways of perfecting the transmission of images using telegraphic technology when he was a professor of physics at the University of Florence. In 1860, Caselli presented the first almost complete Pantèlègraphe (Pantelegraph). Caselli's invention caught the attention of Emperor Napoleon III, who facilitated Caselli's experiments, providing access to the region's telegraphic lines. In November 1860, a telegraphic line was assigned to Caselli for the realization of an intercity transmission between Paris and Amiens. Caselli's experiment was a resounding success in part thanks to his set of synchronization timers immune to the changes in the electrical current of the telegraphic wire. The first pantelegraph was officially registered in 1861.

Nikola Tesla: Wireless Transmission of Energy

Serbian inventor Nikola Tesla (b. 1856) is well-recognized for his strides in electricity and electromagnetism. In 1894 he wirelessly lit up single-terminal incandescent lamps in New York, and in 1896 he successfully demonstrated wireless communication through radio. His electrical work in the late 1800s developed alternating current (AC) electrical power, which formed the basis for modern electricity. (In what is referred to as the "War of Currents" Thomas Edison was at odds with George Westinghouse, Tesla's employer, regarding the preferable means for electrical power distribution. Edison advocated for direct current, DC, rather than Tesla's alternating current, AC). Tesla proposed his system for "the transmission of electrical energy without wires" dependant upon the earth's conductivity as early as 1904, in his essay published in the periodical *Electrical World and Engineer*.

Guglielmo Marconi: Transatlantic Transmissions

Italian inventor Guglielmo Marconi (b. 1874) is responsible for numerous improvements to wireless telegraph devices developed by earlier inventors (Hertz, Popov, Brantley, Tesla, and Lodge). More notably, Marconi plays a major role in the lively discussion around the origins of radio transmission and related patents, which has been a topic of controversy in the courts and recorded history for well over a century. While the success in terms of transmitted content received is also not without controversy, his transatlantic transmission experiments in the early 1900s are indisputable documented events. On December 12, 1901, Marconi's first radio signal was transmitted across the Atlantic from Poldu, Cornwall England to Signal Hill at St John's, New Foundland.

Lee de Forest: First Vacuum Tube, Audion

Responsible for 180 patents in his lifetime, Lee de Forest (b. 1873) is widely regarded for his innovations and improvements to the vacuum tube used in early radio and television. 1n 1906, de Forest's Audion added elements of control and amplification to earlier vacuum tubes developed by Thomas Edison and Ambrose Fleming. De Forest's Audion detected radio signals and converted radio frequency into audio frequency ready for amplification.

Edwin Armstrong: Frequency Modulation

Born in 1890 in New York, Edwin Howard Armstrong was an American electrical engineer and the inventor of frequency modulation (FM) radio. While studying at Columbia University, he invented the regenerative circuit, which he patented as Wireless Receiving System in 1914. The patent was claimed by Lee de Forest in 1914 and sold to AT&T, spurring a lengthy series of lawsuits over radio patent ownership. Twelve years of legal dispute followed, and, though Armstrong won an initial

round in the courts, he eventually lost the case, and the patent was granted to de Forest. While in the midst of this legal struggle, Armstrong began a series of experiments that led to the creation of a wide-band frequency modulator in 1933. These efforts resulted in what is commonly known today as FM radio. In support of his discovery, Armstrong conducted a number of large-scale FM test transmissions from the Empire State Building, from 1934 to 1935. The U.S. Federal Communications Commission (FCC) resisted Armstrong's innovations, articulating an allegiance to the then dominant AM radio technology. Armstrong's FM patent was claimed by RCA, and once again Armstrong found himself entrenched in legal battles. RCA's victory in the lawsuit left Armstrong emotionally and physically distressed. The verdict meant that Armstrong could not collect royalties for his inventions that formed the foundation of modern communications technologies. Following his death, Armstrong's widow continued to petition on his behalf; Armstrong's position was ultimately vindicated through a court victory. Despite his turbulent history, wrought with legal disputes, Armstrong's contribution continues to be widely recognized.

Frank Conrad: First Licensed Broadcast Station, KDKA

Born in 1874, Frank Conrad worked for the Westinghouse Electric Company in Pittsburgh, Pennsylvania. Originating from a Westinghouse building with his own garage as backup service, Conrad launched the first licensed broadcast station in the world, KDKA, 1020-AM, in November 1920.

Charles Francis Jenkins: Transmitting Pictures over Wireless

Charles Jenkins (b. 1867) was an early cinema pioneer who created a projector he called the Phantascope. Jenkins is also among the inventors credited with developing television. In general, Jenkins used mechanical rather than electronic technologies. His article "Motion Pictures by Wireless" was published in *Motion Picture News* in 1913, and

in 1923 Jenkins demonstrated transmitted moving silhouette images. It was not until three years later that he formally presented a synchronized transmission of pictures and sound, and secured the related patent. In 1928, the Jenkins Television Corporation launched the first television broadcasting station in the U.S., W3XK.

John Logie Baird: Moving-image Broadcast

Born in 1888, John Logie Baird was a Scottish engineer and inventor of many successful electronic systems for grayscale and color moving-image broadcast, which would later be called television. Baird publicly demonstrated the product of his first experiments, the scanning disk (or Nipkow disk), from his London laboratory on January 26, 1926. One year later, he successfully transmitted the first long-distance television signal between London and Glasgow; this demonstration was followed shortly thereafter by the first transatlantic television broadcast between London and New York. His television company, Baird Television Development Company Ltd., produced many experimental broadcasts. Included among them was the first transmission of the prestigious Derby horse race at Surrey, England in 1931. In collaboration with French film director and producer Bernard Natan, Baird created France's first television company: Télévision-Baird-Natan. Baird's systems were widely applied at the BBC until the 1930s, when they were replaced by more updated electronic technologies. In 1939, he produced the first experiment with color television by installing revolving color filters in front of a cathode ray tube. He publicly demonstrated the first electronic color TV in 1941. This early system employed a 600-line color patent, and Baird planned to improve the system by increasing the resolution to 1000 lines, making it almost comparable to contemporary high-definition television (HDTV). Baird also developed Phonovision, which was used to record and play back video signals. In addition to his television innovations, he also contributed to the development of fiber optics, infrared night vision, and radar technologies.

AIR RIGHTS (ACTIVISTS)

Mbanna Kantako

Mbanna Kantako (b. 1950 as Dewayne Readus) pioneered microradio as an activist tool in the U.S. in the mid-1980s. While living in a public housing project in Springfield, Illinois, Kantako, a blind African-American, begin transmitting a low-power (one-watt) FM signal to the public housing residents in 1987. The station, WTRA, became a tool for activism and empowerment of a community that until then was without voice. Residents went on air to speak about social issues, including reporting on mistreatment by authority figures, and other injustices connected to race and economic class. The success of WTRA soon drew attention from the Federal Communications Commission, which ultimately charged Kantako with unlicensed broadcasting, precipitating a series of events that emboldened Kantako's energies rather than stunted them. Heralded by many as the microradio movement's founder, WTRA influenced and inspired countless other microradio stations around the country, and spawned a movement credited with influencing legislation that licenses limited low-power broadcast (LPFM). Today, WTRA is known as Human Rights Radio, an international organization devoted to black studies and radical politics.

Free Radio Berkeley

Founded in 1993 as a free speech advocacy organization that challenged the regulatory structure and power of the Federal Communications Commission (FCC). Free Radio Berkeley broadcasted twenty-four hours a day, seven days a week on 104.1-FM with fifty watts of power, serving the greater Berkeley/Oakland area in the mid-nineties. When the FCC took steps to shut the station down, Free Radio Berkeley and its founder Stephen Dunifer engaged in a lengthy and legendary court battle with the FCC, asserting first amendment rights to be on the air. Part of their legal argument was that since (at that time) there was no licensing for stations smaller than 100-watts Free Radio Berkeley's operations were not in violation of any law. During this protracted case, Free Radio Berkeley achieved an unprecedented accomplishment by securing a judicial ruling that allowed them to remain on air for eighteen months. While ultimately their FM transmission was silenced by a court injunction in 1998, Free Radio Berkeley was instrumental in helping to embolden a microradio movement in the U.S. intent on liberating the airwaves from a corporate media stronghold. This movement played a significant and persuasive role in the FCC's establishing a low-power FM broadcast service (LPFM). While certainly a step in the direction of achieving access, LPFM is limited almost entirely to rural areas because of stringent channel spacing requirements. Today Free Radio Berkeley continues to work towards putting broadcasting tools into the hands of the public. Their program IRATE (International Radio Action Training Education) provides transmitter kits, technical support, and training to educate and empower citizen activists involved in liberation struggle movements throughout the world.

Steal this Radio

New York City activists, squatters, and radio enthusiasts came together to form Steal this Radio in 1995. Initially a mobile operation equipped with a five-watt transmitter acquired from Free Radio Berkeley's Stephen Dunifer, STR produced radio parties and performances around New York's Lower East Side in the mid-nineties. STR grew quickly, and soon began transmitting with twenty-watts, serving a potential 75,000 listeners with programming that included anarchist news and events, a nightly community calendar, weekly interviews, and talk shows, as well as several hours of Spanish-language programming. After a visit from the FCC in 1998, STR fought-back with a press release titled "Community Radio Defies FCC: Steal This Radio Returns to the Airwaves and Announces Lawsuit after Threatened with Raid." Eleven months later a U.S. District Court issued an injunction against Steal This Radio, from which STR was unable to recover.

Radio Mutiny/Prometheus Radio Project

Founded in 1996, Radio Mutiny was a pirate station operating out of West Philadelphia until it was shutdown by the FCC in 1998. Prometheus Radio Project emerged from those ashes several months later when activists working within social change movements (many of whom were involved in Radio Mutiny) united and organized during the 1999 Pirate March on the FCC and National Association of Broadcasters in Washington D.C. Prometheus members successfully joined with hundreds of pirate stations across the country to pressure the FCC to create a legal option for community broadcasting. In response, the FCC introduced the low-power FM (LPFM) radio service—the first time opportunity for small community radio licenses in twenty years. Following this new legislation, Prometheus Radio Project focused on advocating on behalf of these new community stations, and ushered countless organizations through the LPFM application and building process. Prometheus continues to support these low-power stations with their day-to-day operations in the present day. When a full-power application window opened in 2007, it helped over one hundred organizations, including free103point9, apply for a non-commercial FM station license. Prometheus's celebrated "Radio Barnraising" events bring together hundreds of community media volunteers to raise a station in three days.

AIR SUPPORT (ORGANIZATIONS)

Experiments in Art and Technology

Formally launched in 1967 by engineers Billy Klüver and Fred Waldhauer, and artists Robert Rauschenberg and Robert Whitman, E.A.T. (Experiments in Art and Technology) was a nonprofit organization active until the 1980s, whose mission was to promote collaborations between artists and engineers. E.A.T.'s initial efforts, in 1967 and 1968, were aimed at recruiting engineers to work with artists as well as to raise money for the organization's operations. E.A.T.'s founders arranged for artists to visit technical laboratories like Bell Laboratories in Murray Hill, New Jersey; IBM Laboratories in Armonk, New York; RCA Sarnoff Laboratories in Princeton, New Jersey. They held a weekly open house at the E.A.T. loft in New York, where artists and engineers could meet and talk informally. Within three years, E.A.T. had more than 2,000 artist-and 2,000 engineer members in twenty-eight regional chapters located all over the country. E.A.T. facilitated and supported the work of a diverse group of notable artists, including composer John Cage, dancer Merce Cunningham, and artist Yvonne Rainer to name only a few. Interdisciplinary collaborations characterized a majority of their programs, including their legendary *9 Evenings: Theatre and Engineering*, held at the 69th Regiment Armory in New York in 1966. Forging personal contacts between artists and engineers, E.A.T.'s projects succeeded in broadening the artists' role in mainstream contemporary society and aided in the integration of artistic practices in emerging technologies.

ZBS/AIR Program

In 1974, ZBS Media, an innovative radio production company, established the ZBS/AIR Program, in Fort Edward, NY. AIR provided audio facilities, personnel, and services to artists working with electronic media. Originally designed as a residency program, AIR quickly became a networking resource, as well as a focal point for production and distribution of a wide range of transmission art. The AIR Program supported both the adventure of individual creative vision, and the political possibilities inherent in cheaper, more portable means of transmission. During its nine years of operation, AIR worked with artists who were experimenting and exploring at early stages in their careers, including Bill Viola, Laurie Anderson, William Wegman, Ron Kuivila, and Tony Conrad. Veterans such as Stan Vanderbeek and Ed Emshwiller applied their years of film experience to investigate the possibilities of video and performance art. Likewise, Philip Glass, Meredith Monk, and David Hykes, utilized audio production techniques to enhance their performance-

based works. Poets such as John Ashbery, Amiri Baraka, Allen Ginsberg, and John Giorno recorded, edited, and transmitted words as if they were music. Dramatic artists, among them Harvey Fierstein, Ronald Travel, Constance DeJong, David Van Tieghem, and the theatre company Mabou Mines used sound to create performance pieces and spaces. The ZBS/AIR Program was developed by Patricia Anderson, engineered by Robert Bielecki, and produced by Greg Shifrin, Gail Turner, and Roma Baran. In the early 1980s, following a decline in state and federal funding and a resistance to the constraints of such support, the AIR program dispersed. AIR's organizers continued working to pursue the program's founding mission, to support experimentation and find outlets for those seeking to transcend corporate control of transmission.

New Radio and Performing Arts, Inc.

New Radio and Performing Arts, Inc. (NRPA) was founded in 1981 to foster the development of new and experimental work for radio and sound arts. From 1987 to 1998, the organization commissioned and distributed over 300 original works for public radio, and introduced American radio art to European audiences. New American Radio is archived at Wesleyan University in Connecticut; the entire catalogue and 140 full-length works are available at somewhere.org. In 1996, NRPA extended its mandate to Net art and launched its pioneering Turbulence Website. Turbulence commissions creatively explore the Internet as a site of production and transmission. They include work by individual artists and collaboratives, emerging and established. Turbulence has commissioned over 170 works and hosted more than twenty multi-location streaming performance events. As networking technologies have developed wireless capabilities and become mobile, Turbulence has remained at the forefront of the field by commissioning, exhibiting, and archiving the new hybrid networked art forms that have emerged.

Kunstradio

Founded in 1987, Kunstradio is a weekly program on Oesterreich 1, the cultural channel of Austrian National Radio, ORF. Conceived as a space for radio art, an art that reflects the radio medium itself, Kunstradio's weekly program almost immediately broadened its mission, serving as a point of access for international visual artists, media artists, composers, and writers. Kunstradio Online launched in 1995 as a venue for announcing and archiving the weekly program and as an additional site for radio art content. In 1996, Kunstradio Online started to stream not only the projects scheduled for the weekly on-air program-slot (especially an increasing number of live projects) but also the very long or even potentially unending online elements of innovative complex networked radio-art projects. These works were soon presented under the umbrella "on-air; on-line; on-site" to characterize the complex context they were created for and unfolded in. Thriving in the present day, Kunstradio continues to encourage artists' reflections about the historical roots of radio art, the intersection of old and new technologies, evolving definitions of author/listener/recipient, and the transference of knowledge between collaborating artists/technicians/producers/theoreticians through curated series, symposia, published catalogues and CDs, as well as being an important historical archive. Kunstradio was a major contributor to *Re-Inventing Radio: Aspects of Radio as Art*, an important publication including texts by international media theorists, art historians, curators, and artists who approach radio as a creative communications space in the widest possible sense.

free103point9

In 1997, DJ and journalist Tom Roe, musician Greg Anderson, and painter Violet Hopkins formed the collective free103point9 in Brooklyn, New York. Aligned with the microradio movement, free103point9's activities in the early years were focused on providing local communities access to their own airwaves. At that time free103point9 principals tirelessly traveled around New York

City rooftops, transmitter and antenna in-tow, microcasting local bands, community meetings, and other Happenings to listeners in the events' surrounding few block radius. As a result of these activities, a community of free103point9 collaborating artists emerged who were interested in the act of transmission as creative expression, conceptually and formally. For these artists, microradio was not simply a distribution device, but rather an exciting gateway to experimentation with the entire electromagnetic spectrum. Responding to this development, by 2002, free103point9 had evolved from artist collective to nonprofit organization, with the specific mission of cultivating and defining the transmission art genre. Supportive of radio art and creative radio the "transmission art" nomenclature was carefully selected to encompass not only linear works made for radio dissemination, but multifaceted and interdisciplinary works created through the full radio spectrum in its broadest definition. The organization expanded programs to upstate New York in 2005, where today free103point9's major programs include the Transmission Art Archive, a definitive resource featuring artists, works, exhibitions and events that define the genre and place it in a historical context and WGXC: Hands-on Radio, a creative community FM radio station serving Greene and Columbia counties.

The Center for New Media Culture RIXC (formerly E-LAB)

RIXC is a multi-disciplinary media arts center in Riga, Latvia. Their annual festival, Art + Communication was established in 1996. Each year the festival operates around a specific theme. For several years Art + Communication focused on ideas intrinsic to the transmission art genre: Waves (2006), Spectral Ecology (2007), Spectropia (2008), Energy (2009). Another program at RIXC, Xchange, is a pioneering streaming audio and sound art project on the Internet. It was launched in 1997 by Riga-based artists group E-LAB (Rasa Smite, Raitis Smits, Jaanis Garancs) in collaboration with other emerging Internet radio initiatives from all over the world.

The intent was to create a network for alternative Net audio content providers and a collaborative platform for creative explorations with real-time sound and live streaming possibilities. A notable third program, Acoustic.Space.Research.Lab is long-term co-operation between several international artists' groups and individuals from the Xchange network. The pilot project, Acoustic Space Lab symposium took place from August 4-12, 2001 in the forests of western Latvia in Irbene, at the site of a Soviet-era dish antenna. Over the days of the symposium, an international team of thirty sound artists, Net, and community radio activists and radio amateurs, in cooperation with VIRAC (Ventspils International Radio Astronomy Center) scientists, explored the possible uses of receiving antennae, making recordings of the sounds and data from planet observations, communication satellites, and surrounding environments.

Resonance104.4fm

Founded in 2002 by the London Musicians Collective, Resonance is a FM station with an exemplary commitment to creative radio. Intent on securing a space for artworks that have no place in traditional broadcasting, Resonance considers itself an invisible gallery, a virtual arts center whose location is at once local, global, and timeless. Resonance104.4fm features programming made by musicians, artists, and critics who represent the diversity of London's artists and arts spaces, with regular weekly contributions from nearly two hundred musicians, artists, critics, and activists.

New Adventures in Sound Art

New Adventures in Sound Art (NAISA) is a Canadian nonprofit organization, founded in 2003, that produces performances and installations spanning the entire spectrum of electroacoustic and experimental sound art. Through workshops, lectures, and demonstrations that teach a new perception of sound. NAISA's Deep Wireless Festival is a month-long celebration of radio and

transmission art that features performances, installations, and radio broadcasts of commissioned works. Deep Wireless culminates with the weekend-long conference, Radio Without Boundaries, which is focused on the potential and boundaries of radio and transmission arts as contextualized by international guest radio art luminaries.

Neighborhood Public Radio

Neighborhood Public Radio (NPR) was founded in Oakland, California in 2004 by LeE Montgomery, Jon Brumit, and Michael Trigilio. Operating under the motto is "If it's in the neighborhood and it makes noise, we hope to put it on the air," NPR straddles between organization and artist collective producing radio-based projects in both community and art-world contexts. As a traveling band of guerrilla broadcasters, NPR collaborators have hosted thematic broadcasts across the U.S. and internationally. Notable projects include a six-month series of broadcasts and public performances in 2007, titled *Radio Cartography*, which was presented in partnership with Southern Exposure gallery in the Mission District of San Francisco. In 2008, NPR produced a four-month broadcast from an Upper East Side storefront in conjunction with the Whitney Biennial in New York.

The Radia Network

Founded in 2005, the Radia Network is a group of independent radio projects that share a commitment to radio as an art form. While members' methodologies differ, as do the local contexts, which range from commissioned radio artworks to struggles for frequencies and access to copyright concerns, Radia projects are united in the goal to foster an audio space where something different can happen. Participating stations produce and share content on a rotating basis, based in Belgium, Canada, Germany, U.S., Austria, France, New Zealand, Italy, UK, Portugal, Czech Republic, Hungary, and the Netherlands.

Inspired and supported by the inventors, activists, and organizations noted above, contemporary transmission art is united by a spirit of experimentation and innovation. Transmission artists find their audiences in galleries, museums, public and private space, and educational contexts. Audiences take the form of listeners, viewers, readers, participants, and students. Transmission projects defy exclusive classification. They take shape as sound artworks, and are presented as composition or live performance. They sometimes appear as moving-image works transmitted as television broadcast or video art. They may appear in installations that draw from the transmission spectrum, perhaps sampling multiple radio or scanner feeds, or adding to what is on-air by creating site-specific radio stations inside a gallery or public space. In addition, reproducible multiples or distributed objects share technology and access in the form of transmission tool-kits, while radio theatre works engage radio space as a stage for storytelling. Interventionist acts intentionally blur the lines between art and activism. Mobile artworks repurpose ubiquitous wireless consumer technologies for creative means. Regardless of a bewildering variety of approaches, transmission art projects all celebrate the imaginative use of tools of communication.

The 150 artists and works identified in the following pages establish a foundation for the free103point9 Transmission Art Archive that ensures the future of the genre through an expansive online resource in which transmission artists are encouraged to submit their work. As new wireless technologies develop so too will the projects of artists.

The free103point9 Transmission Art Archive is accessible at transmissionarts.org. As a supplement to this volume, a special selection of sound and visual materials is available online at free103point9.org/artistandairwaves.

Notes

1. *SG4L (Sending SGLLLL)* is the title of the work by Leslie Sharpe produced in 2006, and described more fully in the Broadcast: Radio and Television section of this volume.
2. "Statement on Intermedia," Dick Higgins, in Wolf Vostell's *Dé-coll/age Happenings*, New York: Something Else Press, 1966.
3. On January 5, 2011, President Obama signed the "Local Community Radio Act," a bill that paves the way for a new wave of community radio stations across the country. The bill passed in the House (December 2009) and in the Senate (December 2010), marking the end of a decade-long struggle between local radio advocates and the National Association of Broadcasters.
4. Velimir Khlebnikov, *The King of Time: Selected Writings of the Russian Futurian*, Cambridge: Harvard University Press, 1985.
5. *Hörspiel USA* included works such as *Five Man Humanity*, Ernst Jandl & *Friederike* Mayröcker (produced in English); *Wind and Sea*, Peter Handke (original WDR production); *The First Casualty of the Trojan War*, Wolfgang Hildesheimer (produced in English); *Roaratorio*, John Cage (original WDR production); *Natural Assemblages and the True Crow*, Alison Knowles (original WDR production); *Hsin Hsin Minh*, George Brecht (original WDR production).
6. As noted by George Maciunas in his 1963 Fluxus manifesto, made available by the George Maciunas Foundation online at http://georgemaciunas.com/?page_id=42

Performance and Composition

Arseny Avraamov

b. 1886 Krasnokutsky, Russia; d. 1944

Arseny Avraamov was a Russian composer, inventor, and theorist known for his work on microtonality and experimental tunings. Avraamov envisioned large-scale outdoor musical performances driven by a socio-political intent. These monumental concerts took place between 1918 and 1923 and involved the use of nonmusical resources such as warships' foghorns, hydroplanes, and artillery guns. A crucial aspect of Avraamov's project was the integration of signaling devices to enable the transmission of sound. Avraamov studied composition with Sergey Taneyev at the Moscow Philharmonic Society's music school. During the First World War, he chose to work as a touring circus artist instead of joining the Russian army. Instrumental in developing sound composition techniques for film, Avraamov's repertoire of inventions includes Graphical Sound and the Ultrachromatic microtonal system. The former is a hybrid form of combined musical notation and sound composition achieved by drawing shapes and patterns directly onto magnetic tape. The latter consisted of forty-eight microtones; its theoretical underpinning was introduced in Avraamov's 1927 thesis "The Universal System of Tones." Avraamov made a significant imprint on early twentieth-century Russian culture.

Symphony of Factory Sirens (1922)

Symphony of Factory Sirens was a canonical outdoor concert. The work was commissioned for the fifth anniversary of the Soviet Republic on November 7, 1922, and performed in the Caspian port of Baku. Avraamov's pioneering Futurist symphony was an experiment in outdoor performance incorporating an unprecedented array of instrumentation and collaboration from a wide spectrum of participants. The composition called for parts to be played by navy ship sirens and whistles, bus and car horns, factory sirens, cannons, the foghorns of the entire Soviet flotilla in the Caspian Sea, two batteries of artillery guns, machine guns, hydro-airplanes, a specially designed "steam-whistle machine" playing "The Internationale" and "La Marseillaise," accompanied by a mass band and choir. This complex score was coordinated through the use of colored flags and pistol shots operated by conductors placed on specially constructed towers. An exemplary work of Futurist music, *Symphony of Factory Sirens* was a groundbreaking multimedia transmission performance between remote participants. In its totality the work was a declaration of community, amplifying the sounds of the street and modern life and calling for the return to the grassroots foundations of the Soviet Republic.

Giancarlo Bracchi

b. 1980 Queens, New York
Lives and works in Long Island City, New York
myspace.com/giancarlobracchi

Giancarlo Bracchi is a multi-instrumentalist, sonic artist, and musician. He began playing music at an early age, teaching himself guitar and playing saxophone in his school band with additional forays into the violin and other stringed instruments. In high school his focus shifted when he joined a hardcore band. This experience directed his attention to extreme sonics and the cathartic uses of sound. As a solo artist and as part of Thick Wisps (his duo with Juan Matos Capote), he has shared stages with Talibam!, Blues Control, Elliott Sharp, Growing, Mudboy, and Bunnybrains. Bracchi runs the record label Viking Foundry, records collectively under the moniker Eroded Goat, and releases material under the nom de plume of Mangoon. Bracchi's most recent works have been an exercise in tone sculpting and synthesis, conjuring celestial sound ghosts from his instruments. In addition to utilizing hacked hardware and self-assembled theremins, mini-synths, loopers, and larger analog synths, Bracchi explores the sounds of metals grating, chains rolling, and decaying wastelands of the vocal spectrum. His weekly show, *DJ Mangoon Presents*, aired on free103point9 Online Radio from September 2007 through November 2009. His solo debut, *Patriot Mythology*, is available through the label Viking Foundry. Bracchi's current project is a collaboration with fellow former free103point9 Online Radio host Radio Ruido/Tmm Mulligan and partner Jennifer Cohlman.

Steaming Meaning (2007–2009)

For sound artist Giancarlo Bracchi, the annual Noise! Festival at the Ontological Theater in Manhattan (organized by free103point9 2006–2010) was a yearly platform to explore his blusterous breed of audio warfare. Bracchi performed consecutively in Noise! from 2007 to 2009, participating in two *Radio 4x4*'s collaborations and curating night one of the 2007 festival. Utilizing theatre-rattling bass, disembodied voices of condemnation, and theremin panthers, Giancarlo's Noise! performances stood as annual landmarks for his trajectory as a sound sculptor and performance artist. A strident conflation of the musical and nonmusical, Bracchi's work blurs the lines between composition and improvisation, drawing equally from the worlds of harsh noise, Dada, and new-age neo-shamanism.

Matthew Burtner

b. 1970 Naknek, Alaska
Lives and works in Charlottesville, Virginia
burtner.net

Matthew Burtner creates sound art performance works exploring noise-based musical systems, ecoacoustic environmental systems, and technological embodiment theory. He composes for a wide range of musicians and ensembles, and for his own groups MICE (Mobile Interactive Computer Ensemble) and Metasax&DRUMthings. Deeply influenced by his early childhood spent living in a small Alaskan village on the Arctic Ocean and on fishing boats on Alaska's southwest coast, the traces of his earliest acoustic memories, such the sound of wind and storms on the ocean, can be heard in his compositions. Burtner's music has been presented widely at festivals and venues throughout North America, Europe, Africa, and Asia. Among recordings for DACO (Germany), The WIRE (UK), The MIT Press (US), Innova (US), Centaur (US), EcoSono (US), and Euridice (Norway), his music appears on three critically acclaimed solo recordings: *Portals of Distortion* (1998), *Metasaxophone Colossus* (2004), and *Signal Ruins* (2000). His 2008 *Signal Ruins* sound artworks DVD was described by London's *Further Noise* as "a dissonant, ecstatic anti-chorus of metallic shrieking, stresses, and crackle … cementing this audio-visual project as a most trenchant experience in ritual." Burtner is associate professor of composition and associate director of the VCCM Computer Music Center at the University of Virginia.

Studies for Radio Transceiver (2001)

Burtner's *Studies for Radio Transceiver* enters a territory crowded with signal intentionality and evades those signals. Specific messages are shunned in favor of message potentialities. *Studies* evokes vast and empty spaces and struggles to keep the means of communication open in these spaces.

> *Study 1.0 (feedback):* Transmit a silent signal. Receive the signal and feed the line outputs of the receiver back into the transmitter.

> *Study 1.2a (net):* Several performers, each playing a different radio receiver, are spaced throughout the hall. Each performer chooses a range of the FM spectrum. Turning on the receiver, they tune to a frequency falling on an unoccupied band of the FM spectrum. Once each performer has found an empty frequency, the noise web is established. Hold the noise web.

> *Study 1.2b (net):* Once the net is established, the radio transmitter transmits a silent signal, and the performer freely alters the circuitry and broadcast frequency.

Imaginary Landscape No. 4 (1951)

John Cage

b. 1912 Los Angeles, California; d. 1992
johncage.org

John Milton Cage was an American avant-garde composer and pioneer. Cage studied music theory and composition in the mid-1930s with distinguished teachers such as Arnold Schoenberg and Henry Cowell while attending USC and UCLA. Later, Cage moved to New York City and began to create a new compositional system influenced by Eastern philosophy. He was particularly interested in exploring ways in which all decisions concerning the development and structure of a piece could be defined by chance operations. Cage also introduced the use of nonmusical objects (i.e., household objects, radios, recorders, turntables, and toys) into his compositions. His "prepared piano" would later be regarded as one of his most influential inventions. By placing screws, rubber, and other material in between the piano strings, Cage transformed the piano into a rich orchestra of combined percussive and melodic tones. Cage's philosophy emphasized the importance of the everyday. He worked often with Marcel Duchamp, David Tudor, Robert Rauschenberg, Charles Olson, and Allan Kaprow, among numerous others. Cage's legendary performances and happenings, including *4'33* (1952), *Imaginary Landscape No. 1* (1939), and *Musicircus* (1967) challenged the audience's critical response and engagement. His collection of writings, *Silence*, introduced his philosophy to a wider audience.

Imaginary Landscape No. 4 is a composition for twelve radios and twenty-four performers. Two performers are stationed at each radio, one for dialing the radio stations and the second performer controlling amplitude and timbre. Durations are written in conventional notation, using notes placed on a five-line staff. The rhythmic structure of the work is 2-1-3 and is expressed in changing tempi. The score gives notations for tuning (controlled by player one) as well as volume and tone color (controlled by the second player). The score was conceived using factors of chance adapted from the Chinese *Book of Changes*. Cage describes the intent and effect in *Silence*:

> It is thus possible to make a musical composition the continuity of which is free of individual taste and memory (psychology) and also of the literature and "traditions" of the art. The sounds enter the time-space centered within themselves, unimpeded by the service to any abstraction, their 360 degrees of circumference free for an infinite play of interpenetration. Value judgments are not in the nature of this work as regards either composition, performance, or listening. The idea of relation being absent, anything may happen. A "mistake" is beside the point, for once anything happens it authentically is.

Damian Catera

b. 1964 Utica, New York
Lives and works in Jersey City, New Jersey
catera.net

Damian Catera is an interdisciplinary sound and media artist, electroacoustic composer, and improviser. Catera's work reflects interests in critical analysis, experimental composition, improvisation, and transmission. He has toured and exhibited his work in the U.S., Europe, and Asia. His primary mission as an artist is to blur disciplinary boundaries, often utilizing appropriated material and algorithmic processing. In recent years, Catera has performed solo improvised "decompositions" using computer-manipulated live radios as instrumentation in such venues as the New Museum and The Kitchen in New York City, the ZKM institute in Germany, and the Institute for Contemporary Art in Prague. As a collaborator, Damian has performed at the National Gallery in Prague, the Walker Center in Minneapolis, and the Adler Planetarium in Chicago. He has exhibited sound installations and video pieces in a variety of forums including The Chelsea Museum and Art in General in New York City; ICMC 1996 in Hong Kong; and MediaForum 2003 in Moscow. Catera holds a master's in electronic arts from Rensselaer Polytechnic Institute and a bachelor's in political science from Siena College. He also studied electroacoustic composition at Les Atelier UPIC, the Paris-based institute founded by composer Iannis Xenakis.

Radio deComposition (2004)

The five pieces that comprise Catera's *Radio deComposition* album represent a coalescence of the artist's research interests in randomization algorithms as a platform for improvisation, with his long-standing critical analysis of broadcast media. The works rely solely on the unpredictability of live radio as source material; therefore, the algorithms function not as an end in and of themselves but as a tool toward a conceptual end—mainly the recontextualization of live radio as a form of social commentary. Reflecting John Cage's conception of structure as an "empty glass" into which at any moment anything may be poured, the algorithms cut up and alter the incoming source material, randomizing pitch, duration, and direction. The resulting soundscape and social critique rely on what Catera calls "happy accidents" emerging dialectically at the confluence of chaos and order. Catera's work since *Radio deComposition* continues to explore these processes and ideas. *Hacking Apart the American Airwaves* (2006) was streamed live from Brooklyn to the Hermitage Museum in St. Petersburg for the "Unauthorized Access" exhibit. Catera's performance painted a portrait of a post-imperial U.S. overwhelmed by its declining international stature and domestic race and class tensions.

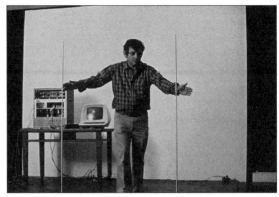

Solo (1978)

Joel Chadabe

b. 1938 New York, New York
Lives and works in New York City
chadabe.com

Joel Chadabe is a composer, author, and internationally recognized pioneer in the development of interactive music systems. As early as 1967, he worked with Robert Moog to design a unique analog system. Since then, he designed the first software sequencer and, more recently, other interactive software for a variety of platforms. Chadabe writes:

> When people ask me what I do as a composer, I explain that I do not compose pieces; I compose activities. A "piece," whatever its content, is a construction with a beginning and end that exists independent of its listeners and within its own boundaries of time. An "activity" unfolds because of the way people perform; and consequently, an activity happens in the time of living; and art comes closer to life.

Chadabe music is recorded on EMF Media, Deep Listening, CDCM, Lovely Music, and other labels. He is the author of *Electric Sound: The Past and Promise of Electronic Music.* His articles have been published in countless leading journals and magazines and anthologized in books by The MIT Press, Routledge, and other publishers. As president of Intelligent Music, a research and development company, he was responsible for the first publications of interactive music software. As president of Electronic Music Foundation, Chadabe has further developed his ideas and techniques for interactive performance.

In his performance, *Solo*, Joel Chadabe utilizes a custom Synclavier to conduct an improvised electronic composition. Standing behind two antennas positioned three feet apart in front of him, Chadabe manipulates a series of discrete sounds by moving his hands toward antennas or by pulling his hands away. The first version of the antennae—custom-designed and built by Robert Moog and premiered at *New Music New York* at The Kitchen in 1979—were six-foot rods, mounted in wooden bases. A year later, Chadabe reconstructed the antennas using Volkswagen car antennas mounted in easily transportable small metal boxes. In *Solo*, the melody is articulated in eight voices, including electronic sounds suggestive of two clarinet sounds, two flute sounds, and four vibraphone sounds that converge around the melody. As Chadabe moves his left hand closer to the left antenna, he introduces different combinations of the instrumental sounds. As he moves his right hand closer to the right antenna, the tempo changes. Waving his hands in the air suggests a conducting metaphor, but here Chadabe's playing exemplifies "interactive composing," privileging the unpredictability of the system rather than a predefined composition.

Nicolas Collins

b. 1954 New York, New York
Lives and works in Chicago
nicolascollins.com

Nicolas Collins is best known for improvised instruments constructed by hardware hacking, a practice about which he has taught and published widely. Concert programs that incorporate live electronics and computers, manipulating feedback, voice, electromagnetic fields, and strings form the basis for Collins's performances. His installation work responds to the sounds and movements of visitors and musicians. His performances and installations have been heard internationally and his recordings have been released on several labels, including Lovely Music, Trace Elements Records, Nonesuch, Periplum, and PlateLunch. Collins studied composition with Alvin Lucier at Wesleyan University, worked for many years with David Tudor, and has collaborated with numerous soloists and ensembles around the world. He resided in Europe for most of the 1990s, where he was visiting artistic director of Stichting STEIM in Amsterdam and a DAAD composer-in-residence in Berlin. Since 1997, he has been editor-in-chief of the Leonardo Music Journal. Collins has served as professor in the Department of Sound at the School of the Art Institute of Chicago since 1999. The second edition of his book, *Handmade Electronic Music: The Art of Hardware Hacking,* was published in 2009.

Devil's Music (1985)

Devil's Music is a performance work informed by global media, local culture, and individual interference. Collins developed *Devil's Music* in 1985 out of the confluence of his fascination with early hip-hop DJs, a Cage-like fascination with radio, the introduction of the first affordable, portable samplers, and a simple homemade "stuttering circuit." In *Devil's Music* the performer sweeps the radio dial in search of suitable material, which is sampled in snippets of one second or less. The samples are then looped, layered, and de-tuned. The stuttering circuit "re-rhythmitizes" the samples by retriggering and reversing the loops in response to accents in the rhythm of the ongoing (but usually unheard) flow of signal out of the radio—in other words, the radio material a listener doesn't hear governs the phrasing of the sounds heard. All sounds are sourced from live transmissions occurring in the AM, FM, shortwave, and scanner bands at the time of the performance; no samples are prepared in advance. The result is a jittery mix of shards of music, speech, and radio noise—a patchwork quilt stitched from scraps of local airwaves. Collins revived *Devil's Music* in 2002 by replicating the original hardware in software for open distribution and group performances.

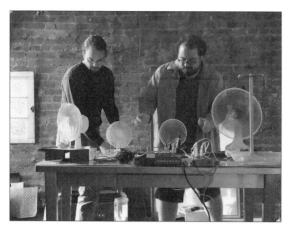

Evidence

Established 2001 Troy, New York
Based in New York City and Edmonton,
Alberta, Canada
ecnedive.com

Evidence is a collaboration between sound art-
ists Stephan Moore and Scott Smallwood, with
activities ranging from studio compositions and
live improvisations to sound installations, street
performances, and numerous collaborations with
other musicians, choreographers, and video art-
ists. Since 2001, they have developed a distinctive
language of deeply layered sound, using field re-
cordings of natural and industrial environments
as a primary source of inspiration and sonic ma-
terial. Stephan Moore is a composer, audio artist,
and sound designer whose creative work centers
upon the collection of real-world sound, creation
and perception of sonic environments, and tech-
nological manifestations of improvisation and
interactivity. In addition to his solo work and
Evidence, Moore collaborates with a variety of
musicians, live-video artists, and choreographers.
Moore served as the sound engineer and music
coordinator for the Merce Cunningham Dance
Company from 2004 to 2010. Scott Smallwood
has been fascinated by the possibilities of record-
ed sound since childhood. His work deals with
real and abstracted soundscapes based on a prac-
tice of listening, improvisation, and phonography.
Ranging from sonic photographs, studio compo-
sitions, instrumental pieces, and improvisations,
the resulting pieces are often textural and always
mindful of space and subtlety.

Evidence. Receiver.

Receiver (2007)

Receiver is a CD-length composition created dur-
ing a residency at the free103point9 Wave Farm
(Acra, New York). The project originated from
a desire to construct a transmission installation
event that would engage with the natural sound-
scape through the use of radio transmitters and
an audience of participants, each equipped with a
portable radio. After spending a week composing
music and creating sounds inspired by the Wave
Farm environment, the project was presented as a
participatory performance at the site. Six separate
sound layers were simultaneously broadcast on
separate channels using low-power radio trans-
mitters tuned to adjacent frequencies that encour-
aged new sounds to emerge through interference
and bleed-through. Using handheld radios with
built-in tape recorders, participants wandered
through the space, creating personal recordings
by interacting with the radio's tuning and volume
controls, orienting their bodies in relation to the
antenna, changing their locations within the to-
pography of the site and the positions of the trans-
mitters, and improvising with other participants
and the evening sounds of tree frogs, crickets,
and occasional distant traffic. The participants'
recordings became source material for *Receiver*, a
thirteen-part studio composition released on CD.

Akin O. Fernandez

b. 1977 USSR
Lives and works in London
irdial.com

Akin O. Fernandez, is an artist working in the medium of sound. In particular, he has utilized recordings of shortwave radio transmissions as the raw material for his work. His fascination with shortwave recordings spans several decades, and has been heavily influenced by the unique sound sculptings of Bruce Gilbert, Graham Lewis, and Russell Mills, and the Italian Futurist Luigi Russolo's 1913 manifesto "The Art of Noise." In the essay, Russolo argued for the incorporation of new noises birthed by the industrialization of modern urban life into musical composition. For Akin Fernandez, the shortwave noise originating from the "numbers stations" he records is itself a form of music. Fernandez has worked under pseudonyms on numerous projects in connection to the label Irdial Discs, of which he is the founder. A continuation of Fernandez's interest in transmission, in 2008, Irdial released *Electric Enigma*, a double CD authored by artist Stephen P. McGreevy, which documents recordings made of atmospheric very low frequency (VLF) effects. This "natural radio" includes electromagnetic perturbations caused by massive energy interactions of the solar wind and the aftereffects of the mixing of lightning strikes with the earth's magnetic field.

The Conet Project: Recordings of Shortwave Numbers Stations (1997)

For more than thirty years, the shortwave radio spectrum has been used by the world's intelligence agencies to broadcast secret messages. These messages are transmitted by hundreds of numbers stations. Shortwave numbers stations are perfected, anonymous, one-way communications. The encryption system used by numbers stations, known as a "one-time pad," is unbreakable. Further, it is almost impossible to track down the message recipients, making the numbers station system an immensely powerful tactical device. Akin Fernandez's *The Conet Project* is an important historical reference work for research into this unreported and unknown field of espionage. The four-CD box set contains 150 recordings spanning twenty years. The stations heard on the discs operate on rigid schedules and transmit in many different languages, employing male and female voices repeating strings of numbers or phonetic letters day and night, all year round. The voices are of varying pitches and intonation. The recordings have been taken from the private archives of dedicated shortwave radio listeners from around the world. Many of the stations on the CDs have ceased operations and can no longer be heard.

Joshua Fried

b. 1959 Los Angeles, California
Lives and works in New York City
radiowonderland.org

Joshua Fried emerged from New York's downtown experimental music and East Village performance art scenes of the 1980s. Fried is known for turning technology on its head, challenging its assumptions, while using machines to accentuate the raw human qualities of live events that are unique to the moment. His work partakes equally of minimalism and the rhythmic experimentation of composer Conlon Nancarrow and his followers, as well as contemporary performance art, dance rhythm, and sound processing techniques. Fried's *Headfone Follies* completed its twelve-week run at HERE Arts Center in New York City in 2001 with a rotating cast of sixty-four headphone-driven performers. His collaboration with choreographer Douglas Dunn, *Spell for Opening the Mouth of N* (featuring eight headphone-driven singer/actors and a dance company of ten), premiered in a sold-out run at The Kitchen, New York City, and was one of the highlights of the 1997 Lincoln Center Out-of-Doors Festival. Fried's thirty-minute *Welcome to the Ice-Box,* commissioned by Danish Radio and recorded at Danish Broadcasting Corporation studios, premiered on Danish Radio and at Sound/Gallery in 1997, where twenty-five loudspeakers were permanently installed in Copenhagen's main town square.

RADIO WONDERLAND (2000 and ongoing)

RADIO WONDERLAND consists of artist Joshua Fried performing live sound processing controlled by an array of repurposed tools, including men's dress shoes and a steering wheel. It begins with Fried entering the performance space and weaving through the crowd, holding a large boom box radio. As he turns the dial the audience is confronted by live commercial FM radio. When Fried reaches the stage, he plugs the boom box into his equipment setup, after which his feed is heard through the performance amplification system. No sounds are pre-recorded; content is driven by live and spontaneous radio samples selected at the beginning and throughout the performance. Fried's samples are processed with custom software written in the Max/MSP programming environment. His controllers are a vintage Buick steering wheel and old men's dress shoes mounted on stands, which serve as percussion surfaces. Fried deconstructs what is at first recognizable radio into clicks and cuts of sound. He then builds those elements back up into grooves, generating rhythm-driven music, which inevitably triggers some, if not all, of his audience to move to the beat.

Anna Friz

b. 1970 Vancouver, Canada
Lives and Works in Montreal
nicelittlestatic.com

Anna Friz is a sound and radio artist, and media studies scholar. She creates self-reflexive radio art/works for broadcast, installation, or performance, where radio is the source, subject, and medium of the work. Friz employs many approaches to experimental radio and radio art: from creating live in-studio or in-situ broadcasts, to composing radio art pieces for rebroadcast internationally, to undertaking nomadic, unlicensed low-power radio interventions, to participating in large-scale network media exchanges. She has also created classic radio theatre staged performances, and installations, and performances using multi-channel radio transmitter and receiver arrays. Her artistic practice draws directly on disciplines such as soundscape recording and composition, audio art, and experimental music. Use of voice, text, and theatrical elements are consistent in her works. Radio functions as a crossroads for Friz's diverse interests that enable a unique interdisciplinarity in her media and sonic practices, which reflect upon persistent questions about human communication, phenomenologies of wirelessness, and relationships of sociality and technology. Friz is intent on reframing transmission as an open, indeterminate, heterogeneous process—an embodied machinic practice within the dimensions of the human that invokes new territories in the imagination, or new experiences of contemporary surroundings.

Respire (2008)

Built on the sounds of human breath and other bodily exclamations typically absent from regular radio broadcasts, *Respire* focuses on the interactions of breath and static. These uneasy nighttime respirations seep up through the welter of intercepted radio signal and sounds composed from instruments that echo human breath (harmonica) or the detuned radio landscape (theremin). *Respire* utilizes a configuration of elevated radio receivers to create an immersive, dynamic field of sound. The radio array consists of between two and four low-watt FM radio transmitters, and groups of palm-sized radio receivers. The radio receivers are suspended just above the heads of the audience, and lit in small constellations by LED lights. Friz's explorations of immersive radio systems, as in *Respire,* are collaborations with the electromagnetic waves themselves through relatively unstable systems comprised of transmitter and receiver arrays. As a result, Friz's sonic landscapes consist of sounds which are not representational, but indexical of devices and bodies in space. *Respire* conjures other possible radio territories than the ones with which its audiences are familiar, and adds intimacy to our experience of radio transmission and electricity. *Respire* premiered as a performance at RadiaLX 2008 in Lisbon.

Max Goldfarb

b. 1969 Alexandria, Virginia
Lives and works in Hudson, New York
m49.us

Max Goldfarb is an artist whose work intersects many disciplines, including objects, drawings, improvised electronics, radio transmissions, publications, and performative situations. His work responds to the maintenance, organization, transformation, and decay of urban space. Using various existing materials and visual languages to reveal the conditions of this urban context, Goldfarb has worked on an ongoing series of public works projects involving material constructions and radio communications. The resulting themes concern the precariously narrow margin between safety and danger, and structure and change. Goldfarb's ongoing project *Mobile49 (M49)* is a retrofit radio-utility truck (a Grumman Kurbmaster Step Van), employed as a platform for mobile radio transmission and other creative applications. As part of his *Unauthorized Public Works* projects, *M49* redirects an array of radio transmissions into unintended areas, creating a temporary interference zone embedded into a powerful commercial radio signal. Goldfarb's *Ambulant Transceivers* (2008), exhibited in a gallery context, is an emergency communications kit including thirty handheld transceivers, two solar 9-volt battery-charging units, and a dispatch radio. Each device is housed inside a vintage first-aid tin.

Deep Cycle (2010)

Presented in three distinct components, Goldfarb's *Deep Cycle: Reincarnation of Herman Meydag* manifests itself as a parade, a procession, and a publication. Thematically, consumption, waste, destruction, and transformation are at the core of the *Deep Cycle* narrative, which conveys a post-oil landscape. On June 12, 2010, Goldfarb's *Mobile49* vehicle engaged with the Hudson Flag Day Parade spectacle as a motorcade participant, displaying newly completed customizations for mobile and solar-powered transmission and pulled by oxen along the parade route. The following day, the *Deep Cycle* project unfolded along a carefully established path through New York's Hudson Valley roadscape. *Deep Cycle* threads together a constellation of area-specific performance incidents using the vehicle itself as a framing mechanism as well as an instrument for articulating the work through low-power radio transmission. *Deep Cycle* includes performances, sounds, and words by a dozen artists including Max Goldfarb, Brian Dewan, John Ashbery, Brett Balogh, Ryder Cooley, Paul Elliman, and Garrett Phelan. There is also a book entitled *Deep Cycle* that documents this project in texts, transcripts, drawings, and photographs.

Sarah Kanouse

b. 1976 Los Angeles, California
Lives and works in Iowa City, Iowa
readysubjects.org

Sarah Kanouse is an interdisciplinary artist and critical writer interested in examining the way histories, public spaces, landscape, and forms of citizenship influence one another and shape the realm of political possibility. Her work, which takes the form of arts practice, writing, and occasional curatorial work, has most recently focused on addressing and intervening in the formation of public memory and radical culture in the Midwest, where she has lived for over ten years. Additional interests include radical media (specifically pirate radio and self-publishing), cultural geography, and social movements. Recent projects include *Voices of America*, a collaboration with Lee Azzarello to create a platform for the exchange and remixing of news coverage of the 2008 Presidential election on the U.S. government's international broadcasting service, the Voice of America. Kanouse's individual and collaborative work has appeared widely in exhibitions and screenings internationally, and her writings have been published in the *Journal of Aesthetics and Protest, Acme, The Democratic Communiqué*, and *Critical Planning and Art Journal*. She received her undergraduate education from Yale University in 1997 and a master's in studio art from the University of Illinois in 2004. She currently teaches time-based media, and art and ecology, in the undergraduate and graduate intermedia programs at the University of Iowa.

Don't Mourn (2005–2007)

Don't Mourn is a series of memorial transmission performances commemorating moments of violent conflict in Illinois labor history from the 1870s to the 1990s. Kanouse traveled to twelve otherwise unmarked sites to broadcast a distorted "Internationale"—the socialist and anarchist solidarity anthem—using a homemade mobile transmission kit consisting of a four-watt FM transmitter, modified HAM radio antenna, and 12-volt wheelchair batteries. Radio's invisibility underscores the marginality of these mostly forgotten, yet nonetheless significant, events. Informed by the writings of artists and theorists like Frances Dyson and Joe Milutis, Kanouse is attracted to the apparent paradox of using an ephemeral medium as a technology of memory. Drawing upon radio's early association with the supernatural and transmitted sound's mediation between the physicality of objects and the transience of time, radio's cultural and material life provide an ideal medium for anti-monumental approaches to memory work. As a form of omnipresent sound that cannot be heard by the unassisted ear and as an invisible immersive technology in which bodies and spaces are always bathed, radio enacts, metaphorically, the troubled nature of public memories, always hovering on the brink of forgetting.

Radiozeit (1988)

Richard Kriesche

b. 1940 Vienna, Austria
Lives and works in Graz, Austria
iis.joanneum.ac.at/kulturdata

Richard Kriesche is an artist, curator, and media art theorist who has worked with electronic media since the 1970s. Kriesche's work stems from an attempt to understand and articulate the challenges and potentialities brought upon social power structures by new technology and scientific advancement. His work, based in systems of perception, assumes many forms, including photography, video, computer and net art, multimedia installations, and performance. Following studies at the Academy of Fine Arts at the University of Vienna, Kriesche went on to teach at the Higher Technical College in Graz. In 1973, he founded the first Austrian new media educational department, the Department of Audio-Visual Media, where he continues to teach. Kriesche established the arts society "pool" in 1968 and edited the arts journal *pfirsich* (peach) with Horst Gerhard Haberl and Karl Neubacher for the society. In 1973, he established "poolerie," a media art gallery in Graz devoted to experimental photography, film, and video. In 1984, Kriesche co-developed "kulturdata," focused on high-tech art, media, and communication. In 2008, *Richard Kriesche Quantitativ*, a three-volume retrospective of Kriesche's work, authored by Astrid Becksteiner-Rasche, was published by Leykam Verlag.

In the performance *Radiozeit* (Radiotime), Kriesche explores the connection between art and radio, which he anchors to notions of embodiment and freedom in public space. The basic elements of this radio performance are: the signals of a weather satellite, Mozart's *Eine kleine Nachtmusik* (A Little Night Music), and the artist's voice. The project includes the collaboration of musician and media artist Seppo Gründler, a ham radio expert; and the Technical University in Graz. The original performance took place as part of the international radio art symposium *With the Eyes Shut* in Graz in 1988. Kriesche invited the participants into his darkened studio, which was equipped with a parabolic antenna harnessing the signals from a weather satellite outside the window; live images from the satellite were projected onto the wall opposite the audience. A digital keyboard containing Mozart's *Eine kleine Nachtmusik* was also connected to the antenna and triggered by the satellite signals. Kriesche sat beside the projection at a table and read a text in the light of a small lamp. Criticized by some for the cacophonous results, the performance is emblematic of one of the central issues in Kriesche's art and theoretical thinking: the white noise of data and the all-devouring backdrop of a digitalized society.

Solar Filters/Mother Evening (2007)

Latitude/Longitude

Established 2004 Brooklyn, New York
Based in New York City
minutesandseconds.com

Latitude/Longitude, a Brooklyn-based experimental music group formed by Michael Garofalo and Patrick McCarthy, began in 2004. They became a trio in 2007, adding percussionist Jason Labbe. Teasing melodies out of prepared and alternately tuned guitars while electronics murmur in a nest of instrument cables at their feet, Latitude/Longitude weaves electroacoustic dream songs from cross-circuit chaos. Eschewing traditional arrangements, they favor a looser, more spontaneous approach to composition. Live improvisations are played back and manipulated until they take new forms. The results range from surreal folk and delicate instrumentals to noise-drenched drones. Latitude/Longitude's instrumentation often includes test oscillators, homemade cassette tape and field recordings, radio transmissions (FM/AM/SW/CB), toy electronics (broken and functional), and percussive refuse, as well as more traditional instruments such as pedal steel guitar, banjo, mbira, drums, cymbals, and voice. In 2005, Latitude/Longitude released their self-titled debut album on their imprint Early Thieves. *Absolute Locations*, a full-length collection of live improvisations, was released as a limited edition in 2008.

Solar Filters and *Mother Evening* are two songs released by Latitude/Longitude as a seven-inch vinyl record in free103point9's Audio Dispatch Series. While working on these recordings, cheap and toy radios were at the foreground of their public performances, often providing the only amplification for instruments and voices. In *Solar Filters* shortwave radio textures open the track, illustrating the sounds of the atmosphere. The title *Solar Filters* emerges from a conceived, but unrealized song cycle about the sun and its influence on the earth's atmosphere. *Mother Evening* originated, like most of Latitude/Longitude's work, as a live improvisation. For lyrics, they turned to a type of spam email received in high volume at the time. The emails were nonsense, comprised of a collection random phrases and sentence fragments. In these disparate texts the artists found something poetic, and used the messages as a palette from which to compose. As with the in-between-stations static on *Solar Filters*, here they also incorporate digital detritus (this time, literally, junk mail) into *Mother Evening*. The recordings were made at the Seaside Lounge Recording Studios in Brooklyn in late 2007.

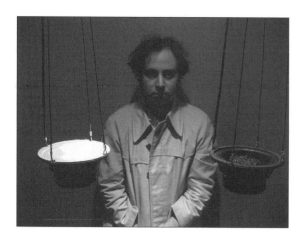

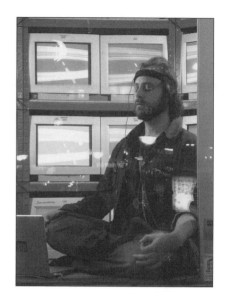

Zach Layton

b. 1976 New York, New York
Lives and works in New York City
zachlaytonindustries.com

Zach Layton is a composer, curator, improviser, and new media artist. His interests are rooted in biofeedback, generative algorithms, experimental music, Dada, and chance. Layton's work investigates complex relationships and topologies created through the interaction of simple core elements like sine waves, minimal surfaces, and kinetic visual pattern. Layton has performed and exhibited at the majority of experimental venues in New York, as well as notable institutions and festivals abroad. A consummate collaborator, Layton has worked with a long list of artists, including Luke Dubois, Vito Acconci, Joshua White, Jonas Mekas, Tony Conrad, Bradley Eros, Alex Waterman, Nick Hallett, Andrew Lampert, Matthew Ostrowski, Michael Evans, MV Carbon, Seth Kirby, Matthew Welch, Christine Bard, Andy Graydon, Ryan Sawyer, Matt Mottel, and Bradford Reed among many other artists, filmmakers, curators, musicians, and friends. Layton is the founder of Brooklyn's monthly experimental music series, "Darmstadt: Classics of the Avant Garde" co-curated with Nick Hallett, featuring leading local and international composers and improvisers, co-curator of the PS1 Contemporary Art Center Summer Warmup Music Series, and the Chief Curator of Issue Project Room in New York.

Megawatt Mind (2010)

Layton writes:

> Since 2005, I have been investigating brainwave activity and its relationship to the production of rhythmic, melodic, and harmonic musical material. John Cage's dictum to "imitate nature in her manner of operation" became an incredibly important source of inspiration. I began to understand brainwave activity, the rhythmic flashing of electricity produced by neurons to function as an organic indeterminacy machine for musical composition. Using a biowave EEG sensor (electroencephalograph) connected to a Bluetooth transmitter I am able to read brainwave data, digitize it, and send it wirelessly to a computer running Max/MSP software. In Copenhagen, I premiered a half-hour meditation performance, *Megawatt Mind*, at Monitorgalleri with twenty-four monitors and two audio transducers attached to the windows. Meditating while sitting in the window of the gallery, my brain produced and manipulated abstract geometrical designs on the television screens behind me and emitted chirping reverberant sounds all around me.

Marc Leclair (Akufen)

b. 1966 Montreal, Canada
Lives and works in Montreal

Marc Leclair, aka Akufen, is widely recognized in electronic music circles for his micro-sampling aesthetic. Akufen represents the phonetic spelling of the French word for tinnitus—a constant ringing in one's ears. Leclair defines his musical practice as one that is in constant flux and evolution. His work in this genre call upon a wide spectrum of influence, origin, and style. Leclair's projects in an art world context are authored under his given name and are poetic reflections on the human experience. *Musique pour 3 Femmes enceintes* (Music for 3 Pregnant Women) is a seventy-two-minute electronic composition driven conceptually by the simultaneous pregnancy of three close friends. The album is organized according to moments in time during a pregnancy ("64th Day," "205th Day," etc.). In 2005, Leclair together with video artist and collaborator Gabriel Coutu-Dumont, performed for the opening night of Ars Electronica. Their project, *5mm*, which premiered at this renowned festival of art, technology, and society in Linz, Austria, was an allegorical look at evolution and development from single cell to social structure.

My Way (2002)

My Way was produced as the debut album under Marc Leclair's pseudonym "Akufen." The release garnered critical acclaim as a pioneering album that influenced and informed numerous subgenres of the electronic music movement. In *My Way*, Akufen mines the radio broadcast spectrum for brief samples, which he harnesses as his palette for collage and composition. The artist manipulates and modulates his radio detritus with astonishing technical prowess. Brief blips of advertisements, pop songs, classical music, and talk radio hosts create a plunderphonic decoupage that evolves against a supporting foundation of a 4/4 beat. Akufen's transmissions were received in a sparsely populated part of northern Canada; and, like related other projects that use radio band content as source material, *My Way* resonates not only as a stand-alone sound work, but also as a sonic portrait of a geographical location vis-à-vis the artist's unconventional field recording process.

Involuntary Reception (2000)

Kristin Lucas

b. 1968 Davenport, Iowa
Lives and works in Beacon, New York
kristinlucas.com

Kristin Lucas addresses the effects of rapid-spread technology on the human condition with strategies of art and intervention. Reversing a popular concept of infusing humanity into machines, she applies familiar strategies of electronic media to her own life. In 2007, with the permission of a judge, Lucas legally "refreshed" herself under the same name as if she were a Website page. Transformations, mutations, and portraiture of a condition of contemporary times are the focus of works set against the backdrop of empty and meaningful exchanges with automated tellers, television, shopping malls, healing arts therapists, police officers, and the State of California court system. Lucas's work has been exhibited internationally. *More Melting* (2008), comprised of several "moving image" sculptures made of wax, wicks, and fire, was conceived for the exhibition *Off The Grid* at The Neuberger Museum of Art in Purchase, New York, co-organized by free103point9. Kristin Lucas teaches at Bard College, Annandale-on-Hudson, New York.

Kristin Lucas's two-channel video projection *Involuntary Reception* presents a double-imaged, double-edged report from a young woman contaminated with a massive EPF (electromagnetic pulse field). Lucas's character has a story to tell, though paradoxically the conventional tools that she would use to convey her story would be instantaneously canceled by her surging EPF. She is therefore forced to self-broadcast, and, fortunately, she is so in tune with the medium that she is able to do this without needing hardware. Quarantined from physical contact, yet still always at risk of contamination, the audience is made to understand that the protagonist's life is one of isolation. Lucas's character is both "out of control" and "outside of" the influence of dominant control systems. She is vulnerable, unruly, and powerful. Lucas's character explains:

> There're so many problems in office buildings that the kinds of problems that I'm creating are not as easily detectable. But you can only last so long in a place like that before people start pointing the finger. I don't jive with this new electronic stuff. Presents a lot of problems for me. Well, for instance, computers freezing ... short-circuits ... a lot of problems like that. A lot of times I just plain old erase the chip and the machine doesn't work anymore.

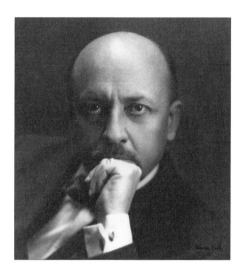

F. T. Marinetti
b. 1876 Alexandria, Egypt; d. 1944

Pino Masnata
b. 1901 Stradella, Italy; d. 1968

F. T. Marinetti was an Italian poet, editor, and founder of the Italian Futurist movement. He developed a passion for literature at an early age. While at school, Marinetti founded the literary magazine *Papyrus*, in which he first began to publish his essays. Although he completed his law studies in 1899, he devoted himself to literature and began experimenting in every aspect of the medium. In 1908, Marinetti wrote the "Futurist Manifesto." The Manifesto envisions a new way of art-making inspired by the speed of industrial technology, the noise and the rhythm of large cities, and the violence of machinery and war. Futurism proposed modernity, speed, and free-form experimentation in all aspects of artistic creation: literature, theatre, film, dance, music, radio, painting, sculpture, architecture, interior design, and gastronomy. Marinetti's love for militarism and war led to his creation of the Futurist Political Party in 1918. Soon after its formation, the group was absorbed by Mussolini's Fascist Party Italian League of Combat. By the late 1930s Fascist politics turned increasingly against radical experiments, a position Marinetti fought against.

Italian Futurist Pino Masnata was a playwright and poet. In 1931, he wrote the libretto for the radio opera *Tum Tum Ninna Nanna – Tum Tum Lullaby*. His co-authorship of *La Radia* places him in a significant position in a history of radio visionaries.

La Radia (1933)

Prefaced by what *The Radio Must Not Be* and what *The Radio Abolishes*, authors F. T. Marinetti and Pino Masnata outline twenty points in *The Radio Will Be*, some of which are:

A new art form that starts where theatre, cinema, and narration break off.

Immensity of space. Being no longer visible nor confined to a frame, the scene becomes universal and cosmic.

Reception, amplification, and transformation of vibrations released by living or dead beings, dramas of states of mind, full of sound effects but without words.

Reception, amplification, and transformation of vibrations emitted by matter. Just as today we listen to the song of the woods and of the sea, tomorrow we shall be seduced by vibrations from a diamond or a flower.

Utilization of the interference between stations and of the intensification and fading of sounds.

Elimination of the concept or importance of the audience, which has always, even for the book, had a distorting or harmful influence.

Marshall McLuhan

b. 1911 Edmonton, Alberta, Canada; d. 1980

Herbert Marshall McLuhan was a Canadian media and communications philosopher, scholar, and theorist. McLuhan's assertion that electronic media make possible the formation of a vast collective society, which he termed "global village," remains one of the most influential contributions to media communication scholarship. He also strongly advocated for an understanding of media based on interactive and multisensory characteristics, where participation on the part of the receiver, evoked by any particular medium, is a distinguishing feature. McLuhan's controversial intellect was an extension of his academic background. McLuhan taught and lectured in many universities in Canada and the U.S. In 1951, while lecturing at the University of Toronto on communication and culture, he published his first major work, *The Mechanical Bride*, about the implications of media advertising on society. At the University of Toronto, McLuhan met Harold Innis, whose theory on media and communication was of great importance to McLuhan's own work. Other major works by McLuhan include *The Gutenberg Galaxy, Understanding Media: The Extensions of Man, The Medium is the Massage: An Inventory of Effects, War and Peace in the Global Village, From Cliché to Archetype*. McLuhan continued to lecture on media and communication until his death in 1980.

Understanding Media: The Extensions of Man (1964)

McLuhan's *Understanding Media* is a pioneering work of media scholarship that has generated many controversial and influential ideas concerning the ways that media function. Most significantly, this work is the origin of McLuhan's infamous theory asserting that the medium is a self-contained message on its own; one that influences surrounding environments and societies. The notion that "the medium is the message" has been widely referenced in many facets of contemporary culture since its penning. When closely considered, the controversy around McLuhan's suggestions regarding media, including television and radio, comes as no surprise. McLuhan's theory argues that, for example, a broadcast's content is irrelevant and that rather the medium of broadcast and its impact on society is what resonates. He writes:

> … no medium has its meaning or existence alone, but only in constant interplay with our media. The new electric structuring and configuring of life more and more encounters the old lineal and fragmentary procedures and tools of analysis from the mechanical age. More and more we turn from the content of messages to study total effect.

Todd Merrell

b. 1967 Worcester, Massachusetts
Lives and works in Hartford, Connecticut
toddmerrell.com

Todd Merrell is a composer and artist whose work explores the relationships of art to medium and audience, and the spaces between musical elements—those places where harmony, melody, timbre, dynamic, and tempo overlap. Merrell spent his early years in sparsely populated areas of New England and New Mexico, finding deeply human connections and inspiration from radio transmissions and music synthesis. His recent work transforms electromagnetic radiation, recorded sonic detritus, and unintentional broadcasts into music, using the media of shortwave radio, granular synthesis, and processing. His recordings and live performances are a celebration of the primacy of radio as rich and ragged analog material, and of the ephemerality of sonic transformation itself. Merrell studied music composition and voice at Berklee College of Music, and with James Sellars of the Hartt School. Merrell has performed and contributed live and recorded work to festivals, exhibitions, and venues throughout the world.

Nagual (2004-2007)

Nagual is a recording of a 2004 performance at Real Art Ways in Hartford, Connecticut. Merrell is joined by his frequent shortwave collaborator Patrick Jordan, as well as Canadian artist Aidan Baker on guitar. Merrell's shortwave performance practice guides the trio's efforts, resulting in lengthy, textured tracks that employ signals excavated from the shortwave spectrum. Merrell contends:

> Part of the impetus for the making of *Nagual* was to include radio as just another instrument, to show how it could be a part of an ensemble that people can understand and relate to. The fun part with it, though, is that the ensemble was two shortwave radios augmented with processing, and one electric guitar, augmented with processing, so the two novelty instruments formed the core of the ensemble, while the more traditional instrument took the novelty role, which actually highlighted the guitar. The radios became the rhythm section, if you will.

Appropriately titled, *Nagual* is a unique coalescence of sound, which simultaneously evokes the natural and electronic, and perhaps suggests its own pathway toward a transcendent reality.

Airspace (2005)

Joe Milutis

b. 1968 Easton, Pennsylvania
Lives and works in Seattle
joemilutis.com

Joe Milutis is a media artist and writer whose interdisciplinary work includes experimental sound and radio, video works, new media, experimental narrative and poetics, theoretical writings, and various media and literature hybrids. Having produced and theorized radio art since 1990, sound experimentation and transmission work form the core of his interests. He has worked with radio in conjunction with live performance, including radiophonic chamber music (with low-power transmitters), and radio-drifts (which intersect transmission experiments with the creative urbanism of the Situationists). Since his short-lived radio art show on WMBR in Cambridge in the early 1990s, which merged interview material with audio art and dramatic forms, he has worked to expand radio documentary and the radio essay. Milutis is the author of *Ether: The Nothing That Connects Everything*. He also contributed to *Experimental Sound & Radio*. Other writing has appeared in *Leonardo Music Journal*, *Cabinet*, *Film Comment*, *Ctheory*, and *PAJ: A Journal of Performance and Art*. Milutis has taught both the theory and practice of radio and sound art at the University of Wisconsin-Milwaukee, University of South Carolina, and Brown University. He currently teaches Interdisciplinary Arts at the University of Washington-Bothell.

Milutis's *Airspace* is a radiophonic chamber performance piece which, in its initial incarnations, used commercially available FM transmitter devices to transmit a mix of live and recorded sounds to radios dispersed throughout a small audience. The sounds, including birdsong, air traffic control voices, computer sounds, feedback, lectures on Zen, processed bells, and live soft-synth input, were calculated to merge and blend with each other and various textures of radio interference once "on air." While no explicit instructions were given, some audience members creatively would tune or detune their individual radios, further blending not only the signal, but also the intentionality of the performer with the backdrop of radio noise. *Airspace* provides something somewhat more intimate, even primitive in comparison to the airspace as dominated by more contemporary wireless networks. As an idiosyncratic, rather than naturalized, network it highlights the idea of transmission art as a questioning of how signals flow and networks emerge rather than an instrumental or transparent use of them.

Antoni Muntadas

b. 1942 Barcelona, Spain
Lives and works in New York City

Antoni Muntadas is a multi-disciplinary media artist whose works address contemporary social, political, and communications issues. The relationship between public and private space within social frameworks is a key theme as he investigates channels of information and the ways they may be used to censor or promulgate ideas. His projects take the form of photography, video, publications, the Internet, installations, and urban interventions. Throughout his work, Muntadas recontextualizes available imagery in order to provoke the viewer into rethinking the meaning of the messages, creating a breach in the uniformly constructed "media flow," a stream of information engineered by advertisers to be consumed whole, unanalyzed by the home audience. Muntadas has taught and directed seminars at diverse institutions throughout Europe and the U.S., including the National School of Fine Arts in Paris, the Fine Arts Schools in Bordeaux and Grenoble, the University of California-San Diego, the San Francisco Art Institute, and The Cooper Union in New York City. He currently serves as professor of the practice in the visual arts program at MIT. His work has been exhibited widely throughout the world. A retrospective of his work was presented at Montreal's Cinémathèque Québécoise in 2004.

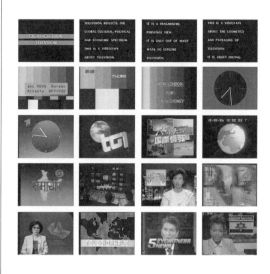

Cross-Cultural Television (1987)

Created by Antoni Muntadas in collaboration with Hank Bull, *Cross-Cultural Television* is a single-channel video work comprised of television broadcast recordings made by fifteen collaborators located around the world. The recordings are edited together by Bull and Muntadas, organized by motif and format. According to Muntadas:

> Television reflects the global cultural, political and economic spectrum. This is a videotape about Television. It is a fragmented, personal view. It is only one of many ways to explore television. This is a videotape about the cosmetics and packaging of television. It is about editing. It presents the work of an independent chain of editors: the cameraman, the correspondent, the satellite, the videotape editor, the broadcaster, the anchorman, the viewers who recorded this material, the editors of this videotape and you, the viewer.

Cross-Cultural Television highlights a global television language. It is one less informed by a specific point of origin than a product of media ecology, a central idea in Muntadas's creative practice-at-large.

Propagation Seems Good Here Tonight (2009)

Terry Nauheim

b. 1970 Washington, D.C.
Lives and works in New York City
terrynauheim.com

Terry Nauheim explores sound and visual relationships through digital media, drawing, and installation. She manipulates sound recordings as physical objects in order to seek new models of authorship. This process includes exploring the genealogy of personal and commercial claims on LPs, shortwave radio broadcast, and found audio recordings as both form (vinyl, grooves, and transmissions) and content (music and broadcast) with the intention of revealing relationships among concepts of memory, ownership, and materiality. Nauheim's work has been exhibited internationally in museums and festivals, and featured by Websites and publications, including Rhizome, art@ radio, *Link: Science/Technology/Innovation in the Arts*, and *Nomads Audiophile*. Nauheim received her master's in mixed media/digital arts in 2001 at the University of Maryland and a bachelor's in painting at Washington University in St. Louis in 1992. She teaches computer arts at New York Institute of Technology. Nauheim sits on the board of directors of NYC ACM SIGGRAPH and served as chair of the 2008 NYC Metropolitan Area College Computer Animation Festival (MetroCAF).

In Terry Nauheim's single-channel animation, *Propagation Seems Good Here Tonigh*t, animated drawings correspond to shortwave radio transmissions recorded in Chelsea, New York City between March 20 and 21, 2009. Imagery alternates between illumination and dimness as if to sift through an atmosphere of random noise in the universe. This unpredictable environment, with its degrees of murk and clarity, propagates waves that bend, stretch, open, close, pack together, and break apart. Nauheim's process of recording high-frequency radio involves sifting through sonic muddle in the atmosphere in search of something notable, be it a southern Baptist sermon, an a cappella doo-wop vocal, or an Ecuadorian news report about Barack Obama. This random sampling of recordings yields abstract material for sound compositions. *Propagation Seems Good Here Tonigh*t adopts the notion of QSLs (the Morse Code symbol "Q-S-L" signifying "I acknowledge receipt") through its reconfiguring of scavenged ephemera into physical form. Vector and hand drawings of transmitters, waves, and atmospheric residue respond algorithmically to the accompanying audio.

Negativland
Established 1980 Contra Costa County, California
Based in Contra Costa County
negativland.com

Since 1980, the collective Negativland has created records, CDs, video, fine art, books, radio, and live performance using appropriated sound, image, and text. Mixing original materials and original music with appropriations from corporate culture and the world around them, Negativland rearranges found bits and pieces to suggest ideas counter to the original author's intent. As a result of their "culture jamming" (a term they coined in 1984), Negativland has been sued twice for copyright infringement. In 1995, they released a 270-page book with a seventy-two-minute CD entitled *Fair Use: The Story of the Letter U and the Numeral 2*. This book documented their four-year-long legal battle over their 1991 release of an audio piece entitled *U2*. In 1995, Negativland was the subject of Craig Baldwin's feature documentary *Sonic Outlaws*. In 2004, Negativland worked with Creative Commons to write the Creative Commons Sampling License, an alternative to existing copyrights that is now in widespread use by many artists, writers, musicians, filmmakers, and Websites. While serving as a high-profile advocate for significant reform of the nation's copyright laws, Negativland exists as an artist collective first and activist effort second. Their artistic practices and media interventions pose both serious and silly questions about the nature of sound, media, control, ownership, propaganda, and perception in the U.S.

It's All In Your Head FM (2006)

A limited-edition double-CD release, *It's All In Your Head FM* includes live recordings of a stage show Negativland has been touring since 2005. Spun off from their weekly *Over The Edge* radio show, which has been on air since 1981 and currently broadcasts on KPFA in Berkeley, California, *It's All In Your Head FM* mixes music, found sounds, found dialogue, scripts, personalities, and sound effects within a radio theatre-of-the-mind performance setting. The two-hour-long CD project is an exploration and critique of monotheism. The persona Dr. Oslo Norway serves as the "radio" host, and Christianity, Islam, and Judaism are the featured religions. Negativland, forever enthusiastic provocateurs, asks their audience to contemplate some complex, serious, silly, and challenging ideas about human belief in this audio cut-up mix and documentary collage. *It's All In Your Head FM* is a compelling and uniquely entertaining approach to controversial theological concepts presented in the expert sound collage and sonic appropriation stylings for which Negativland is celebrated.

Mendi Obadike

b. 1973 Palo Alto, California

Keith Obadike

b. 1973 Nashville, Tennessee
Live and work in New York City
obadike.com

Mendi and Keith Obadike's work examines digital media's creative potential through performance, sound, visual art, and literature. The Obadikes's conceptual art practice explores issues of identity in the digital age. In a 2001 performance work, *Blackness for Sale*, they offered Keith's "blackness" on eBay with a list of benefits and warnings; the text from this work traveled widely online and has been reprinted in magazines in Ireland, South Africa, and Norway. They also created *The Interaction of Coloreds* (2002) for the Whitney Museum's Artport. Their work has been featured in a variety of texts, including *Sound Unbound: Writings on Contemporary Multimedia and Music Culture*, *Re:Skin*, *Racing Cyber Culture*, and *New Media Art*. *Four Electric Ghosts* (2009) was developed at Toni Morrison's Atelier at Princeton and commissioned by The Kitchen in New York City. Inspired by Amos Tutuola's 1954 novel *My Life in the Bush of Ghosts* and Tōru Iwatani's influential 1980s video game Pac-Man, *Four Electric Ghosts* follows the afterlives of four ghosts who separately encounter the same mortal in their journey through the Land of the Dead. Keith Obadike is an assistant professor in the College of Arts and Communication at William Paterson University in New Jersey. Mendi Obadike is an assistant professor in the Department of Humanities and Media Studies at Pratt Institute in New York City.

The Sour Thunder (2002)

In their Internet opera *The Sour Thunder*, the Obadikes merge poetry, rap, acoustic and electronic sounds, and video with live performance to create a multimedia event. The opera tells a double-sided story about language and migration, blending autobiography and speculative fiction. The work explores the role of geography in identity and the idea of language as a technology. One character, Sesom, travels from a land where scent is language to a land where language is spoken, while the character Mendi travels from Atlanta to Santiago. Mirroring this dual nature of the narrative, the opera was simultaneously performed and Webcast from two spaces (the Yale Cabaret and the Yale Afro-American Cultural Center) in 2002. In each performance space, audience members could watch a silent Webcast of the other. Characters moved between the two spaces throughout the performance, and the audiences of each venue switched spaces at intermission. The projected Webcasts of the alternate performance spaces represented the memory of the places the characters—and perhaps also the audiences—had left behind. From the Website, viewers could download MP3s from the opera, watch a live split-screen Webcast, or read an interactive libretto.

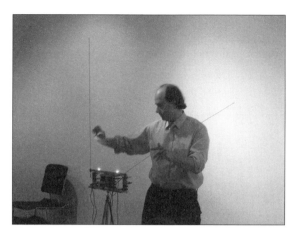 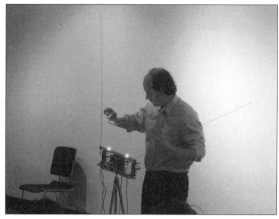

Anthony Ptak

b. 1970 Brooklyn, New York
Lives and works in New York City
axoxnxs.com

Anthony Jay Ptak is an altermodern artist and composer, influenced as a child by growing up near the Brookhaven National Laboratory and the RCA Radio Central testing facility. Ptak was first introduced to the theremin in 1987 by improviser Eric Ross. An inveterate autodidact, he studied with Tony Conrad, Paul Sharits, Lydia Kavina, and Herbert Brün and enjoyed technical consultations with Robert Moog. In 1995, Ptak began playing an etherwave theremin kit 0017, and ten years later, in 2005, he was among the founding members of the New York Theremin Society. Ptak performed at the first International Theremin Festival, and has been a guest theremin artist under director Scott Wyatt at the historic Experimental Music Studios at the University of Illinois at Urbana-Champaign since 2000, where he also has taught sound art and *musique concrète* for new media artists. Ptak's work has been presented widely, including the Society for Electroacoustic Music in the United States (SEAMUS), School of the Art Institute, Chicago Cultural Center, St. Louis Art Museum, Krannert Art Museum, FFMUP Princeton University, Institute for Advanced Study in Princeton, Roulette Intermedium, and both the Kitchen and Issue Project Room in New York City.

The End of Music (2006)

Anthony Ptak's sixteen-channel polyphonic theremin performance *The End of Music* was performed on the occasion of Points in a Circle: Site-Specific Works for the Hemispheres at Issue Project Room in July 2006, curated by Suzanne Fiol and Stephan Moore. Ptak states:

> I recognize the end of music. As an artist I establish a relation without enforcing a relation. An audience, that is to say, a public, ought never be captive. A space can be transformed by the unfamiliar in an arena of recognition. The work is the connection made by the receiver of information, the transmission is the catalyst for this exchange. My expectations are to modulate the signal of infrastructure, to utilize simple means to produce complex results. The theremin is electromagnetism, ether made present in the modulation of transformative wave energy that inducts and traces an exponential axis of gestural interference. The frequency of oscillation along a unified temporal axis reflects a recursive bridging of distance in a soundscape of interference. We listen to the world as a system of associative indices. Sound is a physical axis that occupies and transforms space. The heterophony of the theremin antenna is navigation.

Radio Cegeste

b. 1974 Hobart, Tasmania
Lives and works in Christchurch, New Zealand
radiocegeste.blogspot.com

Radio Cegeste is a transmission art project created by writer, broadcaster, and curator Sally Ann McIntyre. Within its open framework, a series of experiments in radiophonic locality operate as the irregular programming of a nomadic micro-radio station. Radio Cegeste's programs are created as site-responsive events for particular situations and spaces, via the broadcast source of a low-powered Tetsuo Kogawa designed mini-FM transmitter in conjunction with an array of radio receivers. Functioning within an expanded concept of radio as an artistic medium and performance art, Radio Cegeste draws on phonographic, documentary, and broadcast-journalistic concepts and traditions while looking toward the "expanded instrument" potential of radiophonic materiality. Radio Cegeste events have been situated within both media art and experimental music contexts, with performances and presentations at gallery and project spaces, venues, symposia, and various experimental music festivals and events throughout New Zealand. Ongoing Radio Cegeste programs to date include the field recording project *Species of Spaces*, in which sets of recordings of particular spaces are gathered and recatalyzed as event scores via live radiophonic performance; and *Bowed Airwaves*, an investigation into the transmitter as instrument, created with violin in a solo performance or in conjunction with collaborators.

Radio d'Oiseaux (2009–ongoing)

Conceived as a "channel," or ongoing series of programs, *Radio d'Oiseaux* is a project that focuses on the tension between the museological function of recording technologies and the generative potential of radio as a live-art medium. *Radio d'Oiseaux* iterations have included site-specific recordings of taxidermied extinct birds in New Zealand natural history museums pressed onto lathe-cut acetate discs, live performances involving the retransmission of commercially released archival recordings of birds from state broadcaster Radio New Zealand National combined with various bird-related sonic ephemera (such as museum gift-store musical greeting cards), and musical and human-vocalized bird imitations. It has used a solar-powered mini FM transmitter installed in a national park in order to investigate the territorializing impetus of transmission, as well as the national park as a form of living museum that mirrors broadcast radio-space. The project's critical focus on extinction, the archive, and urbanized nostalgia for nature is framed through a consideration of the (im)possibility of pre-human New Zealand radio, via the creation of a sustainably powered radio station solely for native birds that functions without human listeners.

Raindance

Established 1969 New York, New York
Discontinued 1993

Raindance was an experimental video collective founded by Frank Gillette in 1969. Inspired by the critical communication theories of Marshall McLuhan and Buckminster Fuller, Raindance promoted video as an alternative form of communication capable of initiating social change. The name Raindance was itself a direct reference to the Rand Corporation that advised government and large industries. By selecting the ironic name, Gillette asserted the collective as a countercultural version of the corporation. In numerous videos and the highly influential video journal *Radical Software* (1970–1974), Raindance examined cybernetics, media, and ecology—three themes that were burgeoning in critical cultural discourse—and facilitated the dissemination of information about the various experiments artists and communications scholars were beginning to conduct with video. Raindance's video advocacy became a fixture in New York City and at various universities via their street recording, video production workshops, installation work, and savvy use of larger media outlets. The collective grew and included artists and scholars Paul Ryan, Ira Schneider, Michael Shamberg, Louis Jaffe, Marco Vassi, Beryl Korot, and Phyllis Gershuny as members. Though the original Raindance collective disbanded in the mid-1970s, the nonprofit Raindance Foundation continued into the 1990s.

Raindance: Media Primers (1970–1971)

Raindance: Media Primers is a series of three videos addressing the themes and theories that informed the collective's radical, iconoclastic philosophies. Meditating on alternative and mass forms of media, and contemporaneous popular and countercultural developments, the videos reflect the era of technological and conceptual experimentation that marked the work of the numerous video collectives then. Paul Ryan's *Proto Media Primer* presents outtakes from Raindance's vast archive or cultural databank of candid interviews with ordinary people, demonstrations, and concerts. Ira Schneider's *Media Primer (Schneider)* posited footage of the infamous Altamont rock concert against television commercials and news footage taken from network broadcast TV. Similarly, Michael Shamberg's *Media Primer (Shamberg)* constructs a cultural montage that deconstructs the rhetoric and gestures utilized by mass media. Recorded onto half-inch video using Portapak portable recording equipment, *Raindance: Media Primers* juxtaposes mass-media imagery taken from television with Raindance's own documentation of countercultural events to create a critical examination of media practices that would ultimately inform the political structures of emerging alternative media endeavors.

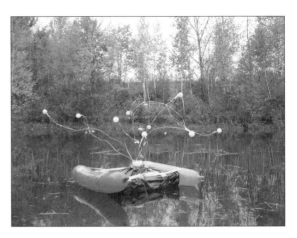

Trailhead (2007)

John Roach

b. 1969 San Francisco, California
Lives and works in Brooklyn, New York
johnroach.net

James Rouvelle

b. 1968 New York, New York
Lives and works in Baltimore, Maryland
rouvelle.com

John Roach and James Rouvelle have been creating collaborative projects since they met at an open studio in 1997. At the time, Roach was a visual artist who wished he was composing music and Rouvelle was a composer who wished to make kinetic sound art. Their first project, *Theoretically Yours* (1999), involved odd sculptural objects outfitted with internal radio transmitters. Made available as a takeaway to audiences attending the exhibition, those who participated transmitted their journey back to the project's point of origin. The project *The South Brooklyn Casket Company* (2000), reconfigured the audio from the rest of the works in the show, and featured a custom-constructed mixing console that enabled visitors to create and archive their own mixes. Rather than simply integrate each other's expertise into their work, Roach and Rouvelle inspire each other to hybridize their respective skills through an ongoing series of collaborations. John Roach teaches at Parsons/The New School for Design in New York City. James Rouvelle teaches interactive media at the Maryland Institute College of Art in Baltimore, as well as at the Milton Avery School of the Arts summer program at Bard College, Annandale-on-Hudson, New York.

In *Trailhead*, developed for their residency at free103point9's Wave Farm (Acra, New York), Roach and Rouvelle planted markers and painted words throughout the wooded acres of the Wave Farm grounds, making crude maps of each designated location. Poet Matthew Rohrer entered the project as performer and collaborator, and was documented as he set out to find the clues and assemble them into a poem. The audio recordings of his journey, which include a mid-forest improvisation with Roach and Rouvelle using spontaneously constructed instruments, were broadcast at night through a sculptural device that floated and flickered on one of the Wave Farm ponds. The floating device responded to the changing frequencies and amplitudes of the sound it received with flickering patterns of light. Participants played handmade instruments and tossed pulsating, illuminated orbs into the pond. In *Urban Trailhead*, a city-based iteration as its title suggests, Roach and Rouvelle led a procession up Sixth Avenue on a cold December night from the theatre district in Manhattan to the pond in Central Park. Once at their destination the participants launched a series of internally lit objects, including a large sound-responsive floating pod, which increased and decreased luminosity based on the group's fluctuating volume.

Tom Roe

b. 1967 Baltimore, Maryland
Lives and works in Acra, New York
free103point9.org/artists/2/

Tom Roe identifies himself as a sound transmission artist sometimes known as DJ Dizzy. He performs with transmitters and receivers using multiple bands (FM, CB, walkie-talkie), as well as prepared CDs, vinyl records, and various electronics. Roe creates radio soundscapes using locally available frequencies, often to the beat of manipulated pop-song samples. He co-founded microradio station 87X in Tampa, Florida; and, with Greg Anderson and Violet Hopkins, founded free103point9 as a microradio collective in Brooklyn, New York, in 1997. Roe has exhibited widely both in the U.S. and internationally. His annual performance, *War of the War of the Worlds*, is both homage to the infamous broadcast, *War of the Worlds* (1938), and a vehicle in which to foreground current international wars and conflicts. In addition to his solo efforts, he has worked frequently in collaboration with others. Roe has a background as a journalist and has written about music for *The Wire*, *Signal to Noise*, and *The New York Post*. He has also led many of free103point9's "Radio Lab" education lectures and workshops, speaking on how to perform with transmitters and the history of radio performance and microcasting, at numerous educational and cultural institutions. Roe's deep commitment to the medium of radio is evident in WGXC: Hands-on Radio (90.7-FM), free103point9's full-power non-commercial FM station in upstate New York, for which he serves as program director.

The Worst Hour of the Year (2010)

The Worst Hour of the Year is a sound work comprised of eleven discrete compositions and live performances that serve cumulatively as an introduction to the transmission art genre. The title, a transmission term itself, refers to the hour of the year during which the median noise over any radio path is at a maximum. It is at this moment that the greatest transmission loss occurs. Roe's project illustrates the breadth of sonic transmission art practices through the use of radio as source material, samples of voices speaking about radio and transmission art, and the juxtaposition of sounds traditionally heard on radio with noises that rarely appear in that medium. One of the compositions, *Tropospheric Wave*, is a series of vocal samples woven together. Included are microradio innovators such as Stephen Dunifer, Joe Ptak, Tetsuo Kugowa, and Mbanna Kantako, as well as a snippet of a conversation between H. G. Wells and Orson Welles about *The War of the Worlds* broadcast. *The Worst Hour of the Year* was developed over several years during Roe's weekly live online radio show, *Dizziness*, and in live performance, often in collaboration with artists who include Andrew Barker and Charles Waters, members of the free jazz Gold Sparkle Band, and visual artist Matt Bua.

Walter Ruttmann

b. 1887 Frankfurt, Germany; d. 1941

Walter Ruttmann was a German experimental film director who pioneered animation techniques. Like his contemporaries Hans Richter and Viking Eggeling, Ruttmann made significant contributions to the German avant-garde of the 1920s and 1930s. Initially trained as a painter and architect, Ruttmann gradually moved away from the static canvas of painting and started experimenting with the moving image through film in 1920. Exceptional examples of his early film work include *Lichtspiel Opus I* (1921) and *Opus II* (1923). These short works established a new form of film expression that influenced many future German directors. Both *Lichtspiel Opus I* and *II* featured moving patterns of light that were sequenced according to a specific score. Ruttmann's most acclaimed film was his *Symphony of a Great City* (1927). This semi-documentary portrayed Berlin, through a series of cinematic events rather than a traditional narrative. Ruttmann continued his observations in Berlin in 1930, though this time focusing on the aural, when he was commissioned by Hans Flesch, director of the *Berlin Radio Hour*, to compose *Wochenende* (Weekend) for broadcast.

Wochenende (1930)

Walter Ruttmann's *Wochenende* (Weekend) is an avant-garde sound collage composed of spoken words, musical fragments, and field recording captured in Berlin. The eleven-minute piece presents an imagined sonic portrait of a weekend in the city. Ruttmann traveled throughout Berlin, collecting recordings onto film. Though *Wochenende* emphasizes that the musical, rhythmic principles are present in the sounds themselves, the piece is guided by temporal limitations, beginning with the end of work on Saturday and ending with a sonic indication of the beginning of the next work week on Monday morning. A precursor to musique concrète, which did not come about as an established practice until the 1940s, the tones and sounds that comprise *Wochenende* are intended to exist as a study in sound-montage. As such, the sounds were assembled with an ear toward their abstract, musical qualities while still maintaining the documentary traces of the multitude of micro-events they capture. *Wochenende* ignites a series of imagined visual occurrences, while exhibiting an attention to musical development—pitch, rhythms, and tone coloration—as it alternates between these narrative elements and their more abstract sonic patterns.

Scanner

b. 1964 London, England
Lives and works in London
scannerdot.com

Scanner 1 (1992) *Scanner 2* (1993)

Performing as Scanner, artist Robin Rimbaud traverses the experimental terrain between sound, space, image, and form, creating absorbing, multi-layered sound pieces that twist technology in unconventional ways. From his early controversial work using found mobile phone conversations, through to his focus on trawling the hidden noise of the modern metropolis, his restless explorations of the experimental terrain have won him international praise. Since 1991, he has been intensely active in sound art, producing concerts, compositions, installations, and recordings. The albums *Mass Observation* (1994), *Delivery* (1997), and The *Garden is Full of Metal* (1998) have been hailed by critics as innovative and inspirational works of contemporary electronic music. In 2004, his Sound Surface work was the first-ever Tate Modern sound art commission. His collaboration with filmmaker Steve McQueen, *Gravesend,* was premiered at the 52nd Venice Biennial in 2007. In 2008, he scored the musical comedy *Kirikou & Karaba* in Paris, and premiered his six-hour show *Of Air and Eye* at the Royal Opera House in London. He has performed and created works in many of the world's most prestigious spaces. His work has been presented throughout the U.S., South America, Asia, Australia, and Europe. Scanner is currently visiting professor at Le Fresnoy National Center for Contemporary Arts in France and University College Falmouth, UK.

Scanner 1 and *Scanner 2,* the first Scanner recordings, reflect a now obsolete telecommunications moment of the early 1990s, when faxes were a key means of communication and widespread use of the Internet was still a distant promise. Inspired by the radio scanner device, Scanner utilized the relatively simple but long-range radio receiver, which allowed him to listen to police emergency services dispatches, pilots, taxi drivers, and cellular phone conversations of unsuspecting talkers. In these works, Scanner edited recorded conversations gathered from the radio scanner device into minimalist musical settings as if they were instruments, bringing into focus issues of privacy and the dichotomy between the public and private spectrum. At times, the high frequency of cellular noise pervades the atmosphere; elsewhere, it erupts into words and meltdown to radio hiss. Intercepted in the data stream, these transmissions mix, blurring the voices and rupturing the meaning. Scanner's methodologies are a means of mapping the city; the radio scanner provides an anonymous window into an alternative reality constructed of information snippets cut and pasted together, capturing and highlighting the threads of desire and interior narratives woven into everyday life.

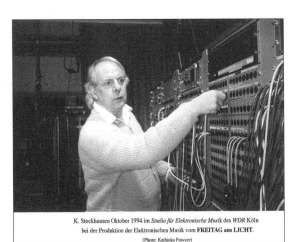

K. Stockhausen Oktober 1994 im *Studio für Elektronische Musik* des *WDR* Köln bei der Produktion der Elektronischen Musik vom **FREITAG aus LICHT**.
(Photo: Kathinka Pasveer)

Karlheinz Stockhausen

b. 1928 Mödrath, Germany; d. 2007

Karlheinz Stockhausen was a pioneering and visionary German composer and theoretician regarded by many as the father of electronic music. His work did not fall in the compositional categorization of his contemporaries because it suggested groundbreaking ideas about graphic forms of musical notation and it introduced aleatory parameters and new forms (variable, polyvalent, open) in the compositional process. Some of these were the spatialization of sound, the qualities and skills of the performer, the dynamics of material used, and the characteristics of space. Stockhausen's most renowned compositions include *Gesang der Jünglinge* (an example of spatialized *musique concrète* electronique); *Kontakte* (a composition that explores the points of contact between different groups of instrumental and electronic sounds whose variables are ruled by the same parameter); *Zyklus* (a piece for solo percussion with an open form graphic score); and *Mikrophonie I* (an example of polyvalent quadraphonic composition that consists of three different sets of performers who explore the inaudible details of the surface of a large tam-tam using a set of material preparations on the surface, microphones to amplify the particularities of the soundsurface, and bandpass filters to appoint certain frequency attributes of the resulting sounds).

Telemusik (1966)

Composed in Tokyo in the electronic studio of Japanese Radio NHK, Stockhausen used shortwave radio transmissions to compose *Telemusik*. He wrote that he wished "to take a step further in the direction of composing not 'my' music but a music of the whole Earth, of all countries and races." While *Telemusik* incorporates sounds from many countries including Japan, Sahara, Bali, Vietnam, China, the Amazons, Spain, and Hungary, Stockhausen does not consider this work to be a collage:

> Rather—through the process of inter-modulation between old "found" objects and new sound events which I made using modern electronic means—a higher unity is reached: a universality of past, present and future, of distant places and spaces: TELE-MUSIK.

Telemusik consists of thirty-two structures (movements) incorporating shortwave radio transmissions. Additional equipment used for the realization of the electronic music were frequency oscillators, sine-wave generators, a transposing tape recorder with a pilot frequency generator, among other devices.

MOONBLACK *(Homage to Leonardo)* (1977)

MOONBLACK takes place in a large empty space; a performer lies on the floor. She is wearing a U.S. Army-issued parachute jumpsuit. Her arms are outstretched and a small video camera is strapped to each wrist. The cables from the cameras feed into three TV monitors. A surveillance camera suspended from the ceiling above the performer projects the performer's image through a video projector onto a large suspended screen. The audience sits on the floor around the performer. Sixteen-millimeter projections display television imagery of the 1960s including riots, the flight to the moon, civil rights demonstrations, and anti-Vietnam War rallies. The soundscape is comprised of audio from these events as well as live music. Aldo Tambellini emerges to draw a wide circle around the performer in chalk. The image of Leonardo's *Vitruvian Man* becomes apparent in the projection on the overhead screen. Slowly, the performer begins to move, ultimately circling the audience. Cameras strapped to her wrists capture and send images of the audience to the monitors. Following a crescendo of simultaneous surveillance of the audience, and surveillance of the surveillant, the lights go dark and the performance abruptly stops.

Aldo Tambellini

b. 1930 Syracuse, New York
Lives and works in Cambridge, Massachusetts
aldotambellini.com

Aldo Tambellini is a painter, sculptor, photographer, media artist, filmmaker, and poet. Though born in the U.S., he spent most of his childhood in Italy, his mother's homeland. Tambellini returned to the U.S. in 1946, and following his studies at Syracuse University, he relocated to New York City. In the 1960s, Tambellini co-founded The Gate Theatre on the Lower East Side, showing avant-garde and independent films daily. With Otto Piene, he co-founded The Black Gate, a pioneering space in New York for live multimedia (electromedia) performances and installations. He was a primary member of the video art movement in New York City in the 1960s, and participated in many of the canonical exhibitions of that era. His film *Black TV* won the Grand Prix at the International Oberhausen Film Festival in Germany in 1969 and is in the collection of the Museum of Modern Art. His *Black Film Series* is in the Harvard Film Archives. From 1976 to 1984, Aldo was a fellow at the Center for Advanced Visual Studies at MIT. There he conducted workshops and organized with "communicationsphere" a series of international interactive media communications projects. In 2007, Tambellini received the Syracuse University Lifetime Achievement Award for his work in film and video, and the key to the city of Cambridge, Massachusetts for his contribution to the cultural environment.

TVTV (Top Value Television)

Established 1972 San Francisco, California
Discontinued 1979

TVTV (also known as Top Value Television) was a San Francisco-based experimental video collective organized around alternative coverage of the 1972 Presidential nominating conventions. The group made radically subversive journalistic work. Their philosophical underpinning was espoused in founding member Michael Shamberg's 1971 book *Guerrilla Television,* in which he advocated a decentralized television system. Mocking the conventions of television reportage, TVTV incorporated subjective accounts, behind the scenes-style footage, candid interviews, and deadpan humor in order to explore the potential for other modes of political media representation. Principally, TVTV sought to promote access to media creation and dissemination via public-access stations and video networks as a means of articulating protests in the tumultuous political climate of the time. TVTV participants included members from several of the era's liveliest video collectives, including Videofreex, Ant Farm, and Raindance. The coverage of the 1972 political conventions resulted in *Four More Years* (Republican) and *The World's Largest TV Studio* (Democratic), both of which were critically acclaimed and groundbreaking demonstrations of what the then available portable video equipment could make possible. TVTV dissolved in 1979.

The World's Largest TV Studio (1972)

Roughly twenty-five members of the San Francisco-based TVTV collective traveled to Miami in July 1972 to cover the Democratic national convention. More than sixty hours of original tape captured by the ad hoc crew formed the basis of a sixty-minute documentary, *The World's Largest TV Studio.* Using the exceptionally portable and affordable lightweight half-inch Portapak video cameras, TVTV developed their freeform, New Journalism-inspired approach while recording the ongoing dramas and mundanities of the convention floor. With greater mobility and spontaneity than the major networks could accomplish, the TVTV crew moved freely throughout the politicians, delegates, voters, protestors, and janitors present at the site. The candid interviews they conducted were presented without commentary used to create a satirical vérité account of the behind-the-scenes goings-on and political maneuvering of the convention. The conventions provided an ideal platform for TVTV to promote their politico-aesthetic agenda. With open contempt, *The World's Largest TV Studio* (and *Four More Years,* produced at the 1972 Republican convention) presents a scathing portrayal of the American political climate and the mainstream broadcast television journalism conventions used to report it.

The Police Car Quartet (2009)

Lázaro Valiente

b. 1984 Mexico City, Mexico
Lives and works in Mexico City
lazarovaliente.org

Lázaro Valiente is the pseudonym under which experimental musician and sound artist Mauricio Pastrana records and performs. Valiente's music is comprised of sounds and silence originating in the daily improvisations of life. It has a rhythmic background and the memory of melody, but all of this is superseded by an exploration into the possibilities of sound production and its distortion and physical arrangement. The music ranges from experimental folk to music made by police cars as instruments, in which a gentle voice guided by live radio signals and a blow dryer, next to dozens of percussion toys, create a simple sing-along song.

Lázaro Valiente's small-scale symphony of sirens, *Police Car Quartet,* was the first of a series of musical happenings dealing with the control of traffic in public space. In keeping with Valiente's commitment to creating sound compositions using uncommon elements and instruments offered by a given space, *Police Car Quartet* utilized four Mexico City police vehicles' sirens, PA systems, and horns to create melodic pop music. By reconceiving of the authoritarian police patrol cars as the affable instruments of a musical quartet, *Police Car Quartet* (non unlike Max Neuhaus's *Sirens,* 1978) envisions a meaningful new way of making music. Guest musicians Willy Damage, Adan Gutiérrez, Ivan Abreu, along with Valiente each occupied one of the patrol cars provided for the concert. Lasting one hour, *Police Car Quartet* presented a surreal musical performance within the heart of Mexico City. The performance was created for *Arte en Vía,* organized by Intersticio Arte Contemporáneo and developed in collaboration with the Mexico City police department. A crowd of 1,000 gathered for the public event, which occurred late at night on May 30, 2009 outside Mexico City's premier opera house, the Palacio de Bellas Artes, and was broadcast on a Mexican national television station.

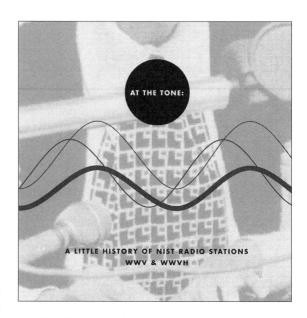

Myke Dodge Weiskopf

b. 1976 Rockford, Illinois
Lives and works in Los Angeles
myke.me

Myke Dodge Weiskopf is a radio producer, historian, and scholar who spent his adolescence listening to the faraway strains of Radio Bulgaria, Radio Cairo, and others via shortwave. He began making his own field recordings via radio in 1990, and traveled to England, Australia, Greece, and elsewhere to record. In 1992, he began publishing and lecturing on shortwave radio. Two years after moving to Boston in 1995, Weiskopf formed the electronic art-pop group Science Park. The group released three CDs on his own Obscure-Disk imprint. While continuing his radio work, he contributed to Akin O. Fernandez's *Conet Project* (1997) anthology of shortwave spy "numbers stations" and began work on *At The Tone*. In 2001, Weiskopf abandoned pop music and focused his artistic practice on sound art composition and experimental radio broadcasting, including commissions and productions for ABC Radio National Australia, American Repertory Theatre, Cambridge Community TV, and Harvard University Radio WHRB. In 1995, he founded the blog, *ShortWaveMusic,* dedicated to the preservation of music and musical noise as received via shortwave radio. He published a commemorative CD anthology of his music and sound art, *30: A Retrospective 1976–2006* (2007) in observance of his thirtieth birthday. Weiskopf continues to travel the world producing new installments of *ShortWaveMusic.*

At The Tone (2005)

At The Tone is the first volume in a series of historical sound portraits of shortwave radio broadcasters. Time-signal stations were among the earliest radio broadcasters and remain in use in many countries (though ever fewer, as satellite-based alternatives proliferate). Weiskopf devoted the bulk of his studies to these stations, which he found hopelessly alluring in their mechanized, ultra-utilitarian wonder. Focused on the American stations WWV and WWVH, the first edition of *At The Tone* was produced on cassette in 1992, under the auspices of the ITDXA, a short-lived organization for shortwave radio enthusiasts founded by Weiskopf in his teenage years. An updated version released in 2005 collects fifty years' worth of archival broadcast recordings (1955–2005) on a seventy-four-minute CD. Accompanied by a thirty-two-page illustrated booklet, the collection represents a huge cross-section of the stations throughout five decades, including: recordings of obsolete formats, original voices and identifications, special announcements, format changes, "leap seconds," and other aural oddities. *At The Tone* is alternately strange and mundane, monotonous and compelling, erudite and obscure.

Installation

Maryanne Amacher

b. 1938 Kane, Pennsylvania; d. 2009
maryanneamacher.org

Maryanne Amacher was a composer, musician, and multimedia artist whose site-specific installations emphasized the psychological experience of listening and the materiality of sound. She was educated in music, acoustics, and computers, first as a student of George Rochberg and Karlheinz Stockhausen at the University of Pennsylvania and later while pursuing a master's degree in computer science at the University of Illinois at Urbana-Champaign. These research interests converged in the creation of sound installations that attempted to develop what she referred to as a "structure-borne sound" that directly interacted with the architectural dimensions of performance spaces. By placing speakers in unconventional places, often submerged inside walls or otherwise hidden from sight, Amacher's intensely loud compositions heightened the awareness of the perceptual experience of listening. Several of her projects specifically dealt with stimulating otoacoustic emissions, the phenomenon in which sound is generated from within the inner ear. Throughout her career, Amacher received several major commissions in the U.S. and Europe and presented her work internationally. Amacher taught electronic music composition at Bard College in upstate New York, and was working on a forty-channel piece commissioned by EMPAC in Troy, New York at the time of her death.

City Links (1967–1990s)

Maryanne Amacher developed *City Links* while she was a fellow at the Center for Advanced Visual Studies, MIT (1972–1976). While in Boston, *City Links* manifested as transmitted soundscapes from Boston Harbor. The first of twenty-two iterations to be produced over three decades, these early transmissions were installed in Amacher's studio at MIT from 1973 to 1978. With *City Links*, Amacher pursued her interest in sonic telepresence using telecommunications technologies to simultaneously transport multiple live soundscapes from remote locations into a listening space. *City Links* employed telephone links to transmit sound in real time. Amacher would carefully position her microphones to capture the sonic panorama of an origination environment, transforming her exhibition spaces solely through the power of sound. As her *City Links* project evolved, Amacher wove more and more disparate soundscapes together, crafting an unlikely and mystifying assemblage of live sounds including feeds from natural spaces, abandoned architecture, and active factories. Amacher proposed that the remote sounds in *City Links* became part of the room they were projected in, creating "synchronicity" between the listener's real listening cues and the disembodied ones.

Khirkeeyaan (2006)

Khirkeeyaan is an open-circuit TV system intended as a local area network communication, micromedia generation, and feedback device. It employs security apparatuses that are otherwise intended for surveillance and "classified" uses. Four stations of equipment, including a television set, inexpensive surveillance equipment, radio frequency (RF) modulator, microphone, audio mixer, and coax cable are installed to form a quadrant system for public collaboration. Sound and image feeds from each station are fed back to a corresponding TV, allowing the subject/viewer/performer/audience to interact with others in the frame. The video playback becomes the host site for these interactions and conversations. Filmmaking acts as an automatic function made possible through eye-level communication, real-time feedback—all without director, camera operator, or editor. Anand recorded segments from seven independent installations of *Khirkeeyaan* in New Delhi during her associate residency at Khoj studios in April 2006 in an effort to expose her process of documentary filmmaking, and to encourage a merging of the creation, reception, and consumption of media.

Shaina Anand

b. 1975 Mumbai, India
Lives and works in Mumbai
chitrakarkhana.net

Shaina Anand has been active as an independent filmmaker and media artist since 1981. Her works are informed by an interest in media and information politics and by a critique of documentary form and process. Anand formed the Mumbai-based ChitraKarKhana for independent experimental media in 2001. ChitraKarKhana's interventions and projects, which include *Rustle TV* (2004), *WI City TV* (2005), *Khirkeeyaan* (2006), *CCTV Social* (2008), and *Wharfage* (2009), embrace experimental pedagogy and employ technologies such as TV, radio, cable networks, and inexpensive surveillance equipment for the creation of temporary communication zones and micromedia landscapes. Anand has exhibited and published widely. In 2007, she co-initiated PAD.MA, the Public Access Digital Media Archive, an online archive of densely text-annotated video material, made available online and for download in non-commercial use. She is a co-founder of CAMP, an organization in Mumbai cultivating radical artistic practice with a variety of media. CAMP seeks to create structures of support, rhythms of production and distribution, and to provide a collaborative atmosphere in which artists can work collectively on the challenges facing art and cultural practices in the region.

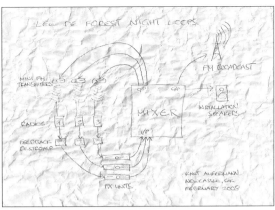

Knut Aufermann

b. 1972 Hagen, Germany
Lives and works in Ürzig, Germany
knut.klingt.org

Knut Aufermann is a radio and installation artist, musician, curator, and organizer. Together with Sarah Washington, he runs the project *Mobile Radio,* investigating alternative means of radio production. Their works have been broadcast in a dozen countries on more than thirty different radio stations. Aufermann is an active member of the international Radia network of independent cultural radio stations and curates the network productions contributed by Resonance104.4fm. Recently, he produced a series of on-air sound installations in Zurich, Newcastle, and Berlin, which provide interstitial material for live radio broadcasts. In addition to his radio-based work, Aufermann performs improvised electronic music. He has performed frequently across Europe as a solo artist and with Sarah Washington as Tonic Train, along with other collaborators. In 2004, he curated and played in the UK tour *Feedback: Order from Noise,* featuring a.o., Alvin Lucier, and Otomo Yoshihide. His musical instrumentation consists of equipment that produces volatile audio and radio feedback. Aufermann received a master's degree in sonic arts from Middlesex University in 2002, writing on the use of feedback in music. From 2002 to 2005 he was the station manager of Resonance104.4fm.

Lee de Forest night loops (2008)

The on-air installation *Lee de Forest night loops* was created to fill late-night broadcast time. This continuously shifting soundscape is produced live by feedback loops between micro-FM transmitters, radio receivers, and assorted audio equipment, creating an unstable and consistently changing output. Loops here do not denote a consistent recurring of sounds, but the unpredictable oscillations of a hardware-based system with its output plugged back to its input. In this instance radio listeners hear among other things the sound of radio transmitters listening to their own transmissions. The long timescale of tonal developments suits the dreamy state of nighttime, when traditional notions of radio are considered to be more elastic. The name of the installation references early radio pioneer and inventor of the Audion tube, Lee de Forest, who happily admitted that he didn't understand the inner workings of his invention. *Lee de Forest night loops* was broadcast for nine consecutive nights in March 2008 on radio stations as part of the AV Festival in Newcastle, UK; Resonance104.4fm at mima in Middlesbrough; and Soundscape FM in Sunderland.

Brett Ian Balogh

b. 1972 Pittsburgh, Pennsylvania
Lives and works in Chicago
brettbalogh.com

Brett Ian Balogh is an artist working at the intersection of objects, sounds, and spaces. His current practice employs audio, radio, and digital fabrication technologies to reimagine traditional notions of space and one's position within it. Central to his practice is the idea of model making as a layer of abstraction between humans and the world. The use of digital technologies in concert with traditional modes of representation and construction can afford unique crossovers between the real and intangible that represent models of other possible worlds. His current work engages with the idea of broadcast sound and radio media as territory. Balogh received his master's in studio from the Department of Art and Technology Studies at the School of the Art Institute of Chicago and his bachelor's in biology from the University of Pennsylvania. He is currently an instructor at the School of the Art Institute of Chicago and the Illinois Institute of Technology, teaching courses in architecture, computer-aided design and manufacturing, do-it-yourself broadcasting, and acoustics. He is a founding member of the experimental sound performance collective Clairaudient and performs with the Chicago Phonographers. Balogh was a 2009–2010 free103point9 AIRtime fellow, and is an active member of the World Listening Project and the Midwest Society for Acoustic Ecology.

Noospherium (2009)

Noospherium aims to render the sphere of human thought as an immersive sonic environment, providing a pansonic/panoptic view of simultaneous broadcasts. Since the inception of radio as a broadcast medium, the earth has been covered by an increasingly dense network of airborne communications. AM, FM, shortwave and other portions of the radio spectrum represent a medium through which a reimaging of space is possible. This hertzian space is not defined by surveyed boundaries or geographic constraints, but rather by field strengths, mass-media service areas, and consumer markets. The overlapping spaces defined by these broadcasts can be collectively referred to as an envelope of thought around the world, or Noosphere. Balogh's *Noospherium* functions as a spectrum observatory to this sphere, where sonic and visual composition unites multiple signals in conversation within the installation space. Balogh characterizes this convergence as the nature of our collective thoughts articulated through chance occurrences, spurious juxtapositions, and the dynamic spatialization of sound. The installation's multi-channel sound component is informed by received signals sampled from the transmission spectrum. A video projection consists of computer-animated representations of the broadcast area, and is used to map a portrait of the transmission spectrum through hypnotic and generative imagery.

CAST (2010)

CAST is a site-specific, sound-art installation located at the end of the pier on the water at Fells Point, Thames Street, and South Broadway in Baltimore. The installation amplifies the sounds reflected by the surface boundary between water and air. This liminal space is an acoustic mix between the "normal" sounds heard above the water and the sounds heard below the water. Multiple radios are placed on the pier and receive an FM broadcast of the underwater sounds. Through transmission the inaudible becomes accessible. *CAST* creates a deep listening duet between these two acoustic environments. The water surface operates as a tympanum or drum being struck from both sides: the noisy rumblings of the Baltimore Inner Harbor district beat upon the upper surface; the aquatic echoes and bay currents reverberate against the underside to complete the listener's circuit of perception. Here, Bradley mediates random noise and constructs another level of sound composition that creates a pattern language for deep listening. What should be disturbing and disruptive becomes diffused and meditative. The live underwater sounds and surface environmental sounds together resonate a multidimensional aural structure of a specific place.

Steve Bradley

b. 1952 Great Falls, Montana
Lives and works in Baltimore
userpages.umbc.edu/~sbradley

Steve Bradley is an intermedia artist who works with low-frequency sound that resonates below the threshold of human hearing, but when broadcast on-site, reveals the structure of environmental acoustics. Using minimal processing, he isolates micro artifacts of sound that become the core material for video, networked live performance, and low-power, site-relational radio. In 1998, Bradley founded art@radio, an online radio project through which he broadcasts artists' sound and experimental music works, invites guest curators, and conducts streamed projects in remote locations where participants perform simultaneously. He is a co-founder and active member of URBANtells.net, whose work focuses on the intricacies between the architecture, cityscape, and human and cultural geography found within any city. URBANtells's art practice involves the use of various forms of low and high technology to engage residents, transients, and lost inhabitants of the city. Bradley has performed and presented at venues throughout the U.S. and abroad, including Kunstradio (Austria), Kiasma Museum (Helsinki), and the Seville Biennial (Spain). Bradley teaches at the University of Maryland-Baltimore County, and serves as the graduate program director of the Imaging and Digital Arts MFA program.

Matt Bua

b. 1970 Wilmington, North Carolina
Lives and works in New York City and Catskill,
New York
bhomepark.blogspot.com

Matt Bua's work has taken shape in installations, drawings, films, videos, and performance art pieces. More recently his creative project has been obsessively focused on large-scale fantastical spaces that redefine and reimagine found objects and sustainable resources as functional elements in architecture. Since 2008, Bua has been constructing small-scale examples of vernacular, experimental, and visionary architecture on a piece of land he calls "b-home," in Catskill, New York. Each structure focuses on a specific, often whimsical, theme and use that is integrated into the surrounding array, which includes a sauna, lower-case "a-frame," and an homage to Jessie Van Vechten Vedder, New York State's first female historian, and author of the *Official History of Greene County New York Vol I 1651-1800.* (The site for the b-home project contains the peak of Vedder Mountain.) A chronic collaborator "b-home" is the site for numerous structures conceived of and built by Bua's frequent cohorts, among them Jesse Bercowetz and Carrie Dashow. These like-minded spirits also contributed works to Bua's major installation *Cribs to Cribbage* installed at MASS MoCA in 2009. A three-part installation celebrating alternative/experimental architecture, the project sprawled throughout the Kidspace renovated gallery, outside a window, and at the entrance of the museum.

Sing Sun Room (2007)

Sing Sun Room is an interactive sound sculpture and installation. The project stems from a pre-existing mobile home located on free103point9's Wave Farm property in upstate New York. As with his ongoing project "b-home" and other recent work, *Sing Sung Room* employs found objects and sustainable resources as functional elements in architecture. Here, Bua constructs a handcrafted addition or outgrowth to the mobile home in the form of a customized gazebo, and harnesses various environmental elements, such as wind, water, and solar energy, in order to transform them into sound. Early electrical experiments serve as inspiration for Bua's series of hand-constructed sound-producing devices, each of which utilizes alternative energy sources for sound production. A bucket battery—a mobile version of the earth battery—powers tin can headphones. Lemons power a Piezo buzzer organ that bursts from the side of the structure. Wind is responsible for sounding a series of wind chimes, a wind tunnel, rubber hose-activated whirligig whistles, an Aeolian wind harp, and swaying violin trees. Rainwater falling from the roof is diverted to metal fastenings to ensure percussive results. And solar sun visor fans located in the center post activate motors that bounce on conductive wires.

Cross Current Resonance Transducer (CCRT)

Established 2005 New York, New York
Based in New York City
resonancetransducer.org

Cross Current Resonance Transducer (CCRT) is a collaboration between LoVid (Tali Hinkis and Kyle Lapidus) and Douglas Repetto. This open-ended collective effort is focused on the trio's common interest in the relationships between science, technology, and art. As CCRT, the artists explore processes of interpretation and evaluation that are inherent in human efforts to understand natural phenomena. CCRT develops sculptural and mechanical systems for monitoring, manipulating, and interpreting natural signals, such as electromagnetic radiation, ambient temperature gradients, wind, and barometric pressure modulations. The purpose of these projects is not to present the phenomena themselves, but rather to explore the often flawed but revealing interpretations of those phenomena that ultimately lead to greater human understanding and scientific progress. CCRT's investigatory practice includes building environmental monitoring devices that are incorporated into sculptures, Web-based works, and visual data drawings. CCRT's interdisciplinary projects represent the process of discovering, understanding, and exploring of the natural world. Each piece is conceived and produced as both a technology-based monitoring system and a visual art object that can be viewed in an aesthetic, experiential, or theoretical way.

Circular Spectrum Analyzer (2008)

Circular Spectrum Analyzer (also titled *Circular Spectral Analyzer* or *CSA*) fuses signal aesthetics and environmental functionality. Solar energy powers and tunes a shortwave radio across the 19MHz spectrum while driving the sculpture's motorized elements, which include seven laser-cut wooden discs. The etchings and forms in the sculpture's seven layers and the seven sides of the base are interpretations of seven months of recorded solar data from seven different locations in New York State vis-à-vis the collective's project *Bonding Energy,* a 2007 commission of New Radio and Performing Arts, Inc. (aka Ether-Ore), for its Turbulence Website. The technology comprising *Circular Spectrum Analyzer* includes no energy storage—no battery or capacitor—and the solar power is immediate so that viewers may "play" the piece. When a viewer's shadow is cast over the panels, both the speed of the moving parts and the radio receiver's behavior are affected. *CSA* presents both the real-time representation of solar data via sound and motion and the after-the-fact analysis and interpretation of collected solar data via shapes, colors, and three-dimensional forms. It is part of CCRT's ongoing exploration of the human impulse to interpret and evaluate the continuous flow of information received from natural signals.

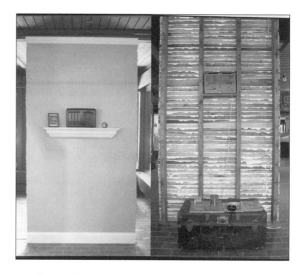

Paul DeMarinis

b. 1948 Cleveland, Ohio
Lives and works in Palo Alto, California

Paul DeMarinis is an electronic media artist and composer who has created performance works, sound and computer installations, and interactive electronic inventions since 1971. Major installation works include: *The Edison Effect* (1989–1993), which uses optics and computers to make new sounds by scanning ancient phonograph records with lasers; *Gray Matter* (1995), which uses the interaction of body and electricity to make music; and *The Messenger* (1998), which examines the myths of electricity in communication. DeMarinis writes:

> Our electronic media may be regarded, in large part, as the outgrowths of nineteenth-century laboratory apparatuses designed to isolate and investigate the functioning of human sensory organs. Viewed thus, they fracture the wholeness of sensation in an effort to preserve, replay, or transmit over distance the specters of our sensory experiences … Perhaps every attempt to reconstitute the sensory wholeness allegedly lost by recording and transmitting media may be regarded as a chimera, the foremost survivor of which has been the sound cinema with its uneasy pact between sight and sound serving to perpetuate a myth of synesthesia. But a host of other teratogeny were, and are, being spawned, tried, rejected, and occasionally marketed in a ceaseless attempt to achieve multimedia.

Walls in the Air (2001)

Paul DeMarinis created *Walls in the Air* for an exhibition about Radio Free Europe, the international broadcast organization whose broadcasts were politically influential in Eastern Europe during the Cold War, at the Hoover Institution in Stanford, California in 2001. The installation consists of a postwar Polish radio placed on a small wooden shelf accompanied by small mementos from the time. The radio receives broadcasts from Cold War-era programs of Radio Free Europe mingled with contemporaneous AM broadcasts. DeMarinis's first-person memories of listening to a 1930s Zenith shortwave radio while reading comic books in his attic bedroom as a child formulate the specific context of *Walls in the Air*. His imaginative impulses were ignited by the experience of listening to commentators speak in languages from distant lands and artifacts of radio interference that he took to be music from foreign countries. As he learned about the oppressive conditions many faced in distant countries, the young DeMarinis began to wonder: "Could I talk to them through my old Zenith? Could I send them a message of hope and friendship? Would it make me feel less afraid?" Ultimately delving into the complexities of memory, this piece examines DeMarinis's personal recollections of that time.

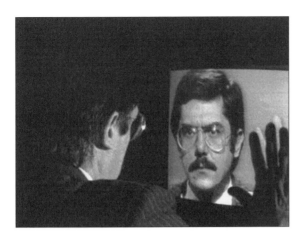

Juan Downey

b. 1940 Santiago, Chile; d. 1993

Juan Downey was a pioneer video and installation artist and painter whose work addressed issues of cultural identity, architecture, anthropology, and the social implications of a growing globalization. Downey was born and raised in Chile, where he completed his graduate studies in architecture. His experiences as a child growing in the Yanomami community in Chile deeply stimulated his understanding of the importance of culture and its manifestations within society. Downey moved to New York City in 1965; there experiments with audio delay and playback led him to the moving image, and in 1966 he encountered video. As described by Lori Zippay, executive director of Electronic Arts Intermix:

> Juan Downey produced a major body of work that interweaves a sophisticated multicultural discourse with an idiosyncratic search for identity. Merging the subjective and the cultural, the diaristic and the documentative, Downey investigated the self through the historical texts of Western art and culture and the rituals of his native Latin America. Subverting documentary and narrative modes, his densely layered works are infused with rich intertextual analyses, associative pictorial metaphors and collage-like, nonlinear strategies.

Three-Way Communication by Light (1972)

Originally commissioned by Central Michigan University, Juan Downey presented *Three-Way Communication by Light* at the 9th Annual Avant-Garde Festival of New York in 1972. *Three-Way Communication by Light* is initiated as a performance, but ultimately exists as a stand-alone installation. Three performers are seated on the corners of a large triangle. The shape of the triangle is defined by laser beams, which carry voice transmission. The lasers are only visible when fog reveals their presence. Each performer is provided with a mirror and has his or her face painted white, which serves as a reflective screen. The performers exchange faces through Super 8 film projection and observe their transformations through their reflections in the mirrors. The performers' voices are transmitted and received through the laser beams. The performance is documented in video for half an hour. When the performers leave, three video monitors take their place and play back the footage documenting the transfigurations of the performers and their conversations.

Melissa Dubbin
b. 1976 Las Cruces, New Mexico

Aaron S. Davidson
b. 1971 Madison, Wisconsin
Live and work in New York City
dubbin-davidson.com

Melissa Dubbin and Aaron S. Davidson have worked collaboratively since 1998. Their practice includes works in video, sculpture, sound, books, and performance. Dubbin and Davidson's earliest collaborations were kinetic works that were internally interactive. Recent works convey an interest in inciting questions rather than focusing on authenticity and apparatus. With no allegiance to any particular medium, the foundation of Dubbin and Davidson's practice has been built through continued investigation into expanded cinema, acoustics, duration, theatre, and engineering. In their 2009-2010 project, *Karen Davidson (Diamond, Ruby, Sapphire, Emerald),* which takes the form of objects, photographs, and audio, gemstones are used to cut a series of four records. The audio recorded onto the blank lacquer discs comes from interviews with gemologist and jewelry designer Karen L. Davidson (Aaron Davidson's mother) talking about the specific gemstone used to cut the record. Dubbin and Davidson have collaborated on projects with Pierre Huyghe, Morton Subotnick, LOT/EK, and Woody and Steina Vasulka, among others.

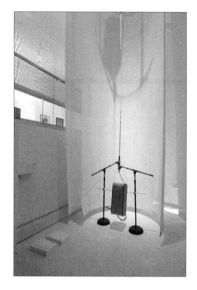

Last & Lost Transmissions (2005)

Last & Lost Transmissions is comprised of two distinct sound works presented in tandem, whereby the transmitters, speakers, and receivers function as sculptural elements. *Last Transmissions* is audible when viewing these objects; *Lost Transmissions* is heard at a radio placed elsewhere in the exhibition venue. In reality, last transmissions typically occur at times of crisis and cultural importance. These historical chapter markers often register as more significant than all previous transmissions. Here, *Last Transmissions* includes sign-off broadcasts from now-defunct radio stations, last addresses of public figures, and last radio contacts with ships, planes, and satellites. Rebroadcasting this collection of messages creates openings into divergent narratives. Occasionally, transmitted messages are lost. They arrive at the wrong place, or no record of their reception is recorded. For *Lost Transmissions* the artists invited the public to contribute messages received, but that were intended for another. By rebroadcasting these misplaced messages, the artists fantasize that they might reach their intended destinations. While many *Last Transmissions* are associated with technological obsolescence and tragedies of the past that cannot be reversed, *Lost Transmissions* offers an alternative to this predetermined outcome. *Last & Lost Transmissions* was first exhibited at *Airborne II: Transmission,* a show co-curated by the New Museum and free103point9 in 2005.

58

EcoArtTech

Established 2005 Starks, Maine
Based in Starks, Maine and Ithaca, New York
ecoarttech.net

EcoArtTech is a collaborative platform for digital environmental art, founded by Cary Peppermint and Leila Christine Nadir. Cary Peppermint is a conceptual and performance artist working with digital technologies and "natural" environments. His Website is an internationally recognized platform for his ongoing series of Net art and networked performance art. His curatorial projects include numerous international exhibitions of digital eco-art. Peppermint is currently an assistant professor at Colgate University, where he teaches courses in the theory and practice of digital and new media art. Leila Christine Nadir completed her doctoral studies in English and comparative literature at Columbia University in 2009, and has taught at Columbia, Oneonta State College, and Colgate University, including courses in American literature, modernity and modernism, and new media art history and theory. A 2009 artist fellow with the New York Foundation for the Arts (NYFA), EcoArtTech's most recent work, *Eclipse* (2009), is an Internet-based work commissioned by New Radio and Performing Arts, Turbulence. *Eclipse* is a user-driven, networked-art application that alters and corrupts U.S. national and state park images from flickr.com based on the real-time air quality index (particle pollution data) provided by the U.S. Environmental Protection Agency (EPA).

Frontier Mythology (2007)

EcoArtTech's *Frontier Mythology* consists of a mobile, solar-powered environmental digital video and FM radio installation made of recycled shipping pallets. Three portable multimedia players inhabit a primitive lean-to structure displaying videos of diverse contemporary landscapes. Concurrently, a transistor radio picks up a microradio transmission reciting quotations from classical works of American literature that both develop and critique the frontier myth that informs American constructions of land, nature, and wilderness. Originally designed to be located along a remote section of the Appalachian Trail, *Frontier Mythology* incorporates new media and sustainable technologies in an exploration of issues of sustainability, technological progress, and the experience of modern, hybrid environments. Authors of texts broadcast via FM transmission include the following: Ursula Le Guin, Willa Cather, Cormac McCarthy, Samuel Clemens, Leslie Marmon Silko, Frederick Jackson Turner, F. Scott Fitzgerald, and William Faulkner. *Frontier Mythology* debuted in New York City at Solar One, Stuyvesant Cove Park, in July 2007 during the CitySol music, art, and culture festival.

Jeff Feddersen

b. 1976 Elkhart, Indiana
Lives and works in New York City
fddrsn.net

Jeff Feddersen is an artist, musician, and engineer trained in computer science and music whose work has increasingly focused on sustainable energy and natural systems. His projects include: *Forestbot* (2003–2006), a kinetic acoustic installation that features a group of five robotic sculptures made of wood, metal, fiberglass, rattles, motors, and custom electronics; *Double Harmonics Guitar* (2006), a ten-foot-long, two-person invented musical instrument created with Tetsu Kondo; and *Silverfish* (2006), a simple percussion hybrid instrument made out of scrap aluminum, amplified with Piezo contact mics, with real-time composition software, and multi-modal digital input devices. Feddersen teaches electronics, sustainable energy, and digital audio at New York University's Interactive Telecommunications Program. He previously worked for the NASA flight hardware developer Honeybee Robotics. He has developed project-based solutions for the American Museum of Natural History; Minnesota Public Radio; Habana Labs, a nonprofit dedicated to researching sustainable energy; and Jeff Kennedy Associates' *SoundPlayground,* featuring four different types of electronic instruments, each allowing the exploration of sight and sound at the Connecticut Science Center in Hartford.

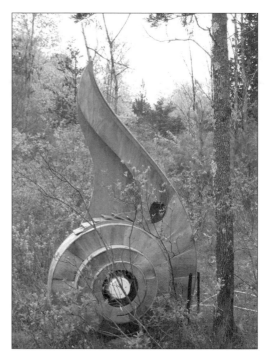

EarthSpeaker (2006–2007)

EarthSpeaker is an outdoor sonic installation made of a series of large-scale, autonomous sculptures. Each sculpture is a large, solar-powered, electroacoustic speaker whose nocturnal sounds are powered by sunlight harnessed during the day. Drawing inspiration from animals active during dusk hours—such as crickets, bullfrogs and fireflies—the speakers are designed to absorb and store solar energy during the day and retransmit the energy as acoustic sound for a brief period of time at dusk. As the sun sets, the system creates a short, distributed chorus of sound until the energy stored for the day is consumed. *EarthSpeaker* represents the cybernetic cycle of natural and man-made forces, depicting the daily interaction via a simple electronic exchange of energy. Creating a long-term, outdoor installation posed many challenges for the artist, ultimately pushing Feddersen's exploration of energy storage, alternative speaker functions, and aesthetic design. Feddersen developed a prototype of the installation in summer 2006 through a residency at Eyebeam in New York. *EarthSpeaker* was installed in 2007 as one of the inaugural installations at free103point9's Wave Farm Transmission Sculpture Garden (Acra, New York).

Kristen Haring

b. 1970 Kutztown, Pennsylvania
Lives and works in Auburn, Alabama

Kristen Haring's creative practices are routed in an extensive academic résumé. She is a historian of science and technology whose interests have always crossed disciplinary boundaries. Questions of identity, culture, and design within communications technology form the basis of Haring's work. She began her studies at the University of Pennsylvania in mathematics. At the University of North Carolina-Chapel Hill, she completed the PhD exams in mathematics before leaving with a master's of science and transitioning to historical studies. Having earned a PhD in history of science from Harvard University, Haring then held positions as a postdoctoral research fellow at the Max Planck Institute for the History of Science in Berlin and as an art, science, and business fellow at the Akademie Schloss Solitude in Stuttgart. Upon completing the fellowships, Haring joined the history faculty at Auburn University. Her teaching addresses science and technology as components of culture, while her research focuses on communications technology. Her book, *Ham Radio's Technical Culture,* chronicles the history of ham radio culture and the identities and communities that formed via this technological hobby. In addition to her scholarly activities, Haring is a founding director of the Keith Haring Foundation, which supports underprivileged children and individuals affected by HIV/AIDS.

Morse Code Knitting (2007)

Haring's *Morse Code Knitting* project refers to ancient tales about messages carried through textiles. The mechanism for the works is a translation between binary systems: Haring spells out words by switching between the two stitches—knit and purl—as a telegrapher switches an electrical current on and off to send Morse code. With patience, text can be deciphered from the shape of the stitches. This project complicates reading partly to emphasize that all communication depends on cultural codes. Understanding Morse code knitting requires combined knowledge of domains often set apart as masculine and technical, in the case of Morse code, and feminine and folksy, in the case of knitting. Individual knit pieces expand upon the project's overall themes and include sweaters bearing information that can be worn openly, yet kept private through a code. Haring's *Morse Code Knitting* project manifests as objects and performance documentation. In performance, her *Recording Series* are real-time, on-site documentations where compressed phrases such as "look at ceiling" and "make calls" describe some of the activities observed at New York's Grand Central Station. The knit pages, like all historical documents, transmit mere fragments of a fuller story.

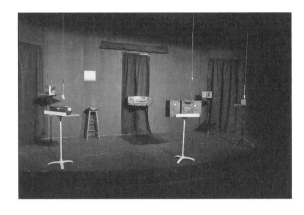

Chorus of Refuge (2008)

Chorus of Refuge is a sound installation for six radios by documentary radio producers Ann Heppermann and Kara Oehler and composer Jason Cady. In *Chorus of Refuge* the stories of six refugee populations (Somali Bantu, Burundi, Afghani, Sudanese, Iraqi, and Burmese) from six different cities across the U.S. (Portland, Phoenix, Amarillo, Omaha, Detroit, and Indianapolis) are transmitted simultaneously to six radios in one space. The chorus is divided into three movements that correspond to each refugee's unique story: home, journey, and U.S.; and the voices are harmonized and synced up rhythmically to unite their narratives. Each voice is assigned to a different radio frequency, and the location of the individual voices on the radio dial changes with each installation of the piece. Visitors to *Chorus of Refuge* walk from one radio to another and hear constantly changing focal points within a continuous background. Through his or her own action, the listener creates new and dynamic figure/ground relationships. One can stand in the center of the installation and hear a chorus of voices or stand close to one radio in order to hear an individual story.

Ann Heppermann

b. 1974 Omaha, Nebraska

Kara Oehler

b. 1978 Indianapolis, Indiana
Live and work in New York City
annkara.org

Ann Heppermann and Kara Oehler are Peabody award-winning public radio producers and media artists. Their stories and long-form documentaries have aired nationally and internationally on public radio shows including *This American Life, Morning Edition, Weekend America, BBC, CBC, Radiolab, Re:Sound, Marketplace,* and numerous others. In 2003, Heppermann and Oehler created an experimental short documentary for the Third Coast International Audio Festival about undocumented migrants' experiences crossing the Sonoran desert. The piece has been featured at festivals around the world and also published in *Documentary 101: A Guided Listening Experience for the Classroom.* From 2007 through 2009, they were series producers for American Public Media's *Weekend America* and also produced, and sometimes hosted, the NPR show *Hearing Voices.* Their recent project, *Mapping Main Street* (2009), made in collaboration with Jesse Shapins and James Burns, is a collaborative documentary media project that creates a new online map of the country through stories, photos, and videos recorded on actual Main Streets. The goal is to document all of the more than 10,000 streets named Main in the U.S.

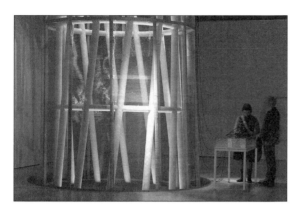

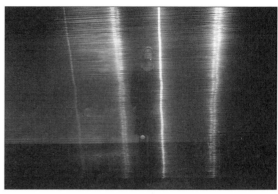

Joyce Hinterding

b. 1958 Melbourne, Australia
Lives and works in the Blue Mountains,
New South Wales
sunvalleyresearch.net

Joyce Hinterding produces works that explore physical and virtual dynamics. Her practice is based on investigations into energetic forces conducted through custom-built field recording and monitoring technologies. Her interest in energy and resonance has been a platform for investigating and extending notions of form and function and digital translations. These explorations into acoustic and electromagnetic phenomena have produced large sculptural antenna works, video and sound-producing installations, and experimental audio works for performance. Her audio work *Spectral* (2003) was based on celestial site recordings of magnetic fields and weather satellites made with custom-built antennae, which appeared as the sound element in *The Levitation Grounds* (2000), an audio/video installation with David Haines, who has become a frequent collaborator. Together, Haines and Hinterding's works investigate energetic forces at the intersection of hallucination and landscape, and explore landscape and architecture as sites of psychic disturbance. Their recent project *EarthStar*, a multimedia installation that explores arcane energies and hidden frequencies, was given an Award of Distinction at the 2009 ARS Electronica in Linz, Austria.

Aeriology (1995–2009)

Aeriology is a large-scale, site-specific, detuned custom-built antenna that resonates to a range of radio frequencies related to its length, dimensions, and physical qualities. Like a classic electrical transformer, *Aeriology* converts electrical and electromagnetic activity in the room and the surrounding atmosphere into electrical activity in the wire. This activity can be translated into sound or image or can be thought about as an alternative power source gathering energy out of the air. Made from copper magnet wire, *Aeriology* is hand-wound onto the architectural features of the gallery, such as internal columns or pillars. *Aeriology* resonates at the VLF (very low frequency) section of the radio spectrum, the part that corresponds to the audio frequency range, thus allowing the antenna to be plugged directly into the audio inputs of a sound system to reveal the live electromagnetic soundscape of the building. At one level, the ceaseless hum of the modern world—the energy surging through the cables and wires of the building—is heard. Also audible is the crackle of spherics from the solar winds as they interact with the ionosphere and background noise of the Milky Way, the energy emitted from stars.

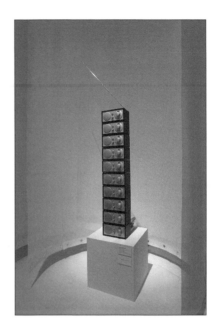

Tarikh Korula

b. 1971 Stanford, California
Lives and works in New York City
uncommonprojects.com

Tarikh Korula is a multidisciplinary artist whose work has included composition, performance, hacking, and sculpture. His practice is a playful meditation on experimental, political, sensuous, dark, or absurd themes. For the past decade, Korula has explored sound through improvisation, field recording, and handmade electronics. His recent performance at PS1 Contemporary Art Center in New York—on the occasion of Printed Matter's 2009 NY Art Book Fair—culled recordings from New York EMS dispatches, Steven Vitiello's contact mic recordings of the World Trade Center, and his own composition and reappropriated media, to create a dense collage of sound, documentation, and fiction. Korula was a founding member of both the New York City Independent Media Center and August Sound Coalition. He has written for *Punk Planet* and *Make* magazines. Korula holds a master's in interactive telecommunications from New York University.

Chop 10 (2005)

Exploiting the techniques of current commercial radio practice, *Chop 10* remixes a live, dynamic assemblage of commercial radio streams as a commentary on the current state of regulated radio. Powered by circuitry customized by Korula, *Chop 10* moves from one Arbitron-rated Top Ten radio station in New York City to the next; the scanning time slowly evolves from long stops on each station (similar to the scan feature on the car radio) to absurdly short intervals. Real, identifiable edits become texture and noise as *Chop 10* deconstructs real-time radio into abstraction. Korula exposes how financially driven systems are (in capitalist economies) competitive systems, where hierarchy and domination are evidence of success. By stacking ten identical receivers, he asserts that commercial radio has lost any individual identity, and is driven by fundamentally identical formulas applied to management and content, and more often then ever before under the same ownership. "I felt like radio had become a race to the bottom," says Korula. *Chop 10* was first exhibited at *Airborne II: Transmission,* a show co-curated by the New Museum and free103point9 in 2005.

LoVid

Established 2001 New York, New York
Based in New York City
lovid.org

LoVid is an interdisciplinary collaboration between Tali Hinkis and Kyle Lapidus. With live video installations, sculptures, digital prints, patchworks, and performances, LoVid utilizes electric signals to explore the translation and preservation of information and memory. Their work is a mix of high- and low-tech, craft, and real-time interventions. LoVid contrasts hard electronics with soft patchworks, analog with digital, and handmade with machine-produced objects. This multidirectional approach is reflected in the content of their work, simultaneously romantic and aggressive, wireless and wirefull. Using exposed electronics, long conductive wires, and audiovisual feeds, LoVid creates narratives of a retro-futuristic coexistence between biological and technological systems. LoVid uses the word "wirefull" to describe their aesthetic and philosophy. Wirefull incorporates the notion of a parallel universe in which technology has taken a different evolutionary route. In this universe, artificial systems are organic, large, chaotic, social, and emotional. LoVid develops these ideas throughout their cross-genre work, which often takes the form of installations in which media materializes into enveloping spaces. In their participatory performances and installations, LoVid highlights audience involvement employing their tactile, physical interaction as significant components in their work.

Ether Ferry (2005)

Ether Ferry is concerned with the preservation and materialization of information that is lost or often ignored in conventional media. The installation's video output is generated by an electrical signal that is simultaneously broadcast between multiple video transmitters and receivers in a gallery space. The video signal responds to manipulations enacted by the exhibition's visitors. The video transmitters and receivers are placed in two sliding boxes so that viewers may slide the boxes in order to change the levels of mixing and decay between the signals and affect the resulting video produced by the system. The sliding boxes and the plasma screen, upon which the video is displayed, are swathed with handmade fabric patchwork, the pattern of which is informed by the repetitive imagery of video signal information. The video-generated fabric component in *Ether Ferry* embodies LoVid's explorations of the translation and preservation of signals. By printing the video on fabric and bringing the fabric back into the installation, *Ether Ferry* draws visitors into a tactile hands-on interaction with technology. *Ether Ferry* was exhibited in *Airborne II: Transmission,* a show co-curated by the New Museum and free103point9 in 2005.

neuroTransmitter

Established 2001 New York, New York
Based in New York City
neurotransmitter.fm

As neuroTransmitter, Angel Nevarez and Valerie Tevere have engaged in an artistic practice that focuses on architectures of broadcast, the particularities of historical resistant events associated with the medium of radio, the rearticulation of radio programming, and the radio "voice." Specific interests lie in the archeology of the medium's history, the study of its architectural residues and monuments, and considering new possibilities for the broadcast spectrum as discursive public space. Nevarez and Tevere fuse conceptual practices with transmission, sound production, and mobile broadcast design. Through the combination of media forms and sound performance, their work re-articulates radio in multiple environments and contexts, considering new possibilities for the broadcast spectrum as public space. Their public performances connect FM radio technology and the body, negotiating, occupying, and sonically mapping the invisible and physical spaces of the surrounding environment. Their project *The FM Ferry Experiment* (2007) was an eight-day mobile radio project held on the Staten Island Ferry in collaboration with the New York City Department of Transportation and WSIA-FM. The project transformed the ferry into a floating radio station, continually traveling between lower Manhattan and Staten Island, and transmitting out to the New York City region.

12 Miles Out (2005)

In their installation *12 Miles Out*, neuroTransmitter merges analog radio transmission with line drawing constructed from wire and nails. This work continues the artists' exploration of offshore pirate radio practices prevalent in the 1960s and 1970s, specifically referencing Radio Caroline, which, in defiance of international broadcasting regulations, transmitted off the European coast from 1964 through the late-1960s. Installed in a gallery setting, the drawing-as-antenna represents a blueprint of one in a fleet of Radio Caroline mobile pirate radio ships. The wire drawing is attached to a radio transmitter and serves as an antenna for the transmission in *12 Miles Out*. The transmitted sound collage, which is created from archived broadcasts of Radio Caroline and ambient sound recordings of a voyage taken out to sea, is received by radios within the exhibition space. Posing questions about governmental control of radio and the subsequent resistance of oceanic territorial boundaries, *12 Miles Out* utilizes the means of rebellious broadcast in order to reconsider radio as a tool for protest and social discourse. *12 Miles Out* was included in *Airborne II: Transmission*, an exhibition co-curated by the New Museum and free103point9 in 2005. It has also been shown in solo and group exhibitions throughout the U.S. and Europe.

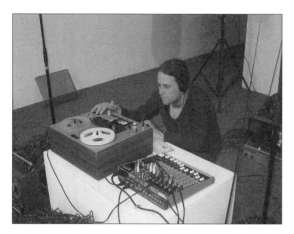

Andrew O'Connor

b. 1978 Waterloo, Ontario, Canada
Lives and works in Toronto
frequent-mutilations.com

Andrew O'Connor is an independent radio producer and sound artist working on both a local and national scale. His work in community radio dates back to 1996 at CKMS-FM in Waterloo. Since then he has contributed to stations like CKLN in Toronto and Shouting Fire Radio in San Francisco, producing everything from hour-long radio art features to a weekly new music program called *Free Music.*

O'Connor has also worked in several different capacities at CBC Radio. His work includes creating the library for the Canadian Composers Channel, a twenty-four-hour contemporary music Internet station; and programming and production credits on new music shows like *The Signal* and *Two New Hours.*

O'Connor has also contributed work to the Deep Wireless Festival in Toronto and created the soundscape for *Moving Target,* a solo physical theatre performance by Erin Bouvy. His work as a sound artist has been featured at festivals such as the Vancouver New Music Festival, the Third Coast Filmless Festival, Megapolis, and the Guelph Jazz Festival's Nuit Blanche program. O'Connor's work also includes a multi-channel installation in which he explores internal music, through the transformation of drumming by the legendary Milford Graves, into the human heartbeat.

Frequent Mutilations (2008)

Frequent Mutilations is a performed installation for four reel-to-reel tape machines and a series of large analog tape loops eighteen to twenty-five feet in length. The piece is based on a long-running radio show of the same name. Each tape machine simultaneously plays a loop of a different duration, played at different speeds so the sounds continually intersect at different points. Each loop contains a single sound like a drumbeat, a voice, or a drone; the sounds on many of these loops have been taken from archival episodes of the radio show, the rest composed specifically for the installation. Every few minutes one of the loops is taken down and a new one is spliced live into the mix. This creates a slowly evolving, slightly random composition that, much like the show that inspired it, is constantly in flux. As a weekly radio program, *Frequent Mutilations* aired original hour-long works of radio art for twenty-five years on CKMS-FM, a small community radio station in Waterloo, Canada. *Frequent Mutilations* varied both from week to week and year to year as programmers came and went and technology changed. The only persistent guidelines were that programs had to be an hour long and include some aspect of collage. In the show's two-plus decades, well over 1,000 hours of original radio art were created for broadcast. The show went off the air in 2008 because of a loss of funding at CKMS and a subsequent shift in programming. *Frequent Mutilations*, the installation, is meant to celebrate one of North America's longest-running radio art programs, giving new life to the program's archives in a gallery setting.

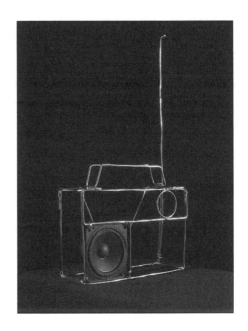

Zach Poff

b. 1978 Baltimore, Maryland
Lives and works in New York City
zachpoff.com

Zach Poff is a digital media artist, educator, and maker. Through his artwork, teaching, and software development, Poff examines the tremendous opportunities and challenges that arise from the translation of experiences into information. Combining circuit-bent objects, video installation, and sound performance, his recent work has been focused on how traditional broadcasting reverberates into digital media and influences notions of an emerging post-broadcast discourse. Poff was a member of MAP Intermedia, a group that combined dance, video, and sound work in a collaborative environment that challenged the traditions of authorship within the performing arts. His previous broadcast-analysis projects include *Appropriate Response* (2008, with N.B. Aldrich), *Video Silence* (2009), and *Parallel Rhetoric* (2004–2008). Poff received a fellowship from New York Foundation for the Arts in 2007, and free103point9 in 2009. His work has been shown in the U.S. and internationally at venues including ISEA 2008 (Singapore), Art Interactive (Cambridge), and Artists Space (New York City). Poff teaches sound art at The Cooper Union in New York City.

Radio Silence (2010)

The installation *Radio Silence* explores the silent moments of talk radio, using the cadences of different live radio personalities to compose an ongoing collaborative "performance" built entirely of negative space. *Radio Silence* consists of eight radio receivers sculpted in order to chart a history of consumer radio casings. Installed within an exhibition space, the radios are tuned to a variety of local AM talk stations. Rather than a cacophony of eight simultaneous sound sources being amplified in the room, only one station is audible at a time; the eight tuners feed their signals into custom software programmed to detect silence (or in this case pauses in speech). When two stations share a silence, the single amplified feed jumps from one receiver and station to another. By de-emphasizing the individual radio broadcast, Poff empowers the pauses to become new parasitic performers, setting the installation in motion and imposing their own formal language on the resulting composition.

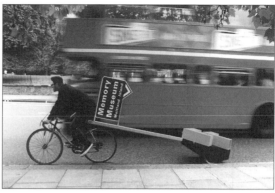

Memory Museum (1996)

Janek Schaefer

b. 1970 Walton by Kimcote, England
Lives and works in Walton-on-Thames, Surrey
audiOh.com

Janek Schaefer is a Fluxus-inspired sound artist, musician, and composer. In Schaefer's work, the spatial context of each idea is central to its development and resolution. His concerts and installations explore the environmental and architectural aspect that sound can evoke, often incorporating prepared technology. Hybrid analog and digital techniques are used to manipulate field recordings with live modified vinyl and found sound to create evocative soundscapes While studying architecture at the Royal College of Art in 1995, Schaefer recorded the fragmented noises of a sound-activated dictaphone traveling overnight through the Post Office. The resultant work, *Recorded Delivery,* was made for the "Self Storage" exhibition organized by Brian Eno, Laurie Anderson, and the college's Acorn Research Cell with London's Artangel. Subsequently, the multiple aspects of sound became Schaefer's focus. Releases, installations, soundtracks for exhibitions, and concerts often center on his self-built/invented record players and include manipulated found sound collage. Schaefer's *Tri-phonic Turntable* (1997), a turntable outfitted with multiple arms, knobs, dials, and switches, is listed in the Guinness Book of Records as the "World's Most Versatile Record Player." He has performed, lectured, and exhibited internationally. In 2008, Schaefer won the British Composer of the Year Award for Sonic Art and the Paul Hamlyn Award for Composers.

Memory Museum is a sound installation within a highway overpass system in London. The site, a traffic island, is named after Maitland, the lead character in J.G. Ballard's novel *Concrete Island,* who became stranded on a similar traffic island after an accident. Schaefer's Maitland Island is an intricate pattern overlapping motorways and pedestrian underpasses, cloaked by an incessant sound of cars, invisible from the vantage point below. Interested in ways to describe the intangibility of memory, Schaefer's *Memory Museum* includes recordings of pedestrians and bicyclists that are delayed four seconds prior to amplification. The sound collage was also transmitted over an FM radio frequency into the private worlds of passing cars interrupting London's Radio 1 feed with field recordings from the site below. The installation was announced to potential audiences through artist-constructed street signs indicating the path to the "museum," and tourist brochures and Underground maps advertising the project, which were distributed throughout the city. In *Memory Museum,* Schaefer explores sound as a dissociated medium. It employs time delay as a mechanism to evoke memory, whereby in an instant listeners witness what they heard moments before.

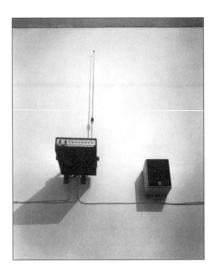

Keith Sonnier

b. 1941 Mamou, Louisiana
Lives and works in New York City and
Bridgehampton, New York
keithsonnierstudio.com

Keith Sonnier redefined the practice of sculpture in the 1960s and 1970s, along with contemporaries including Bruce Nauman, Richard Tuttle, Eva Hesse, Richard Serra, and Barry LeVa. Their work employed innovative materials and ushered sculpture into new terrain. Throughout Sonnier's career, he has experimented with a wide spectrum of materials including latex, satin, bamboo, found objects, neon, transmitters, scanners, and video. In 1968, Sonnier began working with neon, which remains a consistent and defining element in his work. With neon, Sonnier shapes light and color into works that simultaneously evoke drawing and architecture. Sonnier's film and video works, created between 1969 and 1974, were often produced in conjunction with performance. *Channel Mix* (1973), *Animation I* (1973), and *Animation II* (1974) all incorporate off-air television content and are related to Sonnier's interest in the creative potential of the transmission spectrum, which he explores most successfully in *Scanners* (1975). Sonnier has participated in nearly 130 solo exhibitions and over 360 group exhibitions throughout his career, including Documenta 5, Kassel (1972), the Venice Biennale (1972, 1982), and the Biennial Exhibition at the Whitney Museum of American Art (1973, 1977). An exhibition of new neon works from Sonnier's *Herd Series* was exhibited at the Pace Gallery in New York in 2008.

Scanners (Quad Scan) (1975)

Originally titled *Quad Scan, Scanners* involves six to eight radio scanning devices arranged purposefully in an exhibition space and tuned to a variety of frequencies. Each scanner emits real-time sounds including emergency services (police, fire, etc.), ship-to-shore calls, weather reports, and cellular transmissions. The project is both voyeuristic and a type of live conceptual performance specific to the location where *Scanners* is installed. An advocate for both of these arenas, Andy Warhol acquired an early edition of the work and installed it at the entrance to his infamous Factory space. *Scanners* was more recently installed in Sonnier's 2003–2004 exhibition at Ace in New York, which featured Sonnier's installations from the 1960s and 1970s. In this context *Scanners* is poignant, and impressive; forever contemporary, it provides its audience a glimpse into a present moment in their present location, one that typically passes by without notice or knowledge. A conceptually rigorous and timeless project, *Scanners* draws new attention to the airwaves as a medium and a venue ripe-for-exploration.

Wolfgang Staehle

b. 1950 Stuttgart, Germany
Lives and works in New York City
wolfgangstaehle.info

Wolfgang Staehle is a Net artist widely known for his live video-streaming installations. His early works consist of mixed media video installations in various New York and European galleries created in the 1980s. In the 1990s, along with emergence of the World Wide Web, Staehle departed from his solo exhibitions to the creation of a more collective method of work aligned with advances in technology. In 1991, he founded The Thing, an innovative online forum for artists and cultural workers. The Thing began as a bulletin board system (BBS), a form of online community dialogue used before the advent of the World Wide Web. By the late 1990s, The Thing grew into a diverse online community made up of dozens of members' Websites, mailing lists, a successful Web hosting service, a community studio in Chelsea, and the first Website devoted to Net art, bbs.thing.net. In 1996, Staehle began to produce an ongoing series of live online video streams. The first of these works was *Empire 24/7* (1999), a continuous recording of the top third of the Empire State Building that was broadcast live over the Internet. Staehle continues to expand this series with online streams of other buildings, landscapes, and cityscapes such as Berlin's Fernsehturm, the Comburg monastery in Germany, lower Manhattan before and after 9/11, and a Yanomami village in the Brazilian Amazon.

2001 (2001)

2001 is a live video-feed installation exhibited at Postmasters Gallery, New York from September 6 to October 6, 2001. The work consists of the Web-streamed images of three remote sites projected on the walls of the gallery. The installation concept centered upon the evolutionary nature of information transmission and consequently of the modern city. The first image is a panoramic capture of the Manhattan skyline from Brooklyn Bridge to the World Trade Center, the second is the Fernsehturm TV tower in Berlin and the third the Comburg monastery near Schwäbisch Hall, Germany. A wall-mounted quote from Heidegger from 1935 described the rapidly changing character of the modern city and life. The *2001* installation is well aligned with Staehle's attention to process and minimalist art. The gradual but almost static change of the feeds resembles the landscape portraiture of a painting and reaffirms the eternal nature of human evolution through the juxtaposition of monumental buildings of three different eras. It observes the essence of the network itself as an instantaneous yet ever-flowing stream of data echoing the timeless progression of human nature. By witnessing the 9/11 attack on the World Trade Center, the work's temporal and methodical approach to observation inherited unanticipated poignancy.

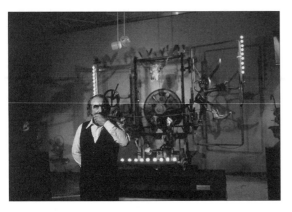

Jean Tinguely

b. 1925 Fribourg, Switzerland; d. 1991
tinguely.ch

Jean Tinguely was a Swiss-born painter and ki-
netic sculptor. In the 1950s he moved to France,
where he began his career as a member of the Par-
is avant-garde. In 1960, he was, with Yves Klein
and Pierre Restany, among the founding members
of New Realism, a movement whose manifesto
claimed new ways of perceiving what was real.
Members appropriated urban, industrial, and
commercial materials in their work as a central
part of their practice. Tinguely's most renowned
works were his self-destructing kinetic sculptures
made of discarded mechanical parts and skulls of
dead animals. He presented these projects in pub-
lic spaces, museum galleries, and deserted fac-
tories. Tinguely's work critiqued industrial mass
production and its self-destructive character. His
Homage to New York (1960) deconstructed at the
Museum of Modern Art, New York, and *Study
for an End of the World No. 2* (1962) detonated
at a desert near Las Vegas, Nevada. Tinguely was
closely associated with painters Yves Klein and
Niki de Saint Phalle, with whom he collaborated
on a series of fountains, including the Fontaine
de Château-Chinon in 1988. Shortly before his
death, Tinguely installed his final exhibition,
Nachtschattengewächse (Nightshade), at the Kun-
sthaus Vienna.

Radio Skulptures (1962)

Jean Tinguely first exhibited his anthropomorphic
Radio Skulptures at the Alexandre Iolas Gallery
in New York City in 1962. Comprised of metal,
appropriated electronics, and natural materials
(such as feathers), the work's kinetic elements
are driven by small electrical motors. Among the
repurposed materials are partially disassembled
radio components including tuning knobs, speak-
ers, and receiving antennae. These functional and
interactive sound sculptures power on at a viewer's
approach, scanning the local radio spectrum. The
result is a composition of abstract radio sounds
determined by chance and viewer participation.

Rirkrit Tiravanija

b. 1961 Buenos Aires, Argentina
Lives and works in Bangkok and New York City

Artist Rirkrit Tiravanija is widely recognized as one of the most influential artists of his generation. His work defies media-based association, as his practice combines traditional object making, public and private performances, teaching, and other forms of public service and social action. Tiravanija's projects focus on the interaction between artist and audience and have involved activities such as preparing food for gallery attendees and creating collaborative leisure environments. Winner of the 2005 Hugo Boss Prize awarded by the Guggenheim Museum, his exhibition on that occasion consisted of a pirate television station (with instructions on how to make one for yourself). His retrospective exhibition at the Museum Boijmans Van Beuningen in Rotterdam (2004) was also presented in Paris and London. Tiravanija is on the faculty of the School of the Arts at Columbia University and is a founding member and curator of Utopia Station, a collective project of artists, art historians, and curators. Tiravanija is also president of an educational-ecological project known as the Land Foundation, located in Chiang Mai, Thailand, and is part of a collective alternative space located in Bangkok, where he maintains his primary residence and studio.

Untitled 2005 (the air between the chain-link fence and the broken bicycle wheel) (2005)

Created for his 2004 Hugo Boss Prize–winning exhibition at the Guggenheim Museum in New York City, Tiravanija's *Untitled 2005* is s self-built low-power television station with text panels that include the First Amendment and a political history of broadcasting. Two rooms are constructed, one a glass vitrine, and the other a room-sized plywood box. The transmitter is installed in the glass room and the receiving television in the plywood enclosure. As the mediums chosen for each of these rooms suggest, it is the transmitter, the voice of authority, which is deemed of high value. While a low-power broadcast could potentially reach viewers miles away, Tiravanija's transmission is restricted to within this gallery's walls due to physical hindrances (for instance, signal interference from satellite television) and the legal and policy implications of broadcasting on museum premises. While the First Amendment (included in the exhibition) protects freedom of speech, the rights to access the technologies that can best distribute free speech are highly regulated. *Untitled 2005* implores individuals to become contributors to their own media culture rather than mere consumers of it. Tiravanija surrounds the installation with texts describing the technology and its history of regulation by the FCC in the U.S. He also offers viewers instructions for building their own homemade TV stations.

Ted Victoria

b. 1944 Riverhead, New York
Lives and works in New York City
tedvictoria.com

Ted Victoria is known for his wall-mounted pieces resembling light boxes. Utilizing a lens light system similar to the camera obscura, Victoria projects actual objects onto a surface to create a "live" picture. This technique, believed to have been used by Vermeer and da Vinci, incorporates a system of mirrors, lenses, and light bulbs with clockwork mechanisms in order to construct moving scenes that may be projected onto walls, custom screens, or other objects. As the materials and site constraints of each piece vary widely, Victoria's low-tech production means are devised and executed largely through a process of trial and error. Each of Victoria's camera obscura pieces suggests its own narrative, creating a seemingly inhabitable environment in which objects as diverse as live shrimp, candlesticks, small collages, tools, and televisions playfully interact within the frame. Victoria received his master's from Rutgers University in New Jersey in 1970. Trained as a painter and printmaker, he began working with various photographic techniques in the 1970s and ultimately concentrated on projection—the medium in which the vast majority of work is produced. His work has been exhibited both nationally and internationally in venues such as the Musée d'Orsay, Paris; the Galerie Bonnier, Geneva; the Museum of Modern Art, New York City; and the Museum of Contemporary Art, Taipei.

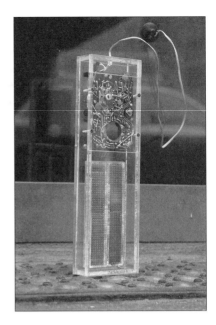

Solar Audio Window Transmission
(1969–1970)

Solar Audio Window Transmission came out of a series of sound sculptures in which Victoria attempted to create something akin to an audio painting by isolating sound onto a visual surface. Eventually, he started to make works that could be transmitted outdoors and powered by the sun. In *Solar Audio Window Transmission,* Victoria uses the sun to transmit radio signals through a variety of unlikely materials and

surfaces such as trees, windows, and water. As designed by Victoria, the series' pieces take a variety of shapes and respond directly to the weather conditions at the time they are outdoors. The sound source is generated at random and comes from a variety of radio sources, sometimes tuned into a National Weather Service station and solely transmitting meteorological forecasts, while in other instances, tuned to news, sports, music, and talk stations. Each sculpture's physical dimensions are designed to alter the radio signals' sound. For example, a series of columns slightly distorts the audio source as it emanates from the piece and, in some realizations, several sources overlap each other to produce a collage of sounds.

Broadcast:
Radio and Television

Robert Adrian X

b. 1935 Toronto, Canada
Lives and works in Vienna
alien.mur.at/rax/

Robert Adrian X's work with telecommunications technologies began in the late 1970s and encompasses a wide range of media including fax, slow-scan TV, amateur radio, electronic bulletin board systems, and other virtual communication tools. Considered a pioneer in artistic practices that first incorporated these emerging technologies, Adrian X participated in the Artists' Use of Telecommunications Conference, a telematic art conference organized by Bill Bartlett for the San Francisco Museum of Modern Art in 1980. The conference brought together artists located in San Francisco, New York, Toronto, Vancouver, Vienna, and Tokyo working with telecommunications, and took place in "telecommunication space." *Die Welt in 24 Stunden* (The World in 24 Hours), one of Adrian X's most recognized works, was first presented at Ars Electronica in 1982. It was an ambitious project using low-tech, telephone-based communications equipment to establish a global network of participating artists and groups, where each organized a contribution from their location using any or all readily available telecommunications technologies. These concerns are further explored in Adrian X's impressive body of work since the 1980s, which redefines and reuses communication tools to establish creative and participatory environments.

Radiation (1998–2008)

Adrian X's *Radiation,* produced in collaboration with Norbert Math, concentrates on shortwave radio. These wavelengths are of specific interest to the artist because of their historical ties to security and espionage agencies, national propaganda and information stations, and amateur radio operators. In *Radiation,* the signals from four shortwave radio receivers are fed into an amplifier and distributed to an array of loudspeakers installed within an exhibition space. Each of the radios is programmed to thirty shortwave stations. A computer program monitors the signal strength; if one becomes too weak, the next programmed channel is accessed. As many shortwave transmissions are received as bursts of coded or scrambled signal including Morse code, fax or image transmissions, and encrypted data, *Radiation* is informed by a sonic palette that is rich and diverse in texture and tone. Unrestricted by line-of-sight transmission as in FM broadcast, shortwave reception is often truly global in content. At any given moment, one might hear numerous languages originating from an even greater number of geographical locations. Shortwave signals are prone to distortion by atmospheric conditions, including solar winds, interference from other transmitters, and local environmental static. This unpredictability places the shortwave spectrum itself at the foreground of this living installation. *Radiation* premiered at the Ars Electronica Festival 98 in Linz, Austria.

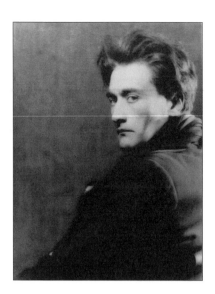

Antonin Artaud

b. 1896 Marseille; d. 1948

Antonin Artaud was a French playwright, poet, actor, and director. His theory and practice were heavily influenced by the tradition of Balinese theatre as well as literary pioneers like Arthur Rimbaud, Charles Baudelaire, and Edgar Allan Poe. During his infancy, Artaud suffered from meningitis and neuralgia that permanently affected his health and stability. He spent most of his adolescence in a sanatorium and suffered from chronic physical pain and psychological distress, which led to a strong addiction to opiates. Artaud was a founding member of the Surrealist movement in Paris. His unwillingness to comply with the movement's rejection of theatre as a product of bourgeois culture led to his estrangement from the influential avant-garde community in 1926. Artaud's deep commitment to theatre was clearly expressed in his 1938 collection of essays entitled *The Theatre and Its Double,* in which he outlined a conceptual approach to theatre that he termed the "Theater of Cruelty." Artaud believed in theatre that provided a sensual experience for the audience and supported unconventional uses of language and gesture in order to challenge audience perceptions of performance.

Pour en finir avec le Jugement de Dieu (1947)

In Artaud's infamous radio work, *Pour en finir avec le Jugement de Dieu* (To Have Done with the Judgment of God), anti-American accusation, anti-religious declarations, environmental prophecy, and scatological pronouncements are articulated in screams, cries, and percussive sounds.

> No more fruit, no more trees, no more vegetables, no more plants pharmaceutical or otherwise and consequently no more food, but synthetic products to satiety, amid the fumes, amid the special humors of the atmosphere, on the particular axes of atmospheres wrenched violently and synthetically from the resistances of a nature which has known nothing of war except fear.
>
> And war is wonderful, isn't it?
>
> For it's war, isn't it, that the Americans have been preparing for and are preparing for this way step by step.

Artaud completed *Pour en finir avec le Jugement de Dieu* shortly before his death. Tragically, French radio's director Wladimir Porché refused to broadcast the play, and it was not heard on French radio until 1968.

Erik Belgum

b. 1961 Minneapolis, Minnesota
Lives and works in Shafer, Minnesota and
Osceola, Wisconsin
erikbelgum.com

Erik Belgum has been involved in experimental writing and speech since 1983. His work is comprised of prose narratives utilizing compositional techniques from avant-garde music, speech-based sound, and text works. Trained as a clinical speech pathologist, Belgum incorporates his formal training in the physiology of oral speech, voicing, and resonance into his creative work. A primary interest in the CD releases, sound installations, and radio broadcasts that encompass the material basis of his work is to create a fictional ambience that enacts a minimalist and architectural alteration of the listening space. Belgum has written and produced audio literary works for ABC (Australia), BBC (England), CBC (Canada), New American Radio (US), and Bayerischer Rundfunk and Hessischer Rundfunk (Germany). In 2003, WDR in Cologne produced a documentary on Belgum's work for radio. He has released seven CDs of audio fiction, which have aired on stations around the world from Hong Kong to Buenos Aires to Vancouver, and on dozens of stations throughout the U.S. Belgum has published fiction in over thirty literary journals and a book of fiction entitled *Star Fiction*. A recipient of numerous commission projects, he has lectured at Bard College, the University of Minnesota, Banff Centre for the Arts, University of Colorado-Boulder, and Loyola University on the subjects of audio literature, radio, and linguistics in art.

"The_City" Battery (2009)

"The_City" Battery (where "The City" is a variable and replaced with the name of a specific location of broadcast) is a dramatic radio series that employs radio broadcast as a tool to perform five episodic neurological and psychological experiments and evaluations on the listening audience in a specific area. Producers of the series are provided with guidelines regarding appropriate durations of "pause" versus "long pause" as well as guidelines regarding an optimum uniqueness and unity between each edition. Each episode deploys a different neurological/psychological evaluation or experiment using a variety of radio formats and forces (call-in, live interview, in-studio, sleight-of-hand, live sampling, etc.). The topics covered by the five episodes are déjà vu, perseverance, hearing, memory, and infant language development. The "host" and "examiner" appear in every episode and unite the presentation. Modern neurological or psychological evaluations or experiments appear as mysterious theatrical experiences. From the de-realized setting, to the unspoken motivations behind the uncanny requests, to the exhausting quality of the event, these supposedly objective and rational moments of medical science feel hermetic and confused. With *"The_City" Battery,* Belgum amplifies that confusion.

Walter Benjamin

b. 1892 Berlin, Germany; d. 1940

Walter Benjamin was a German philosopher and literary critic whose contributions to aesthetic and technological theory reflect a deep commitment to Western Marxism. After studying philosophy in universities throughout Germany, Benjamin settled in Berlin and began work as a literary critic. When Adolf Hitler was appointed Chancellor of Germany in 1933, Benjamin left Germany for Paris in an attempt to avoid persecution as a German Jew. While in Paris, Benjamin continued to publish criticism, forming a close bond with Theodor Adorno of the Frankfurt School in an illustrious exchange of ideas that propelled both men's work in critical theory. One of his most famous essays, "The Work of Art in the Age of Mechanical Reproduction" (1936), explores the fundamental ways that emerging technologies such as cinema and photography alter perceptions of the ritualistic character and political potential of art. It continues to have an enduring impact on cultural studies and media theory. When the Nazis occupied Paris in 1940, Benjamin fled. Although he was long thought to have committed suicide, some recent studies argue that Benjamin was murdered by Stalinist agents.

Radio Scripts for Children (1929–1933)

During the last days of the golden era of the Weimar Republic, Benjamin was commissioned to write a series of scripts for two radio programs for children. Between 1929 and 1933, he wrote and performed on the air a series of twenty-minute stories in educational and conceptual formats. With the arrival of the Nazi regime, Benjamin was eliminated from the radio schedule. Many of his scripts were stored for years in Russia, and kept from public view until 1960, when they were returned to Germany. Unfortunately, none of the on-air programs was archived, and no actual recordings of the broadcasts have been uncovered. Drawing from his own fixation with childhood, children's tales, and toys, Benjamin chose a variety of themes, topics of mainly historical and folkloric background. The elements of horror, humor, imagination, and mimesis are of great importance in his storytelling. On the basis of his belief that children were free of the destructive agendas of adulthood, such as capitalism, consumerism, repetitive work, and rigid perceptual patterns, he aimed to provide his listeners with the right tools so that they could reinterpret and perceive their surrounding urban environment. The radio scripts served as a vehicle for him to combine his Marxist beliefs with his vision of radio's potential as an apparatus for self-education and reconciliation with the modern world and its technological advances. Unquestionably against the mass-educational and patriarchal role of standard radio broadcasts, he preferred the individual experience and prioritized connection with the transmitted voice, creating interior dialogue and imaginative reflection. He invested in younger audiences because he believed children to be active listeners and representatives of reality within dreams and tales. And, most importantly, Benjamin believed that children could become the driving force for social change.

Bertolt Brecht

b. 1898 Augsburg, Germany; d.1956

Bertolt Brecht was a German poet, playwright, and theatre director. Brecht envisioned the social potential of collective participation in a theatrical form he described as "epic theatre." Epic theatre omitted any type of emotional climax in the dramaturgy and instead placed the actor in front of a critical audience that cooperatively participated in the construction of the play's meaning and essence. For Brecht, theatre should not be anything more than a reinterpretation of reality and thus it was important to demonstrate a play's intrinsic qualities and constructed nature to the spectator. Thus, Brechtian theatre was a stripped-down universe focused on social criticism; it aspired to instigate social change. Brecht was strongly affiliated with many artists and intellectuals of his era. His friendship with Walter Benjamin brought him to the medium of radio, for which he developed a strong interest. In his essay "The Radio as an Apparatus of Communication," he applied the same ideas and ethics he envisioned for theatre to radio. In his conception, radio should be a democratic medium that distributes information while also facilitating the listener's critical engagement by demanding his/her participation. In this "two-way" radio, the listener becomes an active speaker in what is a collective, mediated public communication.

The Lindbergh Flight (1929)

The Lindbergh Flight was an interactive radio cantata written by Bertolt Brecht as part of the Baden-Baden Chamber Music Festival in 1929. Inspired by the story of Charles Lindbergh, in 1927 the first aviator to embark on a solo flight across the Atlantic, the libretto symbolizes the power of individual will in society. More specifically, the story presents two contrasting forces: that of an aviator in preparation for his first solo flight and that of his enemies (fog, snowstorm, and sleep) that threaten his extinction. The ships and the sea beneath cover the battle between these two powers. The cantata concludes with the victory of man over nature by overcoming his fears and primitive weaknesses, leading to the conquest of the skies. *The Lindbergh Flight* premiered as an international radiophonic event in July 1929. The performance took place in a room that was temporarily transformed into a studio for radio broadcast. The purpose of the event was to facilitate the work's fundamental aim for interactive radio programming. Consecutive performances of the piece included standard concerts, where the stage was theatrically divided in two sections to resemble the two ends of a radio broadcast—that of the chorus and that of the listener.

Chris Burden

b. 1946 Boston, Massachusetts
Lives and works in Topanga, California

An important and provocative American conceptual artist, Chris Burden received widespread attention for his work in the 1970s. Personal bodily harm and endurance characterized his early performance work. Burden allowed himself to be shot in the arm (*Shoot,* 1971) and crucified atop a Volkswagen Beetle (*Transfixed,* 1974). He marooned himself inside the Ronald Feldman Gallery in New York City for his 1974 performance *White Light/White Heat,* in which he did not eat, talk, or leave his elevated platform for the duration of the twenty-two-day-long piece. While Burden speaks of these early performances in terms of experiments rather than theatre and has no interest in reprising them, he did experiment with video, both within his performances and as documentation. His work in video also included shorts conceived for television broadcast. In the late 1970s, Burden began producing sculptural objects, installations, and technological or mechanical inventions that furthered his interest in the artist's relationship to industry and technology. He was a professor of art at UCLA from 1978 until 2005. His tenure at UCLA ended in 2005 when he resigned following controversy around a student project involving a gun, which echoed Burden's own early work. Burden continues to produce new work and exhibit frequently and internationally.

TV Ad: Through the Night Softly (1973)

In *TV Ad: Through the Night Softly,* Burden, arms tied behind his naked torso, drags himself over shards of broken glass. Burden purchased a commercial slot on a local cable channel to broadcast this performance documentation, which was shown in an on-air intervention for the general viewing public. In a voiceover accompanying the single-channel compilation *The TV Commercials 1973-1977,* Burden says:

> *The TV Ad* piece came out of a long-standing desire to be on television. The more I thought about it, the simplest way seemed to be to purchase a commercial advertising slot … to me the content wasn't so important; it was the idea of being on real TV, which to me means anything you can flip to on a dial. Anything else, cable, educational, video, that's not real TV. I didn't have any illusions that people understood this. That they said, "Oh, there's Chris Burden and he's doing a performance," but I knew it stuck out like a sore thumb. And, that I had the satisfaction of knowing that 250,000 people saw it every night, and that it was disturbing to them. That they knew something was amiss. The ad came on—my ad came on—five times a week for four weeks, right after the eleven o'clock news.

Irvic D'Olivier

b. 1975 Ath, Belgium
Lives and works in Brussels
SilenceRadio.org

Irvic D'Olivier is a radio art producer and curator. He also works as a sound engineer on arthouse films. As a member of l'Atelier de Création Sonore Radiophonique, D'Olivier organized the Radiophonic Festivals in 2003 and 2007. Since 2005, he has been coordinating *SilenceRadio.org*, the project he founded in Brussels. As a teenager, D'Olivier was less interested in making noise with a guitar than in capturing the band on four-track recorders. As a visual arts student, he made several sound installations incorporating headphones and microphones. These experiences drove him to pursue sound production, which he studied over a few months in a cinema school before receiving on-the-job training. Following this period, he thought he would return to contemporary art with technical abilities. While his interests continued to focus on sound, D'Olivier's plastic creativity can be perceived through his current practice. According to D'Olivier, sound is something fascinating and mysterious that will always show resistance to structure; radio's demanding intimacy drives his work and continues to inspire him. Whether producing radio in a studio or attending to a film director's plan for a new project, he lives his life constantly surrounded by sound.

SilenceRadio.org (2005–ongoing)

SilenceRadio.org is an online listening space dedicated to contemporary radio art, founded by Irvic D'Olivier with Étienne Noiseau. Offering free downloads from a wide-ranging collection of audio artworks, *SilenceRadio.org* is designed to be a highly accessible interface modeled on the spirit of serendipitous encounter for inquisitive listeners. D'Olivier conceived of the site, which he established in April 2005, to promote radio art as a means of social, cultural, and political activism. *SilenceRadio.org* contains audio documentaries, sophisticated radio dramas, archival material, and raw field recordings. More than simply a space for sound and radio artists to promote their work, *SilenceRadio.org* is a creative project in and of itself. Viewers and/or listeners access audio works by selecting felted color spots. The interface is as obscure as it is simple—the spot colors indicate mood of the audio piece; each work is described briefly and includes links for downloading, sharing, or embedding. Currently with 129 works from more than ninety artists, *SilenceRadio.org* is a growing and vital resource for emerging radio artwork.

Delia Derbyshire

b. 1937 Coventry, England; d. 2001
www.delia-derbyshire.org

Delia Derbyshire earned degrees in mathematics and music at Cambridge. Following university, she approached Decca records only to be told that the company did not hire women. Shortly thereafter, in 1960, she joined the BBC as a trainee studio manager. Some of her most acclaimed work was done in the 1960s in collaboration with the British artist and playwright Barry Bermange for the BBC's Third Programme, later renamed BBC Radio 3. There, Derbyshire composed and produced scores, incidental pieces, and themes for nearly 200 BBC Radio and BBC-TV programs. By the mid 1970s Derbyshire was disillusioned by the apparent future of electronic music and withdrew from the medium. In the musical dark ages to follow, she worked in a bookshop, an art gallery, and a museum. In the mid-1990s she noticed a change in the air and became aware of a return to the musical values that propelled her own practice. Shortly before her death in 2001, Derbyshire wrote:

> Working with people like Sonic Boom on pure electronic music has reinvigorated me. He is from a later generation but has always had an affinity with the music of the 60s. One of our first points of contact—the visionary work of Peter Zinovieff—has touched us both, and has been an inspiration. Now without the constraints of doing "applied music," my mind can fly free and pick up where I left off.

Doctor Who Theme Music (1964–1973)

While at the BBC Radiophonic Workshop, Derbyshire used *musique concrète* techniques to realize the score for the acclaimed cult soundtrack of *Doctor Who,* composed by Ron Grainer. The BBC Radiophonic Workshop was a sound-effects unit for the BBC, responsible for producing effects and new music for radio and television. The innovative and experimental techniques used by Derbyshire and her colleagues at the Workshop have significantly influenced electronic music composers ever since. In 1973, BBC Records & Tapes released a stereo mix of the *Doctor Who* theme music, prepared by Derbyshire and Paddy Kingsland (also of the Radiophonic Workshop). The 1973 version incorporates the famous *Doctor Who* cliffhanger scream and Brian Hodgson's TARDIS launch sound. In both editions, *Doctor Who Theme Music* made groundbreaking strides in electronic music composition prior to the widespread availability of music synthesizers.

Judy Dunaway

b. 1964 McComb, Mississippi
Lives and works in New York City
emedia.art.sunysb.edu/judydunaway

Judy Dunaway is an avant-garde composer, improviser, and conceptual sound artist who is primarily known for her sound works for latex balloons. Since 1990, Dunaway has created over thirty works for balloons as instruments and has also made this her main instrument for improvisation. Dunaway has presented her compositions and improvisations for balloons throughout North America and Europe at many venues and festivals, including Lincoln Center Out-of-Doors, Roulette, Experimental Intermedia, Soundlab, the New Museum, the Bang on a Can Festival, and ZKM. Her compositions for balloons include electronic and multimedia works, sound installations, and works that incorporate more traditional instrumentation such as string quartet, chorus, and Japanese koto. Dunaway's creative practice also includes projects rooted in social activism and cultural critique. In 2007, she founded a nonprofit educational online archive for audio art and activism concerning the rights of sex workers called *Sex Workers' Internet Radio Library.*

Duo for Radio Stations (1992)

Duo for Radio Stations is a surrealist take on the half-hour live radio show. The form follows a typical format for local small-town commercial radio prior to the Reagan-era corporate radio takeovers of the 1980s, and features a live talk show with hosts Judy Dunaway and Chris Nelson, music, and commercials. The broadcast concludes with a segue into the next faux program, *The Gospel Show*. *Duo for Radio Stations* was performed live on WFMU (New Jersey) and WKCR (New York City) in March of 1992. The project may be experienced individually or simultaneously. Listeners who are interested in the simultaneous experiences are instructed to freely manipulate their radio dials during the piece, providing an audience-participation aspect to the work. The broadcast includes fourteen live musicians in addition to prerecorded content. Besides the actual live transmission, recordings of various noises and types of static from radio and television signals (FM, AM, UHF, VHF, shortwave, etc.) are also included. Improvisation features heavily in the project and takes shape as the collaborating artists listen to the other simultaneous broadcast and respond with or against that signal.

FACING A FAMILY (1971)

VALIE EXPORT

b. 1940 Linz, Austria
Lives and works in Vienna
valieexport.org

VALIE EXPORT (written in all caps as an artist concept and logo) became the artist's assumed identity in 1967. VALIE EXPORT is a prodigious creator and considered an important contributor and pioneer in conceptual media art practice, including performance and film. Her artistic work comprises video environments, digital photography, installation, body performances, feature films, experimental films, documentaries, Expanded Cinema, conceptual photography, body-material interactions, Persona Performances, laser installations, objects, sculptures, and texts on contemporary art history and feminism. Expanding from Viennese Actionism, VALIE EXPORT's works reassert the female body as part of a complex feminist critique of women in cinema and conventional social precepts. VALIE EXPORT's work has been exhibited and presented widely. Solo exhibitions include the Museum of Modern Art Ludwig, Vienna; Akademie der Kunste, Berlin; Centre Georges Pompidou, Paris; and the Generali Foundation, Vienna, among others. She participated in Documenta 6 (1977) and Documenta 12 (2007), in Kassel. Her works are in prestigious international collections including Centre Georges Pompidou; Tate Modern, London; Museo Nacional Centro de Arte Reina Sofía, Madrid; and the Museum of Modern Art, New York City, to name only a selected few.

Among the earliest television interventions, *FACING A FAMILY* was originally broadcast on the Austrian Network television program *Kontakte* on February 2, 1971. In *FACING A FAMILY*, a bourgeois Austrian family is observed watching television as they eat dinner. In a conceptual feedback exercise during the broadcast, it's assumed that other middle-class families would likely find themselves similarly together in front of the television during dinner. *FACING A FAMILY* broadcasts a mirror image to its viewers, simultaneously pointing out the complex relationship between viewer and subject, asserting an active role for the medium of television, and offering a societal critique about passive television usurping interactive communication among family members at the dinner table.

Hans Flesch

b. 1896 Frankfurt, Germany; d. 1945

Hans Flesch was the founding director of the *Berlin Radio Hour* during the Weimar Republic. Central to his radio career was the assertion that the medium of radio possesses specific properties that could be exploited in order to create new modes of information and performance. One of the first practitioners of radio art, Flesch advocated for the multi-directional broadcasting structure utilized in "ham" or amateur radio practices, deeming the mono-directional model utilized by state and commercial-run radio too easily utilized to manipulate the masses. According to Flesch, radio should only transmit programs of artistic value and should be experimental in nature. He created a series of avant-garde compositions that were broadcast from 1924–1934. Flesch collaborated with Hans Bodenstedt in the creation of sound works that documented German cityscapes. In 1929, while the director at the Berlin Funkstunde, Flesch created a studio for electroacoustic and electronic music that was connected to the *Rundfunkversuchsstelle* (Radio Research Section). He commissioned works by composers, theoreticians, and artists like Walter Benjamin, Ernst Krenek, Paul Hindemith, Arnold Schönberg, Eugen Jochum, Kurt Weill, and Bertolt Brecht for German Radio.

Zauberei auf dem Sender (1924)

Zauberei auf dem Sender (Radio Magic) was the first Hörspiel broadcast on the German radio. It was broadcast from Frankfurt on October 24, 1924, exactly one year after the official launch of German public radio. The show was not recorded, owing to the lack of technology and facilities at the time and because of a general belief in the ephemeral character of the radio medium. Nevertheless, its script was published in a weekly journal in Frankfurt a few days after the broadcast. According to Flesch, *Zauberei auf dem Sender* was an experiment with the idea of grotesque and absurd radio making. The script was reinterpreted by a variety of radio stations on an international level. As a celebratory radio drama for the birth of radio itself, Flesch's *Zauberei auf dem Sender* tells the story of a radio station director who, along with other members of the station's team, confronts a constant wave of obstacles and nonsensical interferences in an effort to present the program. Combining real and fictional characters, noise, incomprehensible dialogues and bursts of experimental music, *Zauberei auf dem Sender* simulates the essence behind a radio transmission where the ethereal plane is disturbed by interferences and feedback operations vital for the radio signal's existence and propagation. Radio, and hence the protagonists of *Zauberei auf dem Sender*, escapes its unidirectional mode and dives into a dynamic and polyvalent game of forces and voices. Flesch's *Zauberei auf dem Sender* presents radio as it should be—a platform for the emergence of sound art and new forms of creative expression and dialogue. In the Fleschian conceptual spectrum, radio is essentially art. The script continues to resonate and has been reinterpreted by a variety of radio producers and artists internationally.

Lucio Fontana
b. 1899 Rosario, Argentina; d.1968

Lucio Fontana was an Italian-Argentine painter and sculptor who founded the Spatialist movement. He divided his time between Argentina and Italy, actively engaging with artists and art movements in both countries throughout his life. Having begun his career as a sculptor, in 1946, Fontana founded Academia Altamira, the avant-garde art school in Buenos Aires. The school's aims reflected Fontana's own, and students were encouraged to develop a new art form capable of reflecting the modern world's relationship with science and technology. It was through his connections with Academia Altamira that he first began to espouse his ideas, publishing the first Spatialist manifesto, *Manifesto Blanco,* with some of his students, in 1947. Beginning in 1949, Fontana began making *Buchi* (Holes), the painting series in which he punctured, and later slashed, canvases. That same year, Fontana further disavowed traditional painting in favor of multimedia forms that captured time and movement and began constructing the environments that would become characteristic of Spatialism. His desire to create a new aesthetic language by combining painting, architecture, and sculpture greatly influenced these installation works known as "Spatial Concepts." Fontana continued to experiment in the creation of this new art form throughout the remainder of his forty-year career.

Television Manifesto of the Spatial Movement
(1952)

The Spatialist group, led by Lucio Fontana, was invited to participate when television transmission began in Italy in 1952. On this occasion the group wrote an emphatic manifesto, which was delivered during the broadcast. The complete *Manifesto* is available on the comprehensive online resource Media Art Net and is excerpted here:

> For the first time throughout the world, we Spatialists are using television to transmit our new forms of art based on the concepts of space, to be understood from two points of view:

> The first concerns spaces that were once considered mysterious but that are now known and explored, and that we therefore use as plastic material:

> The second concerns the still unknown spaces of the cosmos—spaces to which we address ourselves as data of intuition and mystery, the typical data of art as divination.

> For us, television is a means that we have been waiting for to give completeness to our concepts …

Digital Folklore (2008)

Ralf Homann

b. 1962 Munich, Germany
Lives and works in Berlin
www.ralfhomann.info

Ralf Homann is an artist and sculptor who creates a diversity of work for, on, and with radio. His pieces are most often part of sculptural objects and larger installations, and they expose radio as a tool and motif of public art. In the early 1980s, Homann was member of the Munich media activist group Audionomix and the art collective Free Class. Later, he was the co-initiator of *no one is illegal,* at Documenta X's *Hybrid Workspace,* Kassel (1997). He also co-founded *schleuser.net* (1998), a long-term art project on undocumented migration and border issues. At the 51st Venice Biennial in 2005, Homann performed *Monoshow,* an ongoing series of radio programs that analyze the aesthetics of documentary and radio entertainment. From 1999–2007, he was a professor at Bauhaus University Weimar, where he was instrumental in the establishment of Germany's only experimental radio department, focused on a diversity of radiophonic production emphases, including radio journalism, radio art and installation, and radio drama. Emphasizing interactive projects, students in the department produce works for Internet radio, streaming transmissions, and other developing mobile formats. While at the department, Homann developed the Webradio platform radiostudio.org and aided in founding the student-run college radio station bauhaus.fm.

Ralf Homann's radio show, *Digital Folklore,* celebrates the sounds produced by the early home computer software BASICODE. Introduced by John Kemeny and Thomas Kurtz at Dartmouth College in the early 1960s, BASIC (Beginner's All-purpose Symbolic Instruction Code) was an early programming language. In an effort to target home computer hobbyists in the 1980s, Dutch Public Radio NOS, the BBC, and the East German radio stations DDR1 and DT64 broadcast software as part of their regular programs. Listeners recorded the broadcasts on compact cassettes and uploaded them onto their home computers via existing cassette ports. Dutch NOS invented a new standard for transmitting BASIC via FM and AM—BASICODE—as a kind of computing Esperanto in 1982. A 0-bit was represented by a single period of a 1200 Hz tone and a 1-bit was represented by two periods of a 2400 Hz tone. The whole program was broadcast as one large block with five-second 2400 Hz leaders and trailers. BBC and DDR radio soon followed suit and began broadcasting BASICODE transmissions as well. The culmination of an AIR-time residency at the free103point9 Wave Farm (Acra, New York), *Digital Folklore* recycled and remixed BASICODE transmissions to create a new form of music. Homann's sounds swing between contemporary easy listening radio stations and electronic beats more suitable for a dance floor—summoning listeners back in time via computing and musical artifacts of the 1980s. *Digital Folklore* was streamed live to the Web on October 3, 2008 from the Wave Farm's wood-stove cabin.

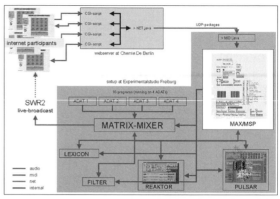

Michael Iber

b. 1965 Mannheim, Germany
Lives and Works in Berlin and Coburg
michael-iber.de

Michael Iber is a pianist, composer, electronic musician, and computer programmer. After receiving his classical training at the Royal Academy of Music in London, Iber became interested in the process of musical interpretation in a broader sense, leading to a differentiated understanding of a piece of art and its authorship. In the course of time, his artistic focus shifted from traditional instruments toward electronic music and computer programming. A strong proponent of open source music software, Iber is a passionate supporter of the Linux Audio community, as is reflected by his musical and aesthetic views put forth in numerous radio features and essays. Linux Audio is an online platform for composing, synthesizing, and recording. His radio program about free software and contemporary composing, *Wo die Quellen offen liegen: Freie Software und aktuelle Musik* (Where the Open Sources are Situated: Free Software and Current Music), features interviews and music by Linux Audio Developers and was broadcast on German State Radio in 2004.

INTEGER (INTErnet GEnerated Radio)
(2001)

INTEGER was a live performance broadcast on South West Broadcast German National Radio (SWR). *INTEGER* initially invited its listeners and performers to log on to the project's Website in order to choose from a pool of sixteen music programs and follow a set of rules that triggered the flow and content of music featured in the radio broadcast. A specially configured server sent the audience's clicks to a computer programmed (using mainly Max/MSP and Reaktor) to encode the incoming network media data (UDP) into MIDI data that controlled and manipulated the playlist. The number of clicks and their duration defined the action to be taken by the program. According to the rules, if, for example, there was only one click in between an interval of ten seconds, the computer would play the most frequently selected piece in its original version. If there were clicks in an interval smaller than four seconds, the software would switch to audio manipulation mode mapping the duration of mouse clicks to parameter values of a predefined storyboard of effects. If there was again no clicking for four seconds, *INTEGER* would then switch back to the unmodified most popular songs. During the twenty-two-minute performance in 2001, *INTEGER,* a hybrid form of multi-participatory cyber concert, counted 35,000 clicks generated by almost 500 participants.

Intermod Series

Established 1999, Chicago, Illinois
Based in Chicago
www.intermodseries.org

Intermodulation occurs when two or more signals mix, generating a new or modified signal. Launched in 1999, the Intermod Series engages through creative interference in urban spaces. Methods of propagation have included altering the electromagnetic field surrounding the power line network, FM radio and CB radio transmission, launching rockets in the city to alter the atmosphere, and a spotters' skywatch network and purging event. Developed to be participatory, the projects are free and distributed with 1-800 numbers, embroidered patches and stickers, radio monitoring frequencies, or online forums and journals. Intermod Series is designed, constructed, and presented by artist Brennan McGaffey. With the Intermod Series, McGaffey designs mailings and constructs objects that may be later used by participants in order to interrupt the normal signal flows that permeate everyday spaces and transmissions.

Selected Transmission Projects (2000–2005)

Audio Relay (2002, redesigned 2005) is a mobile and portable audio player that can accumulate and share homemade or unusual CDs as it travels to different locations. Other audio sources can plug into the line input jack. A four-watt transmitter is built into the unit for FM broadcasting. The *Audio Relay* runs off the power of a twelve-volt car battery, which can be charged using the solar panels provided. *Audio Relay* was developed collaboratively with the experimental space and organization, Temporary Services.

Project Citizens Band, 4 x Daily for 27 MHz (2000-2004) was a month-long broadcast over CB radio using prerecorded sounds designed to be mood altering. There were no voice-overs or songs. Four different audio tracks correspond to common emotions experienced at the scheduled time of day. These were transmitted for a five-minute duration, creating a sedative or stimulating effect. The broadcast was amplified to 225 watts to increase the chance for shortwave skip and reception over long distances. *Project Citizens Band, 4 x Daily for 27 MHz* was produced with Whitewalls, Inc., Chicago.

In *60 Hz, Remote Field Monitoring* (2000), originally broadcast for the Experimental Sound Studio (ESS), Outer Ear Festival of Sound 2000, a VLF radio was used to receive a live signal generated by the electrical power lines in and surrounding the ESS building in Chicago. This signal was rebroadcast over FM twenty-four hours a day for three weeks.

Ernst Jandl
b. 1925 Vienna, Austria; d. 2000

Friederike Mayröcker
b. 1924 Vienna, Austria
Lives and works in Vienna

Ernst Jandl was an experimental poet whose innovative poetics centered on concrete poetry's objectification of language. Deeply influenced by Gertrude Stein's work and closely associated with the avant-garde writing community the Vienna Group, Jandl split words from their semantic, phonetic, and syntactic contexts, imploring the reader to reconsider these poetic elements anew. These components were reconstructed via a method he defined as *Einübung des Ungewohnten* (Practicing of the Unusual), often emphasizing a single word or object that then became the key point of interest in a poem.

Friederike Mayröcker is an experimental poet whose work is comprised of Surrealist multi-layered constructions. Unlike her Vienna Group colleagues, her poetry emphasized the imaginative aspects of language rather than its concrete materialism. Utilizing various compositional strategies such as montage and citations, Mayröcker crafts everyday observations into dense textual innovations emphasizing the "magical" aspects of language.

Life partners from 1956 until Jandl's death in 2000, Ernst Jandl and Friederike Mayröcker collaborated on a multitude of projects in different contexts and media, including drawing, text, and radio art.

Fünf Mann Menschen (1968)

The story of *Fünf Mann Menschen* (Five Man Humanity), composed for Southwest German Radio, unfolds within thirteen poetic vignettes exploring the life of a complex human being—an entity consisting of five babies. During the play's fifteen minutes, the listener is exposed—as in a cinematic flashback—to five identical life cycles: the birth, upbringing and education, military service and time in the war, trial and imprisonment, and execution of the five babies. Whereas most radio drama of the time was considered as a sort of aural cinema for the ears combining speech, music, and sound effect, *Fünf Mann Menschen* epitomizes the *Neu Hörspiel* (New Radio Drama) developed during the 1960s in Germany. Emphasizing the acoustic properties of the composition, placing the listener squarely in the sonic experience of the play's unfolding, *Fünf Mann Menschen* served as the first critically acclaimed example of this new school of radio composition. Jandl and Mayröcker applied their personal poetic practices in every step of the process by abandoning the mainstream dialogue and music in favor of a mixture of concrete poetry, surrealist language montages, and unusual speech sounds.

Christian Jankowski

b. 1968 Göttingen, Germany
Lives and works in Berlin
www.lissongallery.com

Christian Jankowski is a multimedia conceptual artist whose works take form as installation, video, photography, performance, and literature. By combining different mediums or putting them in relation with each other, Jankowski's work utilizes the media of popular culture to critique the nature of contemporary art production. Most often, Jankowski collaborates with other individuals, including children, magicians, customs officials, artists, therapists, telephone psychics, and theologians, giving creative responsibility to his collaborators. These interactions typically involve a surprising turn of events and a subtle sense of humor. He is also interested in examining boundaries and relationships between fiction and reality, art and commerce, art and the public, and art and popular culture. The ubiquity of mass media in contemporary society and its inherently populist potentiality are clearly evident in Jankowski's work including *Holy Art Work* (2001), a collaboration with a television evangelist; and *Talk Athens* (2003), where the artist is the guest on a popular Greek talk show. Jankowski attended the Academy of Fine Arts in Hamburg, Germany and attracted significant international recognition at the 48th Venice Biennale in 1999. His work has been featured in solo exhibitions throughout Europe, and he made his U.S. debut in 2000 at the Wadsworth Atheneum, Hartford.

Telemistica (1999)

Telemistica, Jankowski's contribution to the 1999 Venice Biennale, is a video work comprised of conversations between the artist and several call-in psychics and astrologers. While in Venice preparing for the Biennale, Jankowski learned enough Italian to call several of these popular prophecy shows and ask about the success or failure of his work. Jankowski's questions include:

> "What will the public think about my work?"
>
> "Will they like it?"
>
> "Will I be successful?

The mystic not only provides Jankowski with his private prophecy, but also gains a greater significance as the work reflects back onto itself and predicts its success once it is exhibited in the Biennale.

Stubblefield's Black Box: An Intricate Game of Position (2004)

Tianna Kennedy

b. 1977 Merced, California
Lives and works in Hamden, New York and
New York City

Tianna Kennedy is experimental composer, musician, and multidisciplinary artist whose work aims to create points of public access for increasingly privatized public resources. Often performing with cello, Kennedy regularly collaborates with a staggering number and ever-changing collection of ensembles. Her experiments in transmission (which began in 2003 as monthly improvisatory radio broadcasts) include performances, installations, sculpture, sound, video, writing, and teaching. Kennedy served on transmission art organization free103point9's staff from 2003–2008. She was a founding member of the August Sound Coalition, an autonomous media project, which, in one manifestation, created a popular "Art and Action Radio" station coincident with the 2004 Republican National Convention and protests in New York City. Kennedy is also a founding member of the Empty Vessel Project, which centered on a derelict World War II Navy rescue boat reinterpreted as an action, art, and design center fostering projects focused on sustainable living in urban landscapes. Kennedy's work with the Andes Sprouts Society (ASsociety) in upstate New York is focused on community-supported agriculture and artists' residency project works toward the exchange of knowledge and labor of urban gardening and field farming with eco-bio-media issues from an international perspective.

Stubblefield's Black Box is a performance and installation conceived for the free103point9 Gallery in Brooklyn, New York in 2004. The title and concept of the piece refer to Nathan Stubblefield, a folk-hero figure in the history of radio, who was the inventor of early wireless communication through induction. Kennedy saw Stubblefield's black box, which as early as 1892 demonstrated wireless reception, as a metaphor for free103point9's exhibition space. The project consists of a series of site-specific low-powered radio and online-streamed broadcasts, creating both a local and networked community. Participants created music, radio plays, drawings, projection, mail art, and live improvisation that were mailed to free103point9, delivered to the event space during the broadcast, or performed live. Drawing inspiration from Alvin Lucier's *I am sitting in a room,* Kennedy envisioned *Stubblefield's Black Box* as a discrete enunciation, which would dissolve into noise with the progression of the project broadcasts. Although the resulting contributions—different and sometimes irrelevant to the desired effect—caused the project to deviate from this first assumption, *Stubblefield's Black Box: An Intricate Game of Position* proved to be a successful example of collaborative broadcast, fulfilled by interesting and surprising variations and dynamics.

Alison Knowles

b. 1933 New York, New York
Lives and works in New York City
aknowles.com

Alison Knowles is a visual artist known for her sound works, installations, performances, and books. As a founding member of Fluxus, Knowles produced a pioneering book object, a can of texts and beans called the *Bean Rolls* (1963). Since then, Knowles has consistently engaged in experimentation on the sculptural potential of the book, a consistent and important thread in her artistic practice. In 1967, Knowles produced "The House of Dust," possibly the first computerized poem, which she created with composer James Tenney following his informal seminar on computers in the arts held at her home with her husband Dick Higgins. Knowles has produced an important body of sounding objects. Her *Bean Turners* are constructed from beans and paper and are both book pages and sonic instruments. Distinct from her prodigious Events and live performances, Knowles has been active in sound since the late 1960s. In 1968, Knowles designed and co-edited John Cage's *Notations,* a book of visual music scores for the Something Else Press. Her *Bean Garden* (1971), installed at Charlotte Moorman's annual New York Festival of the Avant-Garde, amplified the sounds of people walking over a large platform covered with beans. In 2011, Knowles offered her iconic performance *The Identical Lunch* to museum visitors as part of the Museum of Modern Art's *Performance Exhibition Series.*

Bohnen Sequenzen (1982)

Knowles's interest in the effects of resonant sounds produced by beans and hard surfaces was explored in a series of radio programs broadcast by German station West Deutscher Rundfunk (WDR), where in 1982 she received the prestigious Karl Sczuka Prize for her radio work *Bohnen Sequenzen* (Bean Sequences). A humble and simple staple, beans have long occupied a central place in Knowles's artistic exploration. Texts derived from the scores of Knowles's WDR radio programs, and related live performance, were assembled and published in the volume *Spoken Text* in 1993. *Bean Sequences* opens the publication. On the first eighteen pages, the names of different types of beans in different languages are presented in various fonts, sometimes horizontally, sometimes going down the page. Hand-written texts encircle the bean names. Critic Karl Young writes:

> Beginning in the mechanics of evolution, this free association text includes the nutritional value of beans, the symbiosis of beans with other plants, fights for beans in Brazil, beans in religion, the symbolism of beans in dreams, beans as omens and as part of such folklore as banshees, and, of course, a story about a child who put a bean in his nose where it later sprouted.

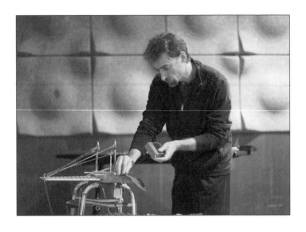

Sounds From Chicago (1988–1992)

Eric Leonardson

b. 1958 Elmhurst, Illinois
Lives and works in Chicago
ericleonardson.org

Eric Leonardson is an audio artist, sound designer, improviser, and radio artist with a background in visual art. He is a founder of the Midwest Society for Acoustic Ecology and director of the World Listening Project, founded in 2008. Leonardson performs in Chicago Phonography, a collective of field recordists and phonographers, and with Auris, a collective of new music composers and instrumentalists. In 1986 he helped found the Experimental Sound Studio, which at that time was the only nonprofit sonic arts organization in the Midwest. Leonardson is a founding member of Plasticene, an experimental physical theatre company for which he has designed sound, composed, and performed music since 1995. Many of Leonardson's musical efforts are distinguished by the unique sounds of the springboard—an electroacoustic coil spring instrument he built in 1994 to explore unusual electronic sounds created by haptic manipulation. He has toured and performed with the springboard internationally. Leonardson often works in collaboration with sound-radio artist Anna Friz, and together they have performed and been broadcast in the Deep Wireless Festival, Kunstradio, and Deutschlandradio. Leonardson is an adjunct associate professor at the School of the Art Institute of Chicago, Department of Sound and Contemporary Practices, where he has taught since 1997.

Sounds From Chicago is a thirty-program radio series featuring the work by over 100 Chicago-based artists. The series ran under Eric Leonardson's direction from 1989 until 1992 and was produced and distributed by Experimental Sound Studio. The initial impulse to start *Sounds From Chicago* came in 1988 when Neil Strauss invited Experimental Sound Studio to submit work by Chicago artists for airplay on WKCR in New York City. Rather than simply passing on tapes, Experimental Sound Studio made a formal series of radio programs promoting Chicago's diverse sonic arts and music communities. The series evolved under Leonardson's direction. Influenced by Hörspiel and the efforts in the U.S. to use radio as a unique medium for the transmission of sound as art, in the final year of *Sounds From Chicago*, open calls challenged artists to explore broadcast radio transmission as a medium with its own unique expressive possibilities. *Sounds From Chicago* was made available to radio stations free of charge and was heard on as many as thirty radio stations across North America and Europe. A printed catalogue was sent to station program directors to market the series, and to assist directors and DJs with speaking to their listeners about each program in the series.

Raphael Lyon

b. 1975 Albuquerque, New Mexico
Lives and works in New York City
mudboymusic.com

Raphael Lyon is a sound designer, musician, and installation artist. His work focuses on creating a sense of wonder in dark spaces, magic in the lit ones, and meditations on the shape of life as a primary practice. He performs under the moniker "mudboy" on a variety of home-built electronic keyboards and the occasional electroacoustic pipe organs. Lyon is also closely associated with the concept of "Dark Cinema" or the production of immersive sound-only narratives. He is interested in the cognitive effects and semiotic function of audio recordings and is currently developing a theory to describe the relationship between the use of sound in sound narratives and its relationship to the guided experiences found in hypnotic trance induction. Lyon graduated with honors with an art-semiotics degree from Brown University in 1998. He is a former member of Providence's Fort Thunder collective and entered the Columbia University Visual Arts MFA program in 2010. Lyon's recent installation work is designed to be exhibited in dark spaces and uses interactive LED technology to mimic the chaotic patterns found in the natural world. In addition, he also curates the label Free Matter for the Blind Records (Fm4tb), whose tag line is "Strange Sounds for Strange People."

Psicklops (2005)

Psicklops is a creative commons project, produced by Raphael Lyon and Fm4tb. The first work in a series of radical audio theatre recordings under the moniker "Dark Cinema"—an imageless film to be listened to—the conceptual standpoint of *Psicklops* questions the idea that the act of hearing cannot be represented or perceived physically and mentally. To this end, *Psicklops* combines the point-of-view vocabulary normally limited to gaze-based cinema with the abstraction inherit in audio works. Throughout the sixty-four-minute narrative, the audience is complicit in and anticipated by the work itself. A modern-day sequel to Franz Kafka's *The Trial*, *Psicklops* is composed as a multi-textured story collage of found sounds, guerrilla field recordings, sampled creative common works, studio actors, experimental electronics, and other mind-altering subsonic practices. The result is an invitation to a hypnotic journey, a one-way pass to a dark world of interrogation, surveillance, and modern-day capitalism. The 2005 *Psicklops* release included work by over two dozen artists and musicians and coincided with a series of international transmissions and screenings involving two dozen radio stations and over fifty different participating locations around the world.

Emmanuel Madan

b. 1970 Vancouver, Canada
Lives and works in Montreal
undefine.ca/artists/emmanuel-madan

Emmanuel Madan is a composer and sound artist. In 1993, he completed studies in electroacoustic composition under the direction of Francis Dhomont. Since 1998, his primary activities have centered on the reclamation and subversion or transformation of found sonic environments and artifacts. That same year, he co-founded the artistic collaboration [The User]with architect Thomas McIntosh. [The User]'s projects include the *Symphony for dot matrix printers* (2008), *Silophone* (ongoing since 2000), and *Coincidence Engines* (2009). He has been active as a community radio broadcaster since 1992, and his recent radio interventions include *A Series Of Broadcasts Addressing the Limitlessness of Time* (2006–2007), which aired weekly on CKUT-FM in Montreal; the experimental multi-channel transmission work *The Joy Channel* (2007–2008), co-created with Anna Friz. *The Joy Channel* takes the hybrid form of a science fiction style–radio drama and an experimental radio art piece. Three versions of the piece exist: a theatrical live performance using low-watt FM transmission, walkie-talkies, and a four-channel speaker system; a 5.1 surround-sound broadcast work; and a stereo recording for CD release and radio broadcast. Madan also works as an independent sound art curator, most recently on the *SIMULCAST* project, inviting sound and transmission artists to create a series of unchanging radio broadcasts.

FREEDOM HIGHWAY (2004)

FREEDOM HIGHWAY is a project about mass media and American public discourse. In the period between 9/11 and the start of the Iraq War, Madan made numerous road trips throughout the U.S. He covered thousands of miles, surveying the monoform landscape of the U.S. interstate system. Without a particular destination in mind, Madan's goal was to listen to and record talk radio programming. *FREEDOM HIGHWAY* is centered on a multi-voiced spoken narrative, derived from hundreds of individuals recorded in about twenty states. The resulting audio footage is assembled into an "audio self-portrait" of America as rendered by the nation's political and religious radio broadcasters, and as intercepted by a listener who is not the intended audience of these broadcasts. Madan writes:

> The AM radio band in the U.S. is a fascinating thing. Incredibly skewed towards the right wing, talk radio's domination by ultraconservatives politically and evangelicals religiously has played a major role in legitimizing and mainstreaming the ideological beliefs and policy priorities dominant during the Bush administration and now expressed by the Tea Party movement. While not ignoring the persuasive power of the genre, my primary interest is in talk radio as a cultural phenomenon.

Patrick McGinley

b. 1975 Wilkes-Barre, Pennsylvania
Lives and works in Põlvamaa, Estonia
murmerings.com

Patrick McGinley (aka Murmer) is an American-born sound, performance, and radio artist who has lived and worked in Europe since 1996. His work concentrates on the framing of sounds from the environment which normally pass through the ears unnoticed and unremarked, but which out of context become unrecognizable, alien, and extraordinary. Examples include crackling charcoal, a squeaking escalator, a buzzing insect, or one's own breath. From 1996 until 1998, McGinley lived in Paris, where he began his sound experiments while studying theatre. After moving to London in 1998, he began a collection of found sounds and found objects that would become the basis of his subsequent work. He has composed works for several theatre productions. In recent years, McGinley's presentations, workshops, and performances have been based on the exploration of site-specific sound, and sound as definition of space. In live performance, his initial interest in field recording has developed into an attempt to integrate and resonate found sounds, found objects, specific spaces, and moments in time, creating a direct and visceral link with an audience and location.

Framework (2002–ongoing)

Framework began broadcasting in June 2002 on Resonance104.4fm in London. At present, *Framework* broadcasts in two distinct alternating formats—a standard series constructed and mixed from contributions submitted by listeners and members of the field recording community; and a guest-curated series produced by artists from all corners of the globe based on their own themes, concepts, or recordings. Every edition begins with the text "open your ears and listen!" McGinley sees *Framework* as a tool in a new folk movement, and as a community-driven exchange point for creators and listeners alike. *Framework* presents the extremely diverse sound environments of the world along with the extremely diverse work that is being produced by the artists who choose to use these environments as their sonic sources. The work hopes to dispel any attempts to corner field recording as a style or genre, and to reveal it as an uncontrollable and indefinable instrument or tool that may be interpreted, manipulated, and appropriated by anyone with a microphone and an idea. *Framework* airs on six radio stations around the world, with more to follow soon, and streams and podcasts from its own Website.

Christof Migone

b. 1964 Geneva, Switzerland
Lives and works in Toronto
christofmigone.com

Christof Migone is a multidisciplinary artist and writer. His work and research delve into language, voice, bodies, performance, intimacy, complicity, and endurance. Migone co-edited the book and CD *Writing Aloud: The Sonics of Language*, and his writings have been published in *Aural Cultures*, *S:ON: Sound in Contemporary Canadian Art*, *Experimental Sound & Radio*, and *Radio Rethink: Art, Sound and Transmission*. He obtained a master's from Nova Scotia College of Art and Design in 1996 and a PhD from the Department of Performance Studies at the Tisch School of the Arts of New York University in 2007. He has released six solo audio CDs on various labels (Avatar, ND, Alien 8, Locust, and Oral). Migone frequently curates events and performs at various festivals. His installations have been exhibited widely. A monograph on his work, *Christof Migone—Sound Voice Perform*, was published in 2005. In 2006, the Galerie de l'UQAM presented a retrospective on his work accompanied by a catalogue and a DVD entitled *Christof Migone: Trou*. He is a lecturer at the University of Toronto, Mississauga and the director/curator of the Blackwood Gallery in Toronto.

Danger in Paradise (1987–1994)

Produced and hosted weekly from 1987 to 1994 on CKUT 90.3 FM, Radio McGill in Montreal, *Danger in Paradise* was a live-to-air series presenting projects that included listener participation and interaction. Typical programs included *Describe Yourself*, *Gridpubliclock*, and *Body Map*. *Describe Yourself* was concerned with defining the radiophonic through descriptions that callers gave of themselves. In *Gridpubliclock* the host welcomed the listening audience from the studio microphones and then immediately left the studio. The host then called from every public phone (in the era before cell phones) he encountered and asked the audience to tell him where to go next, receiving directions from the listening audience through their live-to-air calls. Here the ambience of the city leaked through each telephone booth and created a portrait of an "electrocuted" city. *Body Map* was presented with Julia Loktev. A reclining body was transposed onto a map of Montreal. People phoned in to discover on which part of the body they resided. They were asked to make a noise with their same body part, to describe how they moved around the body, and to say if they had any out-of-body experiences to share on the air.

Michelle Nagai

b. 1974 San Juan, Puerto Rico
Lives and Works in Princeton, New Jersey
michellenagai.com

Michelle Nagai is a composer, performance artist, and improviser who creates site-specific performances, installations, radio broadcasts, and other interactions that address the human state in relation to its setting. These works and activities explore the exchange of perception between performer and audience/viewer. Nagai recognizes transmission, reception, and "limbo" as continuously shifting, highly interactive states of being. She engages these states in her working process in order to open up the field of perception and action beyond that which she is herself capable of comprehending, making, or doing. Recent projects incorporate composed and improvised music for acoustic instruments and electronics, as well as work with natural environments; found objects; and video, textual, and material structures fabricated from a variety of media. Nagai's work has been presented throughout the U.S., Canada, and Europe and has received support from a variety of foundations and arts organizations. Nagai is a founding member of the American Society for Acoustic Ecology and former co-chair of the New York chapter of that organization.

EC(h)OLOCATOR (2003–2004)

EC(h)OLOCATOR originated in March 2003. In the eighteen months that followed, six live broadcasts as well as a number of public performances, talks, and soundwalks were realized in collaboration with independent campus and community radio stations in Canada and the U.S. Conceptually, *EC(h)OLOCATOR* engages with the idea that every place has a unique sonic character that impacts the emotional and physical lives of each organism living within its boundaries and that this sonic character is worthy of attention, study, and deeper understanding. Inspired by the sense of cooperative individualism that defines the "community" of community radio, and encouraged by the freedom to experiment that is one part of the ethos of transmission art, Nagai set out to create something that would subvert the "anywhere, anytime" homogeneity of most FM radio—something site-specific and undeniably local, yet moving beyond "local" in the traditional sense of local producers with familiar voices playing local favorites. The *EC(h)OLOCATOR* broadcasts include a combination of straight field recordings, live processing and mixing of all kinds of sounds, pre-edited material, call-in comments from listeners, and live vocal and/or ambient sound input.

Le son de l'amour
by Étienne Noiseau

Original language: French	English
Jingle : This is the Sound of love.	*Jingle :* This is the Sound of love.
Rires. Plusieurs personnes indistinctes : _ C'est vraiment bizarre, ce truc ! … _ Je sens que ça va être désagréable au possible. _ Moi aussi, j'ai pas envie. … _ Ça chatouille. _ Ah, ça donne la joie quand même, ce truc. _ Ah là là, non ! _ Ça, c'est génial ! … _ C'est pas mal, ça ne me laisse pas indifférente. … _ Ça chatouille, ça fait des frissons partout. _ Oh, mon Dieu ! _ On sait pas quoi dire, hein ? … _ C'est froid ! Ouh, oui. Oh non, ça c'est moins gai ! _ Et toi, Xavier ? _ Moi, je déteste.	*Laughter. Several indistinct people :* _ That thing is really strange! … _ I'm sure this is gonna be so unpleasant. _ Me too, I'm not in the mood. … _ It's tickling. _ Ah, that thing gives you joy, don't it? _ Ooh no! _ This is terrific! … _ Not bad. I'm not indifferent. … _ It's tickling, it's shivering all over. _ Oh my God! _ We don't know what to say, uh? … _ It's cold! Oh, yes. Oh, no, this is less funny! _ What about you, Xavier? _ Me? I hate it.
Jingle : This is the Sound of love.	*Jingle :* This is the Sound of love.
Ambiance : _ Ambiance ? _ Ouais. Et puis, euh, on fait un « son de l'amour »…	*Ambient :* _ Ambient ? _ Yeah. Then, er, we're gonna make a "sound of love"…
Animateur : Vous écoutez « le Son de l'amour ». On se retrouve : vous écoutez « le Son de l'amour ». Il est… oh non, ne parlons pas d'heure, ne parlons pas de temps, chassons le temps ! Je suis bien content de vous retrouver pour ces petites bulles d'émotion, ces petites bulles de son que vous m'envoyez régulièrement et que je vous sélectionne avec délectation tous les soirs. Ces émotions quotidiennes, provoquées ou enregistrées à la volée : ce qui nous importe, c'est d'avoir juste besoin de les entendre. C'est du plaisir avant tout, du désir. Voilà,	*DJ:* You're listening to "the Sound of love". We're meeting up: you're listening to "the Sound of love". It is… oh no, let's not talk about time, let's chase out time! I'm so happy to be with you again for these little spots of emotion, these little spots of sound that you regularly send me, that I am selecting every night with great delight. These everyday emotions, that you incited or recorded by chance: what only matters to us is the need of hearing them. Before anything else it's pleasure, it's desire. So, what moves you? What goes through

Étienne Noiseau

b. 1978 Le Mans, France

Lives and works in Ille, France

beaubruit.net

Étienne Noiseau is a sound artist and experimental radio producer. He works as a sound engineer for authors and artists, produces radio programs, and initiates workshops and artist residencies. Noiseau studied sound production in cinema and theatre at the National Institute of the Performing Arts in Brussels from 1999 to 2003 and wrote his dissertation on radio documentary. In Brussels, he became involved in Atelier de Création Sonore Radiophonique—an organization created in 1996 to develop a space for reflection and resistance to the alarming decline of creativity in the broadcasting institutes in francophone Belgium. On its behalf, he worked on documentation about sound and radio, co-ran experimental sound workshops, and organized the festivals *RADIOPHON'iC* (2003) and *Microphon'ic* (2004). Noiseau also co-founded *SilenceRadio.org*—a listening space on the Internet for contemporary creative radio. In Marseille, from 2005 to 2008, Noiseau managed the experimental studio Euphonia, associated with Radio Grenouille 88.8fm. He was responsible for Grenouille's participation in the Radia Network, an international network of independent and experimental cultural radio stations. Currently, Noiseau works as a sound artist and manages *Syntone.fr,* a blog for news and reviews of radio art.

Le son de l'amour (2006)

Le son de l'amour (The sound of love) is the name of a fictional call-in requests radio show. However, in *Le son de l'amour* it isn't music that is requested, but rather sounds from everyday life, sounds which move the program's faithful listeners. *Le son de l'amour* deals with loneliness and self-sacrifice. It is a celebration of sound on the radio and a self-reflection on communication with radio. Noiseau writes:

> When I conceived this work on the moving capacity of sound, at first I meant "emotion," then I discovered I wanted to experiment on sound "in motion" too: record people's bursting screams in a fair, make recordings in a car, fasten a stereo pair on a bike and a wireless lapel mic on a dog. In Art, I like open works. In traditional radio, narration tells you what to think. I wanted to make something different at the risk of bothering or disconcerting some listeners. That's why it starts like an (almost) ordinary radio show then, little by little, it opens on several possible interpretations. This DJ, is he a real one? Is he a pro or only pretending? Is he dreaming? Is he sick, or just delirious? Or is it the world around him that is not coherent anymore but surreal?

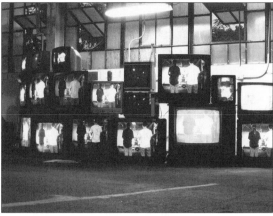

Ian Page

*b. 1985 Boston, Massachusetts
Lives and works in Pittsburgh
ianpage.net*

Ian Page is a Pittsburgh-based sculptor and video maker whose multimedia sculptures pair things like electricity and water, tape and magnets, and radio and concrete in order to explore the physicality of electricity and signal. In these pairings, Page pursues sculptural signal distortion and accentuates the physical side of transmission. In conjunction with his sculptural work, Page has also operated pirate TV stations in both Ohio and Pittsburgh. His video work, developed with broadcast television in mind, includes TV collage, live TV remix, and a demented fishing and cooking show. *Bondage Happens* (2010) is a two-week performance in which the artist attempts to condition his body to salivate each time his cell phone vibrates. Page is outfitted with a self-constructed electronic headpiece connected to his cell phone. Each time a call is received the device releases lemon juice into his mouth. In his single-channel video work, *Pleasant Momentum* (2010), a psychodrama unfolds within an intentionally low-tech and handcrafted environment. Here Page combines performance with primitive theatrical object-making. Page also curates video programs created by others for broadcast, and is active as a collaborator in the Miss Rockaway Armada art collective.

The End of Television (2009)

Page organized *The End of Television* as a video program, the beginning of which marked the end of analog television. On June 12th, 2009 the U.S. television broadcast signal changed over from analog to digital, requiring televisions to be outfitted with a special converter box in order to receive a broadcast signal. Through an open submission process, Page collected approximately twenty hours of video from artists all around the world to mark the occasion. *The End of Television* aired through analog broadcast television on channel five in Pittsburgh. When broadcasters turned off their analog transmitters, *The End of Television* turned on its analog transmitter and broadcast the videos submitted for the program. Utilizing analog broadcast TV, a restricted and nearly obsolete medium, *The End of Television* reimagined the omnipresent media trope: "broadcast yourself." The program was shown on over forty television sets at the Nerve Gallery in Pittsburgh, where the exhibition opened with a broadcast and performance by the Histrionic Thought Experiment Cooperative (HiTEC). Seizing a moment when the country was particularly aware of TV, *The End of Television* attempted to be the last remaining analog TV station in the U.S.

103

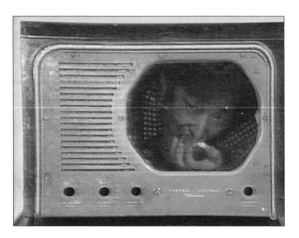

Nam June Paik

b. 1932 Seoul, South Korea; d. 2006
paikstudios.com

A seminal figure in the history of media art, Nam June Paik was prolific in video, composition, sculpture, installation, performance, and works for broadcast. When he was a student in Germany, Paik's early experiments were in music and performance. He became an important participant in the international Fluxus movement. In Germany, he collaborated with artists including Wolf Vostell and Joseph Beuys and met John Cage. Cage would become not only an important collaborator, but also a close friend and a powerful influence on the conceptual underpinnings of Paik's work at large. Paik's most notable Fluxus actions included prepared pianos and manipulated television sets. In 1964, Paik came to New York, coinciding with the first availability of the Sony Portapak. This portable video camera redirected Paik's focus toward the creation of a vast body of single-channel video work that catalyzed a movement of video works by artists. In New York Paik began his longtime collaboration with avant-garde cellist Charlotte Moorman, with whom he produced a series of important performance-based works. Paik's landmark installations and sculpture spanning four decades were featured in the major retrospective *Worlds of Nam June Paik* (2000), which premiered at the Solomon R. Guggenheim Museum in New York, and traveled to Bilbao, Spain and Seoul, South Korea. In 2008, two years following his death, the Nam June Paik Art Center opened in Yongin, South Korea.

Documenta 6 Satellite Telecast (1977)

Paik's experiments with satellite technology began in 1977 at Documenta 6 in Kassel, Germany. Lori Zippay, executive director of Electronic Arts Intermix, describes the single-channel video document of the work in the EAI Collection:

> In 1977, Documenta 6 featured the first live international satellite telecast by artists. Performances by Nam June Paik, German conceptual artist Joseph Beuys, and Douglas Davis were transmitted to over twenty-five countries. Paik and Charlotte Moorman are seen live from Kassel in Fluxus-inspired collaborative performances, including *TV Bra, TV Cello,* and *TV Bed.* They fuse music, performance, video, and television in an homage to global communications. Also from Kassel, Joseph Beuys presents a direct address to the public, elaborating on his utopian theories of art as "social sculpture," which were crucial to his conceptual project. From Caracas, Venezuela, Davis performs *The Last Nine Minutes,* a participatory piece in which he addresses the time/space distance between himself and the television viewing audience.

At what point will common sense prevail
(2008–2013)

Garrett Phelan

b. 1965 Dublin, Ireland
Lives and works in Dublin
garrettphelan.com

Garrett Phelan is an artist who works in media and processes including FM broadcast radio sculptures, video installations, sound installations, animation, drawing, online platforms, posters, and zines. Working both in gallery and non-gallery settings to create expansive works, Phelan acts as an antagonist or anti-editor, combining disparate information while refusing to draw distinctions or provide perspective. His preferred artistic method of communication and information dissemination is frequently in the guise of voice-based radio transmissions. In many of his works, he constructs narratives that parody an experience of the (re)presentation of the real, and one's physical engagement with the natural world. This recent work is intentionally intense, regurgitated, confused, and disjointed. Phelan has presented his work in numerous solo and group shows internationally. He represented Ireland in the Manifesta 5 European Biennial at San Sebastian, Spain in 2004 and at the Auckland Triennial in New Zealand in 2010. Phelan's solo exhibition *Between two ITs* was on view at SMART Project Space in Amsterdam in the spring of 2010, and many of the works shown there included site-specific transmissions. For example, in *Radio Tombs* radios emitted faint signals from within concrete sculptural tombs.

Garrett Phelan's online audio project *At what point will common sense prevail* consists of a series of FM broadcasts, performances, and installations, comprised of twenty-six sound works. The project is to be presented over a five-year period culminating in 2012 in archive form. Cumulative works deal with cognition and how the cognitive process is applied or called upon in conversation, discussion, and debate. Phelan generated a script for each of the sound pieces by instigating and contributing to online forums, ranging from forums on physics to religion. Responses to topics such as "Commitment to truth," "Youth isn't a defense," or "Change is our only Commonality" directly informed the scripts, which were then translated into different languages including French, Chinese, and Kirundi, and recorded by native speakers reading the scripts in their own languages. Using these recordings, each participant was then recorded a second time listening to his or her own voice in the first recording, while repeating the words in real time to produce "regurgitated monologues." Each participant is also visually documented in a portrait that accompanies the recordings in installations, performances, or radio broadcasts throughout the five-year period.

Paul Pörtner

b. 1925 Elberfeld, Germany; d. 1984

Paul Pörtner was a German writer, translator, and experimental radio producer. He began his career as a poet, eventually turning to experimental live theatre and radio plays. While working as a freelance writer, translator, and editor in Switzerland the 1950s, he established ties with various burgeoning avant-garde art movements in Europe. His literary interests began to deviate from an emphasis on semantic meaning and concise narratives toward the development of language games. He became affiliated with Lettrism—a politically-motivated French avant-garde art movement with roots in Dadaism and Surrealism—and began to create work centered upon devising a purely formal, objectified use of language which highlighted infra-linguistic phenomena. Inspired by his involvement with the Lettrists, Pörtner's interest in developing a new form of radio drama arose directly from a desire to subvert the mechanization of cultural life created by capitalism. This new radio aimed to emphasize and explore the relationship between text and sound, materializing the use of spoken language rather than focusing on the syntactical meaning derived from a narrative in the creation of sound games. Montage was the key technique utilized; Pörtner's compositions created playful interactions between disparate elements. From 1976 until his death, Pörtner served as the drama director for North German Radio.

Schallspielstudie (1964)

Schallspielstudie (Sound Play Study) was first presented on the Bavarian Broadcasting Network. A dense collage of voice and sound effects, this provocative work was created in the studio by applying a series of intentional and systematic electronic manipulations to language. Mark Cory translates Pörtner's words about Schallspielstudie in the foundational text *Wireless Imagination: Sound, Radio, and the Avant-Garde:*

> I trade the desk of an author for the studio of the sound engineer, my new syntax is the cut, my product is recorded over microphones, mixers, and filters on magnetic tape, the principle of montage creates a playful composition *(Spielwerk)* out of hundreds of particles.

Ezra Pound

b. 1885 Hailey, Idaho; d. 1972

Ezra Pound was an American poet and intellectual who was a prominent figure in modernist poetry. The epic poem *Cantos* is an exhaustive representation of Pound's poetry and technique. Pound left the U.S. in 1898 to travel in Europe, where he became an influential member of the artistic circles in London, Paris, and Italy. While in England, he was a close collaborator of William Butler Yeats and participated in the creation of Imagism and Vorticism—two literary movements that helped to bring public recognition to the work of James Joyce, C.S. Lewis, William Carlos Williams, Robert Frost, T. S. Eliot, and others. In 1920, Pound moved to Paris where he met Marcel Duchamp, Tristan Tzara, Fernand Léger and other representatives of the Dada and Surrealist movements. There he worked closely with avant-garde composer George Antheil for the creation of microtonal speech systems that would clearly reflect the music in the opera *Le Testament* (1924). In 1924 Pound relocated to Italy, where he spent most of his remaining life working on the completion of his *Cantos* and in a series of radio programs with strong sociopolitical criticism that brought him back to the U.S. to defend himself against charges of treason. Found incompetent to stand trial, Pound was hospitalized in Washington, D.C. from 1946 to 1958. After his release, Pound returned to Venice, where he died in 1972.

The Testament of François Villon (1931)

At the invitation of BBC producer Edward Harding, Pound began work on his first made-for-radio opera, on François Villon, the famed French poet, thief, and vagabond. Harding was knowledgeable in radio technique, technology, and theory and generously provided as much tutelage in this arena as was possible during the pair's brief meetings in Paris leading up to the broadcast. *The Testament of François Villon* was transmitted as a studio performance and was among the first electronically enhanced operas to be broadcast in Europe. The opera's screenplay, reproduced in Margaret Fisher's *Ezra Pound's Radio Operas: The BBC Experiments, 1931–1933,* demonstrates the significant role of these electronic effects, including recurring use of echo and fades.

Triangulation (2006–ongoing)

Radio Ruido/Tmm Mulligan

b. 1967 Oceanside, New York
Lives and Works in Yantacaw, New Jersey and
New York City
radioruidotriangulation.blogspot.com

Radio Ruido encompasses radio projects initiated by sound artist Tmm Mulligan, whose interests include radio art, free improvisation, noise, field recordings, and electronic versus folkloric traditions in music. Created both as solos and in collaboration, these projects entail composed installations as well as various improvised live sound situations. Often site-specific in content, Radio Ruido projects seek to challenge conventional concepts of radio as well as explore and challenge the physicality of the performance space. Tmm Mulligan has performed live with the audio-visual collective Dimmer and designed sound for Teatro Chinampa. He has exhibited at Deitch Projects, White Box, and Participant, Inc., in New York; at the Contemporary Museum in Baltimore; the Center for Contemporary Art Ujazdowski Castle in Warsaw. Radio Ruido produced *Triangulation* as a weekly online radio program for free103point9 from 2006 to 2010. Triangulation remains an active program and is now accessible online as *X>Triangulation>X*.

Triangulation is a weekly survey and forum hosted by Radio Ruido. A celebratory broadcast from Studio Cyclops in Brooklyn, *Triangulation* features live performances as well as experimental DJ mix sets. Tmm Mulligan writes:

> We listen openly to sounds and ideas from the worlds of experimental music and beyond. Finding fountains of song in both electronica and folklorica we also listen to field recordings, radio, magnetic phenomena and noise, as well the spoken or sung word in all languages. As sound unfolds around us as a live event as we all more relative to each other in time, we find it paradoxical to form a static view. Dynamically employing multiple angles we play a game of constant repositioning in order to get a find a locus that offers a better position for our ears and thoughts. The radio and web allows the expansion of this game on a global scale, allowing both immediacy as well as documentation in the process. Importantly both radio and the web invite live interaction via an electronic interface.

Pierre Schaeffer

b. 1910 Nancy, France; d. 1995

Pierre Schaeffer was a French composer, engineer, radio broadcaster, and musicologist most renowned for his work in experimental and electronic music. Schaeffer's research in communications and acoustics deepened while he was employed as a broadcaster at Radiodiffusion Française in Paris from 1936 until 1948. With Radiodiffusion Française's innovative equipment at his disposal, he developed the avant-garde musical form *musique concrète*. Reconceiving the uses to which phonographs could be put, he began manipulating gramophone records by increasing and decreasing the playing speed, playing them backwards, and creating disjunctive combinations between distinctive decontextualized sounds. Emphasizing natural and everyday sounds rather than musical or human compositions, *musique concrète* applied a seemingly counterintuitive approach to musical composition by abstracting the sounds of the world into musical units. Many of the techniques Schaeffer employed in the compositional process include splicing, looping, and collage, and comprise some of the most prevalent techniques used in contemporary music. Schaeffer broadcast his first public piece, *Étude aux Chemins de Fer* (Railroad Study), on Radiodiffusion Française in October 1948.

La Coquille à planètes (1948)

While working as a broadcaster at Radiodiffusion Française, Schaeffer wrote and produced the experimental radio opera *La Coquille à planètes* (Universe in a Shell) from 1943 to 1944. The opera integrated speech, music, and field-recorded sound in eight one-hour segments, which comprise the series and exemplify Shaeffer's enthusiasm for radiophonic expression. About radio technologies, Schaeffer writes:

> [They]are not content to retransmit what was given to them, they have begun—as if of their own accord—to make something. I anthropomorphize a little, but let's say that accidents are creative.

Apart from the music, which was composed by Claude Arrieu, Schaeffer undertook most of the production himself. It was during this process that he familiarized himself with turntables. This discovery informed his early record experiments and his theory around "sound objects." Intended to open a pathway to new perceptive form known as acousmatics, or reduced listening, the "sound object" highlighted particularities of sounds themselves as discrete units without origin. *La Coquille à planètes* was recorded at the Club d'Essai in Paris and broadcast on Radiodiffusion Française in 1948.

SG4L (Sending SGLLLL) (2006)

Leslie Sharpe

b. Medicine Hat, Alberta, Canada
Lives and works in Edmonton, Alberta and
Bloomington, Indiana
lesliesharpe.net

Leslie Sharpe's works manifest primarily as installation and locative, or mobile media. Her early works explore questions about subjectivity and embodiment, whereas recent projects address memory, history, climate change, and the politics of place using physical aspects of site and data related to the site (such as GPS, toxicity levels, etc.). *Northern Crossings* (2009) is a sculpture-sound-video installation using data and content from the Canadian North; *Speculations at the Remote* (2008–2009), is a video about oil in Alberta that was transmitted daily as cell phone video messages to the exhibition *RealTime08* in Dallas; *Fever* (2009) is a locative walk and performance for wearable electronics, cell phone, and accordion taking place at the sites of Guglielmo Marconi's first transatlantic wireless transfers in Newfoundland, Canada and Poldhu, UK. Fever is part of a larger series of projects using mobile media and wireless networks (Bluetooth and the Internet) to share, present, and distribute content gathered at the sites of Marconi's early wireless stations. Sharpe has exhibited internationally and has been an artist in residence at the Banff New Media Institute in Canada and at PS1 Institute of Contemporary Art in New York. She has taught at Indiana University-Bloomington; University of California-San Diego; and the Pratt Institute in Brooklyn, New York.

SG4L (Sending SGLLLL) is a series of audio and video podcasts created for the online exhibition *Surge,* co-organized by free103point9 and Rhizome. Sharpe's previous works used short-range Bluetooth wireless technologies to create ad hoc distribution networks in social events and performance. These distribute or install images and text on devices as part of an installation. *SG4L* was similarly created to be experienced on personal devices for an intimate small-screen experience, but used the Internet and RSS feeds as the means of transmission. *SG4L* is a loose multimedia narrative about a ghost that is actually a signal lost in one of Guglielmo Marconi's first transatlantic wireless transfers. Sharpe recorded visuals and sound for the project onsite and later edited these with other sound and imagery of her own creation. The narrative is also influenced by traditional folklore of the region, which has a strong narrative tradition—primarily ghost and fairy tales—about those lost at sea. *SG4L* is part of Sharpe's series of projects based on Marconi's early wireless stations. It poses questions about transmission space's possible otherworldly inhabitants as a means of exploring the conditions of embodiment or subjectivity in a wireless space.

The Video Gentlemen

Established 2007 Portland, Oregon
Based in Portland, Oregon and
Pittsburgh, Pennsylvania
thevideogentlemen.wordpress.com

Under the group moniker The Video Gentlemen, artists Carl Diehl, Jesse England, and Mack McFarland work with second-hand telecommunications detritus to facilitate independent, collaborative, and audience-participatory events and performances. Jesse England's work involves documentary projects, found-footage video works, live video performance, and experimental motion imaging methods. Carl Diehl's practice engages the abundance of residual media circulating through second-hand markets as signs of missing links rather than fossil traces. Characterized by humor, mysticism, chance, repetition, and the multi-sensory, Mack McFarland's video work and drawing invites the viewer to experience the intersection of the aesthetic and the cognitive. The three artists draw upon their individual experience in intermedia artwork as The Video Gentlemen. Their live television projects are the estranged relative of contemporary VJ performance and live media art. Before the institution of mass-mediated schedules and scripted routines, live television was spontaneous, subject to improvisation and unexpected occurrences. Countering mass-mediated culture with the potential of an immediate means of electronic cultural production, The Video Gentlemen return to these real-time roots, collapsing media histories and celebrating the possibilities of recombinant telemedia spaces.

BYOTV (2009)

In June 2009, the U.S. ceased analog broadcasting. Preempting this scheduled program of obsolescence, The Video Gentlemen presented *BYOTV,* offering a six-week season of special reports engaged with the techno-cultural turnover from analog to digital television. Transmitted from within the New American Art Union in Portland, Oregon, a variety of interdisciplinary artworks, live presentations, and freeform forays within the ether excited inquisitive constellations around topics including e-waste, surveillance, haunted media, and media archeology. Low-wattage transmissions emanated from an array of reconfigured electronic detritus distributed around the gallery. Telecommunication, and the distance implicit in its operation, was countered by a physical proximity prescribed by the limited range of the *BYOTV* transmissions. Weekly rotations of eclectic programming were comprised primarily of single-channel works culled from an open call. Over twenty local, national, and international artists' works critically and creatively engaged with televisual technoculture were included. Visitors were encouraged to "bring their own TV" or borrow one from the gallery in order to intercept and engage transmissions from and within their immediate air space.

Wolf Vostell

b. 1932 Leverkusen, Germany; d. 1998
museovostell.org

Wolf Vostell was a German painter, sculptor, noise musician, and performance artist who was one of the original members of the Fluxus movement in the 1960s. Vostell spent most of the 1950s studying lithography and art in Düsseldorf and Paris, where, working with billboard posters, he developed the dé-coll/age practice that would become an important motif in his career. With dé-coll/age, Vostell's acts of destruction intuitively reflected the political motives behind his artworks. Often working with appropriated, readymade materials, he preferred to combine several types of media in order to distance the materials from their identities as standardized, fabricated goods. This was a means of critiquing the capitalist drives that were beginning to permeate Western society at the time. With his intermedia artwork, collaborative actions, and large-scale environmental sculptures, he strove to create a heightened relationship between art and everyday life. Beginning with *The Theatre is on the Street* (1958), which incorporated automobile parts and televisions, Vostell devoted much of his artistic energy into creating Happenings that placed performance and installation in the streets and other public spaces. Vostell's *6 TV Dé-coll/ages* exhibited at the Smolin Gallery in New York in 1963, is among the earliest examples of televisions positioned as an interactive artistic material in a gallery or traditional exhibition setting.

TV for Millions (1959/1963)

Applying his dé-coll/age practice to television, Wolf Vostell's *TV for Millions* sought to distort the television picture reaching viewers by disrupting network broadcast signals. Inspired by images of malfunctioning televisions, *TV for Millions* would enact a temporary interruption in normal network programming—inserting three-minute blurred and disfigured imagery to initiate the piece. Millions of home viewers would presumably approach their television sets to adjust the controls effectively, becoming part of a collaborative performance that would further distort the signal. Following the three-minute static interlude, an anonymous announcer would instruct viewers to perform a series of Fluxus-inspired actions such as, "Hide your face, sit directly in front of the screen and brush your teeth, walk or crawl around the room and repeat everything said on the program, lie down under the bedcovers with a micro TV set, and feed the television set a TV dinner." By enacting such activities, viewers would create a performance within their own homes heightening their awareness of their relationship with the media platform. Though Vostell's vision for the broadcast never came to fruition, the piece exists in the form of several scores and a performance.

Sarah Washington

b. 1965 Redhill, Surrey, England
Lives and works in Ürzig, Germany
mobile-radio.net

Sarah Washington is a musician, instrument builder, teacher, writer, and broadcaster. Washington creates handmade electronic instruments by circuit bending toys, and utilizes ultrasonic devices and radio technology. She plays in several groups, including the experimental electronics duo Tonic Train, whose work explores the sensitivities of wild circuitry and radio feedback. In her ongoing experiments in broadcasting, she has produced hundreds of hours of radio art programs for the station Resonance104.4fm in London, which, as a director of the London Musicians' Collective, she helped create. As a co-founder of the Radia network, Washington seeks possibilities for international collaboration by forming new radio art projects with independent stations around the world. The Tate Modern in London showcased her series *Hearing in Tongues* (2007) as part of the institution's first radio art commission. To supplement her artistic work, Washington writes articles on radio and sound art, and teaches workshops for cultural institutions and universities across Europe.

Mobile Radio (2005–ongoing)

Sarah Washington, with Knut Aufermann, conceived of *Mobile Radio* in 2005 as an indefinite transmission portal enabling broadcasting to happen outside of the typical environment of a radio studio. Their key principles are ease of access and spontaneity. *Mobile Radio* is an ongoing touring project that enables Washington and Aufermann to provide technical and production skills to those who want to realize concepts through the medium of radio. Within *Mobile Radio,* three predominant ways of working have emerged for the artists. First, a traditional model of broadcasting utilizing a minimal setup is employed in unlikely settings. Purging the baggage that inhabits the artificial environment of the radio studio, the artists embrace the fact that broadcasts can be transmitted from any location with a stable Internet connection. Next, employing low-powered portable transmitters, Washington and Aufermann use narrowcasting as a performance tool. Finally, the artists look to radio technology as inspiration for their musical instrumentation. Using tiny transmitters as feedback and interference devices that complement other feedback and circuit-bent electronics, the transmitters become tools in concerts or create the bedrock of other radio transmissions and installations.

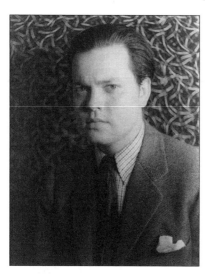

Orson Welles and The Mercury Theatre

b. 1915 Kenosha, Wisconsin; d. 1985
mercurytheatre.info

Orson Welles was an Academy Award-winning American director, writer, actor, and producer of works for theatre, film, radio, and television. In 1937, he formed the Mercury Theatre Company, one of America's most famous theatres, with John Houseman. Among the many productions they staged are *Julius Caeser,* set in fascist Italy, and a black *MacBeth* set in Haiti. A year later Welles, who was just finishing his season-long run on radio as "The Shadow," showcased the Mercury players on his own weekly radio series broadcast from New York City. The sixty-minute program was initiated on July 11, 1938 as *The Mercury Theatre on the Air.* The company produced many famous stories and plays, including *A Tale of Two Cities, The 39 Steps,* and *Dracula.* Innovative use of sound effects and music (by CBS staff composer/conductor Bernard Herrmann), combined with Welles's gripping performances made *The Mercury Theatre on the Air* one of the most compelling radio programs of its day. Following his *War of the Worlds* broadcast, Welles was offered a contract to direct two films that would establish him as one of film's most pioneering and inventive directors: *Citizen Kane* (1941) and *The Magnificent Ambersons* (1942). Welles directed fourteen and starred in more than fifty movies. He died in Los Angeles in 1985, a few hours after his last interview on *The Merv Griffin Show.*

The War of the Worlds (1938)

On the evening of October 30, 1938, The Mercury Theatre presented an updated version of H. G. Wells's *The War of the Worlds* (1898), adapted by Howard Koch and John Houseman for the airwaves, and directed, produced, and starring Orson Welles. This infamous Halloween broadcast was performed in the form of a CBS news bulletin, and created a massive wave of panic from radio listeners who believed that a Martian invasion was underway in Grover's Mill, New Jersey. While specific statistics around the reported widespread public reaction are the subject of debate, it seems certain that many listeners were alarmed. In 1938, radio audiences were unfamiliar with pseudo-documentary and would assume the content to be true. *The War of the Worlds* is an important marker in the historical trajectory of transmission art. Welles, Koch, Houseman, and their collaborators employ radio not only as a creative medium, but also as a means to subvert a listener's assumed trust of a broadcaster, highlighting the perils of one-way communication between transmitter and receiver. *The War of the Worlds* broadcast has inspired countless subsequent projects in the form of remakes, sequels, and conspiracy theories.

Gregory Whitehead

b. 1955 United States
Lives and works in Lenox, Massachusetts
gregorywhitehead.com

Gregory Whitehead is the writer, director, and producer of more than one hundred radio plays, essays, and acoustic works. His work has been broadcast on the BBC, Radio France, Australia's ABC, NPR, and other outlets. Drawing on his background in improvised music and experimental theatre, Whitehead has created a body of radiophonic work distinguished by its playfully provocative blend of text, concept, voice, music, and pure sound. In 2001, shortly before 9/11, he created a video installation at Location One gallery titled *Delivery System No. 1,* which explored the complicity of synchronized media heads within the rhythms of catastrophe. His imaginary documentation turned installation, *The Bone Trade,* centered on the buying and selling of celebrity body parts and was installed at MASS MoCA in 2003. Along with Douglas Kahn, Whitehead co-edited the influential anthology of writings on the history of radio and audio art *Wireless Imagination: sound radio and the avant-garde.* He has also authored numerous essays that explore the politics and paradoxes of radiophonic space and the diverse absurdities of the sociopolitical present. Whitehead is a frequent performer as well as a featured guest speaker at conferences and audio festivals throughout the U.S. and Europe.

Pressures of the Unspeakable:
A nervous system for the city of Sydney
(1991)

For *Pressures of the Unspeakable: A nervous system for the city of Sydney,* Whitehead spent several weeks in Sydney, Australia documenting the city's "screamscape." As "Resident Director of the International Institute for Screamscape Studies"—a fictive institution created for the piece—Whitehead collected screams for analysis. Through the establishment of a series of cross-media circuits, Whitehead attempts to transform the screamscape, both as an idea and as an acoustic phenomenon, into an "Invisible City," Sydney's nervous system. In Sydney, *Pressures of the Unspeakable* culminated in a broadcast, a radiophonic "theatre of operations." The institute consisted of three modes of production. First, Whitehead established a twenty-four-hour answering machine called the "screamline," at which people called and recorded themselves screaming into the telephone. He also opened a scream room within the Australian Broadcasting Corporation (ABC), where screams were also documented. Finally, Whitehead executed a concerted circulation of "scream discourse" within various news media: column eight, ABC television, and various talk/cultural affairs programs within ABC radio. The resulting work for broadcast combines selections from participating screamers in counterpoint with notes and ruminations on the fundamentals of scream discourse.

Public Works,
Interactive Networks,
and Tools

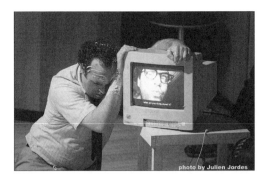
photo by Julien Jordes

31 Down Radio Theater

Established 2001 New York, New York
Based in New York City
31down.org

The company known as 31 Down Radio Theater creates dark performance-based works that explore sexual motivation as informed by the theatre company's interest in film noir. Their work emphasizes obsession, fear, voyeurism, and a critique of the media. Interactive systems, including new and old technologies, are intrinsic to the performances, all of which are automated and controlled by the performers onstage. This is how 31 Down describes the work:

> The overall scope of our work aims for a disorientation of the senses. Listening to a radio at the turn of the twentieth century tuned the world toward a different kind of perception—a disembodied voice and a remote sense of time and place. This complex sensation informs our visual tableau and aural landscape, which set out to put the audience into a dreamlike heightened state.

They incorporate physical computing and wireless radio technologies, including networked objects, interactive devices, MIDI, OSC, XBEE, and Bluetooth communications systems, telephone systems, and streaming servers in their performances and installations. Collaborators include these artists: Ryan Holsopple (founder, artistic director, sound design, performer), Shannon Sindelar (writing, direction), Mirit Tal (video), Jon Luton (lights), and Andreea Mincic (scenic design).

Canal Street Station (2007)

Canal Street Station is a public media art installation set in the labyrinthine Canal Street subway station in New York City. In this interactive telephone mystery, participants are invited to make toll-free calls from any pay phone inside the station's turnstiles. Upon calling, a recorded message places "players" in the shoes of private investigator Mike Sharpie. The project narrative follows Sharpie as he searches for a young Frenchwoman who may have committed a murder or who may, as participants discover, be a figment of his wandering imagination. As part of his plea for assistance, Sharpie offers participants a series of clues including maps, numbered doors, and other architectural signifiers from specified train platforms leading them to other pay telephones in order to retrieve new clues. The subway station platforms and stairwells are released from their traditional commuter function and are reinvented as a place for exploration. *Canal Street Station* was performed by Tajna Tanovic and Ryan Holsopple and presented March through October 2007 in conjunction with free103point9's tenth-anniversary celebration.

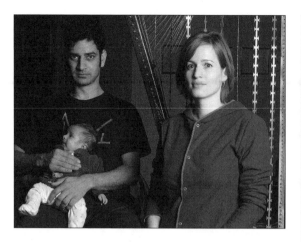

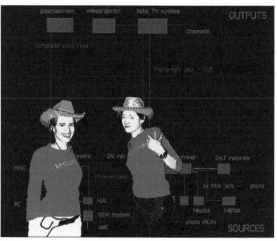

Ambient Information Systems

Established 1999 London, England
Based in London
ambientTV.NET

Ambient Information Systems is comprised of artists Manu Luksch (born 1970, in Vienna) and Mukul Patel (born 1971, in Bombay). Together, and in collaboration with numerous others, they create projects that explore the changing nature of human relationships with information in the era of digital networks. Live data broadcasting and transmission comprise the theme, media, and space for many of Ambient Information Systems's works, which take shape in installation, performance, documentary, dance, gastronomy, sound, and video. The intersections of social and technical infrastructures—such as access to information, privacy, and surveillance—are core issues for Ambient Information Systems; their work takes the form of collaborative media, community, and research-based projects informed by these ideas. Projects include: *FACE-LESS* (2007), a science fiction film composed entirely of closed circuit television images obtained via the UK Data Protection Act 1998; *Voluptuously Blinking Eye (VBI)* (2006), a curatorial lounge comprised of a directory of unscheduled broadcasts, a survey of illegal transmissions, and a reverse engineering of television broadcast technologies; *Orchestra of Anxiety* (2007), a participatory installation featuring instruments that use materials and technologies from surveillance industries. Participatory processes, creation of tools, and archiving and documentation are significant aspects of Ambient Information Systems's recent projects.

Broadbandit Highway (2001–2006)

Comprised of hundreds of live traffic surveillance streams, *Broadbandit Highway* is a self-generative video work with a staggering duration of 42,000 hours. The project, which was authored by Manu Luksch and Ilze Black, utilizes JavaScript to cull forty-second intervals from hundreds of traffic cams located around the world and assembles them for a closed-circuit television broadcast. It has been exhibited at galleries, festivals, and online. Each time a camera stream is disabled or retired, a black segment is visible as *Broadbandit Highway* cycles through the array of its sources. In April 2006, nearly five years following the project's inception, the final remaining traffic cam source ceased and *Broadbandit Highway* reached its conclusion. *Broadbandit Highway* premiered with a live soundtrack performed by Kate Rich and Sneha Solanki at "Please Disturb Me," a group exhibition at the Great Eastern Hotel in London, 2001.

Inter-section Radio (2004)

Inter-section Radio explores the diffusion of sound on the Internet. Programmers present ideas and modes for organizing content in a public forum. Participating artists then execute the ideas presented. The result is a collaborative selection process, which generates a playlist. The works included might range from seconds to hours in duration. These are chosen as a result of a conceptual framework or formula set forth rather than subscribing to the conventional parameters that commercial radio stations adhere to when assembling their programs. Content is selected, using Web radio both as media tool and transmission medium. At the heart of this project lies the will to create another kind of radio in contrast to Hertzian or Internet. *Inter-section Radio* is a conceptually driven project where durational programming finds a home in radio space without the restrictive constraints typically mandated by broadcast.

APO33

Established 1996 Nantes, France
Based in Nantes
apo33.org

APO33 is an interdisciplinary laboratory drawing on both artistic and technological fields of interest. APO33 fosters collective projects that unite research, experimentation, and social intervention. Founded by French multimedia artist Julien Ottavi, who serves as the artistic programmer, the APO33 collective works in the fields of sound art, free software, collaborative practices, micromedia, and urban and environmental mutations. Through their diverse roster of public programs including workshops and events, APO33 examines contemporary transformations in artistic and cultural practices that originate from the reappropriation and usage of communication and information technologies. In 2003, APO33 established RACCORPS, a place for creative experimentation within the framework of Web radio. In 2005, APO33 created OCTOPUS, an experimental radio network including a system of audio streaming exchanges and a visual cartography of the network, which was commissioned by the French multimedia centers Bandits-mages (Bourges), Labomedia (Orléans), and nUM-Esbat (Tours). APO33 continues to work across disciplinary fields, exploring possible passages and crossings between artistic creation and other social practices such as political activism; social mediation; urbanism; economy; ecology; human, environmental, natural, and applied sciences.

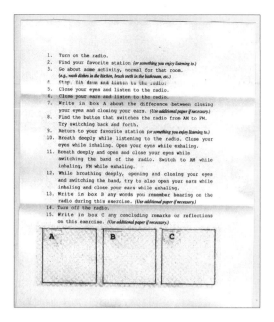

Alexis Bhagat

b. 1974 New York, New York
Lives and works in New York City

Alexis Bhagat's work is dedicated to the destruction of authorship and authority through the cultivation of new forms for radically polyvocal sound, transmission of promiscuous conversation, and obsessive never-ending correspondence. Bhagat speaks and writes on anarchism, prisons, and sound art. He is the curator of ((audience)), a nomadic festival of surround-sound compositions, and a founding member of the August Sound Coalition. Intrigued by the "lecture" as a form ripe for intervention, Bhagat's *Lecture on Democracy as Word and Brand* (2009) was commissioned by Parsons/The New School for Design as part of the exhibition *OURS: Democracy in the Age of Branding*. Bhagat is the co-editor, with Lize Mogel, of the widely acclaimed *An Atlas of Radical Cartography*. The project includes a collection of ten maps and ten essays about social issues from globalization to garbage, surveillance to extraordinary rendition, statelessness to visibility, and deportation to migration. *An Atlas of Radical Cartography* provokes new understandings of networks and representations of power and its effects on people and places, and asserts that these new perceptions of the world are the prerequisites of social change.

Instructions for Listening to Radio (2009)

Bhagat invites participation from the reader with his instructional work and event score. The reader performs the work by following instructions 1 through 15. An homage to works by Yoko Ono, John Cage, and Alison Knowles, this artwork literally exists in both the conception and realization, and is activated and realized through these actions. Instructions 1 through 11:

1. Turn on the radio.

2. Find your favorite station.

3. Go about some activity, normal for that room.

4. Stop. Sit down and listen to the radio.

5. Close your eyes and listen to the radio.

6. Close your ears and listen to the radio.

7. Write in box A about the difference between closing you eyes and closing your ears.

8. Find the button that switches the radio from AM to FM. Try switching back and forth.

9. Return to your favorite station.

10. Breathe deeply while listening to the radio. Close your eyes while inhaling. Open your eyes while exhaling.

11. Breathe deeply and open and close your eyes while switching the band of the radio. Switch to AM while inhaling, FM while exhaling.

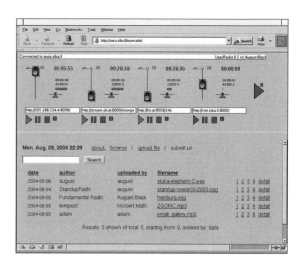

August Black

b. 1975 Baltimore, Maryland
Lives and Works in San Miguel de Allende,
Guanajuato, Mexico
aug.ment.org

August Black is an artist, researcher, and developer of new tools and instruments. His research is based in the intersection of culture, craft, and code. As a visual artist and programmer, Black has worked with electrocommunications and networked radio since the mid-1990s. His artistic work—a mix of radio, video/film, installation, and software—has been shown internationally at venues such as Ars Electronica Festival (Linz), Künstlerhaus (Graz), Pixelache Festival (Helsinki), InterCommunication Center (Tokyo), Transmediale Festival (Berlin), and Piksel Festival (Bergen). Black has produced weekly and monthly experimental radio programs for Austrian radio on Radio FRO 105 (Linz), and Radio Orange 94.0 (Vienna). In 1997, he co-founded the artist network Alien Productions, focused on cooperative projects with other artists, technicians, theorists, and scientists to create an open network of creative power, where specialists of different provenances work in an interdisciplinary way. In 2002, Black co-organized *Open Air: A Radiotopia for the Ars Electronica Festival* (Linz). Conceived as a utopian radio network for communication, exchange, and dialogue, *Radiotopia* aired sounds, poems, and other audio ephemera submitted from all over the world live on ORF Kunstradio in Vienna from September 8–12, 2002.

UserRadio (2002)

Aware of the historical efforts to employ technology for creative convergence, *UserRadio* mixes new (as of 2002) personal communication technologies with older broadcast radio technology. *UserRadio* makes available a set of tools for collaborative, networked audio production, where an unlimited number of individuals can mix multiple channels of audio simultaneously and together from anywhere online using a standard flash-capable browser. The audio output of the application is broadcast on terrestrial FM radio. Users, at any given iteration, are ideally within the broadcast diameter where latency between control commands sent through the *UserRadio* interface and the output on FM is minimal to none. *UserRadio* was initially programmed for the *Fundamental Radio* show on Radio FRO in Linz, Austria and used in the radio and communication project, *Open Air: A Radiotopia* to control the four sets of 100,000 watt speakers of the Ars Electronica Klangpark. *UserRadio* has also been integrated as part of the temporary FM stations Radio Oltranzista (Amsterdam), and Aaniradio (London).

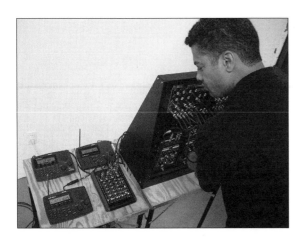

Kabir Carter

b. 1969 Los Angeles, California
Lives and works in New York City
kabircarter.com

Kabir Carter's work moves between performance and installation, focusing on the physical and emotional effects of architecture, acoustics, and communications technology in private and public spaces. His activities consist of an ongoing inter-rogation of complications and tensions that bind performer and audience in their respective uses of acoustic media. In temporarily modifying son-ic environments and corporeal sensations, Carter works both inside and outside of perceived human and nonhuman conditions to reveal changes in the embodiment of perception and feeling in to-day's media enriched world. In his projects he has employed low-power radio transmission and cap-turing technologies, analog sound synthesis, and a range of strategies borrowed from psychoacous-tics and architectural acoustics. Over the past five years, Carter's work has been presented at 16Bea-ver, apexart, Bronx Museum of the Arts, Diapason Gallery for Sound and Intermedia, d.u.m.b.o. arts center, PS122 Gallery, Socrates Sculpture Park, and the Studio Museum in Harlem, New York City. He has also shown his work in museums and galleries across the U.S. and abroad. He holds a master's from the Milton Avery Graduate School of the Arts at Bard College, where he was a Joseph Hartog Fellow in 2009.

Shared Frequencies (2001–2005)

Shared Frequencies was first realized on New York City sidewalks and has been installed in public plazas and museums, along several urban walk-ways, in front of numerous storefronts and oth-er buildings, and at various other art exhibition spaces. A portable sound installation, *Shared Fre-quencies* consists of a set of small folding tables, a modest array of radio scanners, a bank of ana-log synthesizer modules, and a flexible configu-ration of sound-mixing and projection devices. The radio scanners cycle through specific two-way radio frequencies to capture incidental and unpredictable contours of transmitted acoustic communications, interference, noise bursts, and inadvertently transduced environmental sounds. These dynamic and ever changing acoustic events are routed through and modulated with low pass filters, and further reshaped by additional analog sound synthesis processes to form temporary and abstract acoustic mappings of locally dispersed radiophonic energies. The mixture of electro-acoustic interactions in *Shared Frequencies* is also altered by the shape, volume, and ambient charac-teristics of each installation's site.

Carrie Dashow

b. 1971 Salem, Massachusetts
Lives and works in New York City
www.dashow.net

Carrie Dashow is an interdisciplinary artist working at the intersection of video, performance, and new media. Her work is often participatory and ranges from historically based community projects examining the undercurrents of space and storytelling to multichannel video performances and installations. Dashow approaches a diversity of mediums and practices, including drawing, painting, writing, song, book art, and clay to create experiential stories. She is the co-director, with Jesse Pearlman Karlsberg, of the Society for a Subliminal State, a historical society-like effort focused on the subconscious. In 2007, she toured New York State to assemble a narrative about New York, its land progress, industrialization, and utopianism—its "subliminal history." An artist in residence in New York City public schools from 1998 to 2006, she taught video and media literacy to staff and students through a variety of arts-in-education organizations and museums. Dashow holds a master's degree in integrated electronic arts from Rensselaer Polytechnic Institute in Troy, New York and a bachelor's in video and performance from the San Francisco Art Institute. She has taught video and new media classes at Rutgers, RPI, ICP, Pace University, and SUNY Purchase College. She is currently continuing her history- and land-based projects with an investigation into cemeteries at the Archive of Lost Thought.

The 13th Screen (2007)

The 13th Screen is designed as a democratic editing device. The hardware is to be used by communities as a collaborative tool or by individuals and audience members in an interactive and participatory performance setting. The machine repurposes a surveillance multiplexor. The image jumps, when cued by a person putting a hand over the lens for a second, causing the screen to go black. This black produces that view and everything after the black, to appear on the "edited" screen until an alternate camera is cued. The resulting assemblage is determined by the participants' "cutting" actions. *The 13th Screen* is shown as a multichannel installation or as a single-channel screen of automatically assembled cuts as cued by participants, live or recorded. The device was funded through NYSCA's Individual Artist grant in 2007 and the Experimental Television Center's Finishing Fund and was originally designed for the Subliminal History of New York State "Route of Progress" tour. The tour traveled to six towns, working with six local communities to create a publicly shown piece and demonstrated that something a community of people can create together one individual cannot possibly create alone. *The 13th Screen* was designed with the intention to provide an alternate view—inaccessible to a single individual and only achieved when viewed by a community.

Douglas Davis

b. 1933 Washington, D.C.
Lives and works in New York City

Douglas Davis is an artist, theorist, critic, teacher, and writer. Active in contemporary art since the 1960s, Davis was an art critic and editor for *Art in America* and *Newsweek*. Trained as a painter, Davis began creating Fluxus-inspired performance-based events in the late 1960s. Beginning in the 1970s, these performances often incorporated video and satellite technology. His live satellite performance/video works were groundbreaking exercises in the use of interactive technology as a medium for art and communications. During live performances in galleries and museums, and in his videotapes, Davis spoke directly to the camera, engaging in dialogue with the viewer in an attempt to supersede traditional, one-sided communication practices. His work has continued to evolve with technology. *The World's First Collaborative Sentence* (1994) is a Web-based platform upon which visitors may add their own contribution. Over 200,000 textual and pictorial contributions—in dozens of languages and styles—have been added thus far. His work has been the subject of solo exhibitions at the Centre Georges Pompidou (Paris), Metropolitan Museum of Art (New York), Everson Museum of Art (Syracuse), and The Kitchen (New York), among other institutions. Davis is the author of several books, including *Artculture: Essays on the Post-Modern, The Five Myths of TV Power or, Why the Medium is Not the Message,* and *Art and the Future: A History/Prophecy of the Collaboration Between Science, Technology, and Art.*

Electronic Hokkadim (1971)

Douglas Davis organized *Electronic Hokkadim* at the Corcoran Gallery of Art in Washington, D.C. in conjunction with WTOP-TV. *Electronic Hokkadim* was promoted as "the world's first participative telecast live while it is happening; the viewers create what they watch and hear at home." This influential event culminated with evening contributions from some of the most active artists and collectives experimenting in video at the time, including Peter Campus, Bruce Nauman, Nam June Paik, Raindance Corporation, and the Videofreex. Howard Wise, philanthropist, gallerist, and founder of Electronic Arts Intermix, delivered the keynote address, which is made available through Electronic Art Intermix's historical project *A Kinetic History: The EAI Archives Online.* A prophetic precursor to the challenges faced by future participatory and technology-based public projects, *Electronic Hokkadim* failed to wholly live up to its claims for achieving two-way communication through broadcast. However, it was a successful catalyst for much work and energy around creative television. *Electronic Hokkadim* was reprised in 1974 as part of *Open Circuits: An International Conference on the Future of Television,* a forum on artists and television at the Museum of Modern Art, New York.

Justin Downs

b. 1980 Detroit, Michigan
Lives and works in New York City
johnhenryshammer.com

Justin Downs earned his master's degree at the Interactive Telecommunications Program at New York University in 2008 and has worked in a variety of fields from construction to conservation. His projects are based in mesh networking, self-sustained technologies, building, and computer vision—all with a foundation of political activism. The primary issues that influence Downs's processes include social and psychological interpretation that defines interaction and mechanics between technologies and people. His work takes the form of new networks and technologies based on the abilities of cognitive and social processes. Through device design, Downs explores actions sustained by their environmental surroundings in the absence of a larger structured network. In his building methods, he works to create a transparency of action and structure that allows for a more accurate participation in a system. In addition to his own work, Downs designs and constructs work for many artists, including the Starn Twins *(Attracted to Light, The Carbon Arc Lamp,* and *Gravity of Light),* David Byrne *(Playing the Building),* and Amorphic Robot Works *(A Tree for Anable Basin and Inflatables).* He is a principal member of GRND LAB, a creative and collaborative studio and shop specializing in rapid prototyping, hardware, and software development, interactive design, and specialty fabrication.

Will o' the wisp (2009)

Will o' the wisp is an interactive installation, comprised of multiple networked solar-powered modules, housed in folkloric animal sculpture, installed at free103point9 Wave Farm (Acra, New York). Each module includes a speaker, solar panel, and power source. Viewers are guided from one module to the next by sound produced as each module's sensor is triggered by a viewer. The modules are mobile, and intended to be placed in a roundabout circle or pattern leading a viewer down a predetermined cyclical path. Each module is positioned at a distance from the next so that the modules remain on the periphery of discovery. Downs's original design intended to collect positional information as viewers/participants interact with the project. Data generated from the user's movements (based on the order in which each module was encountered and the length of time spent with each module) would create a sonic map of the mental interaction the user has with the piece. Because of yet-unresolved complications with the radio frequency (RF) system connectivity, this component of the project is unresolved. However, the collected data, code, and necessary technologies for the project are documented online in service to other projects tackling similar issues.

Public Radio (2007)

Simon Elvins

b. 1981 Kent, England
Lives and works in London
simonelvins.com

Simon Elvins is a designer and artist with a background in graphic design and print. Elvins's work is informed by his interest in the wider impact of communication design and how it is changing in contemporary cultures. This emphasis influenced the inclusion of sound and interaction design into his work and has formed the basis for an ongoing project at large that aims to create a better understanding of sound in the everyday environment, and how it can be incorporated into communication design. His recent works incorporate a multidisciplinary approach that utilizes a variety of media. In his *Paper Record Player,* Elvins constructed a fully working record player made only of paper and a series of audible notation scores using graphite. His *FM Radio Map* is an interactive silkscreen map that plots the location of London's commercial and pirate radio stations. Power lines drawn in pencil on the back of the map conduct electricity from the radio on the front of the poster, and by placing a metal pushpin onto each station the listener is able to hear the sound broadcast live from that location. His work has appeared in *The Map as Art: Contemporary Artists Explore Cartography, Rethinking the Power of Maps,* and *Creative Review.* Simon Elvins is also one-third of the collective St. Pierre & Miquelon, along with Julie Hill and Tom Mower.

Public Radio is a series of site-specific installations in public spaces across London. Each AM radio is built from found and secondhand components in order to create a radio from everyday materials by the simplest means possible. The radios are only complete and functional once they are installed in the public domain, latching onto the nearest pole, tree, or lamppost to create the coils required to power and tune them. The earth connection is literally plugging into the ground and the aerial is attaching to the highest point of the structure. This early and basic design, harnessing atmospheric electricity and radiant energy, requires no battery or main power supply, as the radio is powered from the energy within the radio waves themselves. With *Public Radio,* Elvins offers people a quiet spot to listen to radio within a busy city and to reconsider the invisible environment that radio constantly occupies around us all. In addition to its installations in public spaces, *Public Radio* was exhibited at *Deptford Design Market Challenge,* Royal Festival Hall, London. The exhibition was part of the 2007 London Design Festival, which included projects by twenty-seven international designers commissioned to redesign discarded objects from Deptford's thrift market.

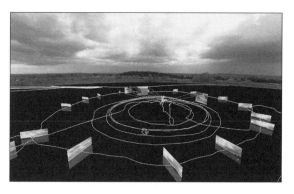

Simultaneous Echoes (2009)

Masaki Fujihata

b. 1956 Tokyo, Japan
Lives and works in Tokyo
fujihata.jp

Masaki Fujihata is a digital media artist who began working with computer graphics and animation in the 1980s. Among his best-known early works are his *Computer Generated Sculptures,* small-scale sculptures produced with so-called "Micro_Machine Technology" perceivable only with the use of a microscope. His more recent works are imbued with the special features unique to the newest technologies in interactive art, virtual reality, and networking. They continue to develop alongside technological advances, raising a variety of issues not yet articulated in earlier media. For instance, *Beyond Pages* (1995–1997) and *Global Interior Project #2* (1996) affirm Fujihata's pioneering vision to use technology in order to interact, augment, or question the audience's awareness and perception of reality. Attuned to this conceptual and creative framework are his *Field-Works* projects using GPS systems. *Field-Works* are ongoing projects initiated in the early 1990s. Highly acclaimed internationally, Masaki Fujihata's works and projects are born from his unique philosophy and playful ideas. Embracing the unique perspective that the realm of reality is likely more imperfect than its digital counterpart, Fujihata has sought, through use of new media, to fulfill this vision by transcending reality. Fujihata implores his audience to ponder reality's constructs and how it is perceived, and offers ways to approach and react to the new world order that will be created by the media of the future.

Simultaneous Echoes is the latest rendition of Masaki Fujihata's *Field-Works* series. This practice-based research project explores how fragmented musical elements, which were recorded in different locations and at different times, can be reconstructed in cyberspace to create an interactive, three-dimensional, and intuitive composition. The source materials featured in the piece are collected with a set of audio recording devices and video cameras. With the support of GPS technology, the data is sampled in collaboration with local music communities at specifically selected locations. The data is then imported onto a three-dimensional cyber map that is projected on the exhibition space and accessed by the visitor through a navigation wheel. The flow and order of the projected visuals and the musical composition vary, depending on the audience's perception cues and interests. *Simultaneous Echoes* serves as a unique testimony that the structure of cyberspace—the synthesis of movement, video, and position—can be used as a musical notation system in addition to organizing visual materials. *Simultaneous Echoes* innovatively reframes the process of producing whole data: recording, capturing, editing, and disseminating music and soundscapes.

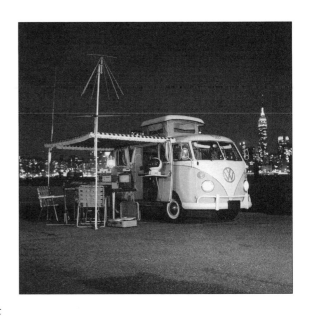

Gregory Green

b. 1959 Niagara Falls, New York
Lives and works in Tampa, Florida

Gregory Green is internationally recognized for his challenging work and the numerous controversies it has spawned in the U.S. and Europe. Since the mid-1980s, Green has created artworks and performances exploring systems of control and the evolution of individual and collective empowerment. Green's work considers the use of violence, alternatives to violence, and the accessibility of information and technology as vehicles for social or political change. Since 1992, he has installed at least thirty different "pirate" radio stations in more than twenty-six cities around the world. Referencing historical precedents and disturbing current events, Green's provocative works expand the parameters between art and activism, culture and social commentary. The subject of over twenty-six solo exhibitions and included in hundreds of group exhibitions, Green has played a significant role in the contemporary art discourse of the last twenty years. His work is represented in major public and private collections, namely the Museum of Contemporary Art, Los Angeles; the Tate Gallery, London; the Saatchi Gallery, London; the Museum of Modern Art, New York; the Whitney Museum of American Art, New York; and MAM-CO, Geneva, among others.

Green was a working artist in New York City for eighteen years before joining the faculty at the University of South Florida-Tampa, where he currently resides.

M.I.T.A.R.B.U. (mobile Internet, television and radio broadcast unit) (2000)

M.I.T.A.R.B.U. (Mobile Internet Television and Radio Broadcast Unit) is a fully restored 1967 Volkswagen camper van outfitted with a fully functional thirty-five-watt FM radio transmitter, 100-watt television transmitter, and Internet broadcast system. Inside the van, a modest sound and video recording studio and a computer system for continuous live streaming are also installed. The broadcast systems are capable of transmitting from the parked or moving van. The mobile unit serves as a romantic emblem of a potential media activist/anarchist mobile pirate broadcast studio. When installed for exhibition, *M.I.T.A.R.B.U.* becomes an open forum for an individual or group to utilize as a broadcast environment in which they may transmit any desired material; there is no curatorial agenda for content. *M.I.T.A.R.B.U.* explores the power of aesthetic intervention to access all forms of broadcast media as a vehicle for social growth and individual empowerment. Originally produced for an exhibition at Feigen Contemporary in New York City in 2000, *M.I.T.A.R.B.U.* was also exhibited at the Wexner Center in Columbus and Locust Projects in Miami. The work now resides in a private collection in Moscow.

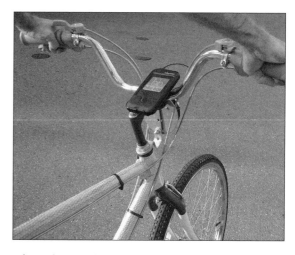

Sabine Gruffat

b. 1977 Bangkok, Thailand

Bill Brown

b. 1969 Cleveland, Ohio
Live and work in Madison, Wisconsin
www.sabinegruffat.com

Sabine Gruffat is an interdisciplinary media maker whose work seeks to redirect and manipulate the classification conventions as disseminated by cultural media production. She received her bachelor's from the Rhode Island School of Design and master's from the School of The Art Institute of Chicago. Currently, Gruffat is an assistant professor of digital media at the University of Wisconsin-Madison. Bill Brown's art making is an attempt to correlate geographical coordinates with conceptual ones. He is interested in physical landscapes and in uncovering the memories and histories folded up inside them. Among his films are *Roswell* (1995), *Confederation Park* (1999), *Buffalo Common* (2001), *Mountain State* (2003), *The Other Side* (2006), and *Chicago Corner* (2009). Brown's interest in exploring art after production, and the ways that art practice can be extended to the exhibition of artwork led to a number of film tours, such as *La Cyclo-Cinémathèque* (2007), a bike/movie tour across Europe conducted with Gruffat. *Time Machine* (2009) is an expanded cinema collaboration also undertaken by the two artists. In this project, they explore the implications of human interaction with a diverse set of analog and digital technologies and the ways these technologies allow us to access memories, engage and empower one's body, and conjure up impossible new worlds.

The Bike Box (2010)

The Bike Box is a mobile-media bicycle library and interactive installation, which allows participants to check out cheap, durable, technology-enhanced bikes and a free open-source iPhone application developed especially for the project. As participants pedal around central Brooklyn, they are able to offer site-specific audio through the iPhone application, as well as listen to a curated collection of geo-specific sounds provided by a variety of local land-use experts, historians, poets, artists, and other interpreters. Selected contributors include: John Bennet's contact microphone recordings of audio frequencies emitted by power transformers, electric lights, and air conditioners throughout Brooklyn; Jonny Farrow's solo soundwalks in the Brooklyn outback; Cathleen Grado's field recordings drawn from locations in Ridgewood and Bushwick, focusing on the contrasting sounds of rural and urban environments. *The Bike Box* hopes to give participants access to the layers of lived experience, personal anecdote, and history that are piled up invisibly on every street corner and city block. *The Bike Box* was developed as part of a free103point9 AIRtime fellowship and presented at the Devotion Gallery in Brooklyn, New York in 2010.

Linda Hilfling

b. 1976 Odense, Denmark
Lives and works in Copenhagen

Linda Hilfling is a Danish artist with a background in filmmaking, architecture, urban planning, and media design. Her interest in those fields is focused on the structures of which they are a part, and how artistic practices can conceive of alternative uses and functions of these fields in contemporary culture. Hilfling's work is centered on the premise of participation and public spaces within pre-existing media structures, recombining old and new, analog and digital, with a focus on means of control such as codes, organization, and law and their cultural impact. Her artistic practice takes the form of interventions reflecting upon or revealing hidden gaps in these structures. Hilfling's diverse body of work utilizes a wide range of media and socio-political concepts. Her works range from concepts for using ATMs or surveillance cameras as local media platforms to the *Misspelling Generator* (2008), an extension for the Web browser Firefox that circumvents Google's self-censorship and rigid information structure. Hilfling is also co-curator and initiator, with Kristoffer Gansing, of The Art of the Overhead, a media archeological festival, which pays tribute to the almost forgotten apparatus of the overhead projector. Hilfling has a master's in networked media from Piet Zwart Institute and bachelor's in architecture, in addition to her background in filmmaking.

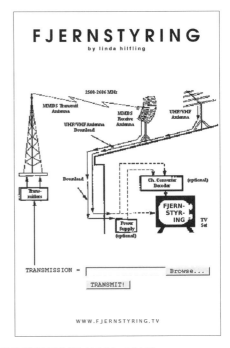

FJERNSTYRING (2008–2010)

FJERNSTYRING is a critical reflection on participatory media through participatory media. The transmission space of tv-tv, a non-commercial, artist-run television station based in Copenhagen, is extended into the living room and the hands of a viewer. Through a Web interface, a viewer is able to remote control the entire transmission. The *FJERNSTYRING* program comes in three default modes: "Radical," "Binary," and "Egalitarian." Each mode activates a different control structure for the viewer to interact with the transmission. Viewers may upload their own material to be transmitted at any time, but the mode will alter all material according to its particular premises of participation. For instance, the mode of "Radical" democracy allows the viewer to interrupt other viewers' transmissions whereas the mode of "Equal" alters the duration of all submitted material to be exactly the same. In the "Binary" mode viewers may turn off the transmission (for all viewers) completely, and then, if they wish, turn it on again. The transmission in itself is a live performance of the participants and the programmed control mechanisms in use. *FJERNSTYRING* problematizes control mechanisms, participation processes, and the paradox of so-called democratic media.

Ray Johnson

b. 1927 Detroit, Michigan; d. 1995
rayjohnsonestate.com

Ray Edward Johnson was a collage and performance artist based in New York. From 1945–1948, he studied at Black Mountain College under pioneering figures of the avant-garde art scene, including John Cage and Merce Cunningham. While in New York in the 1950s, he become part of the downtown art scene and developed ties with Andy Warhol, Jasper Johns, and Robert Rauschenberg, among others. His interest in Pop Art was initially expressed though his "moticos" or collages. His methodology included the re-usage, recycling, and cutting from a diverse set of materials. Even his own works were often subject to recapitulation. Johnson often commented that he preferred to refer to his art as "Chop-Art." In the late 1950s, Johnson began experimenting with the possibilities of mail art as an artistic practice for social networking and participation. The content of his mail art consisted mainly of conceptual games of texts and images, combined with instructions for the receiver/sender. In addition to his mail art, Johnson also developed a series of performances that he dubbed "Nothings" (in contrast to Allan Kaprow's "Happenings") in the 1960s. Johnson was considered a quintessential anti-artist. He rejected any form of popularity, celebrity, or fame. For many years, until his death in 1995, he staged performances and created artworks that satirized the art world and its conventions.

New York Correspondance School (1962)

Johnson used the postal system as part of an art practice that links people in a wide circle of exchange. Through his "mail art," Johnson sent highly conceptual images and texts to friends and acquaintances urging them to "Please Send To …" and later to "Please Add To & Return …" In 1962, a correspondent suggests the name New York Correspondence School (NYCS), a humorous play on the "art" schools that advertised on matchbook covers in the 1950s and 1960s and on the "correspondence" courses offering advanced degrees by mail. (Johnson changed the spelling from "correspondence" to "correspondance" to evoke the choreographed nature of these actions). Beginning in April 1968, Johnson distributed mailings, which called for "meetings" of the NYCS, where people sometimes came together (sometimes not) and often Johnson might perform a "Nothing." Many of his announcements were of fictive or virtual "meetings" of phantom "clubs." On April 5, 1973, Johnson sent a notice to *The New York Times* announcing the "death" of the New York Correspondance School. It is signed "Buddha University" with a bunny head. After this date, Johnson's mailing activities continue apace despite their announced "death." New club announcements, including the Spam Radio Club, continued into the late 1980s.

Eduardo Kac

b. 1962 Rio de Janeiro, Brazil
Lives and works in Chicago
ekac.org

Eduardo Kac is internationally recognized for his telepresence and bioart. A pioneer of telecommunications art in the pre-Web 1980s, Eduardo Kac (pronounced "Katz") emerged in the early 1990s with his radical works combining telerobotics and living organisms. His visionary integration of robotics, biology, and networking explores the fluidity of subject positions in the post-digital world. Kac's work has been exhibited internationally at venues such as Exit Art and Ronald Feldman Fine Arts (New York), Maison Européenne de la Photographie (Paris), Lieu Unique (Nantes), OK Contemporary Art Center (Linz), Fundación Telefónica (Buenos Aires), InterCommunication Center (ICC) (Tokyo), Seoul Museum of Art, and Zendai Museum of Modern Art (Shanghai). Kac's work has been showcased in biennials such as Yokohama Triennial, Japan, Gwangju Biennale, Korea, and Bienal de Sao Paulo, Brazil. His work is part of the permanent collection of the Museum of Modern Art (New York), the Museum of Modern Art (Valencia), the ZKM (Karlsruhe), and the Museum of Modern Art (Rio de Janeiro), among others. It has been featured in contemporary art publications, contemporary art books, and in the mass media. Kac has received many awards, including the Ars Electronica's Golden Nica Award, and lectures and publishes worldwide.

Interfaces (1990)

Interfaces is an interactive telecommunications work. This live exchange took place on December 10, 1990, between a group of artists in Chicago and another group in the Center For Creative Inquiry, at Carnegie Mellon University, Pittsburgh. The piece dynamically explores the formation and dissolution of identities online and establishes a visual dialogue between participants in a way that is purposefully similar to a verbal exchange between two people, bringing the improvised and spontaneous feedback loop of a personal conversation to the realm of video. This "visual conversation" explores the characteristic top-to-bottom, vertical rendering of slow-scan TV (SSTV) to produce unexpected faces in real time. In 1990, participants in Chicago were not aware of the exact images that would be transmitted by the Pittsburgh group and vice versa. This unpredictable situation added an element of surprise to the process. As images overlapped on the screen, parts of a face (from Pittsburgh, for example) were slowly scanned over another face (previously sent by the Chicago group). Successive faces were created in the virtual space of the screen as the performance progressed. It took approximately eight seconds to form each image on the screen. Participants in one location transmitted an image as soon as they received an image from the other location. Improvisational and unpredictable, *Interfaces* addresses the emergence of a "collective identity" through telematic networks.

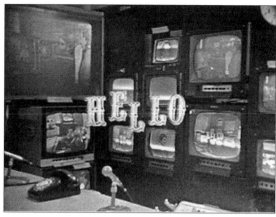

Hello (1969)

Allan Kaprow
b. 1927 Atlantic City, New Jersey; d. 2006

Allan Kaprow was a painter, assemblagist, critic, and the inventor of "Happenings." During his student years at the New York University and The New School for Social Research, Kaprow was introduced to ideas and methodologies that influenced his perception of art as a creative process inherent to life and social identity. Kaprow studied composition with John Cage and art history with Meyer Shapiro. It was the latter's paper, "The Social Bases of Art," from which Kaprow's idea of creating a form of art that asserts public participation and creative expression outside the studio was born. These acts were intended as a means of questioning the social organization imposed by the capitalist system, and would form the foundation of much of Kaprow's oeuvre. Kaprow coined the term "Happenings" for the public art performances in the 1950s and 1960s in which participants engaged in experimental, non-narrative activities in numerous non-institutional spaces. The focus of these performances was on the process of creating and not the product of creation—hence removing the works of art from traditional art markets and inserting them into the realm of everyday life. His book, *Essays on the Blurring of Art and Life,* compiles Kaprow's essays on un-art, Happenings, and the role of the avant-garde in everyday life, written between 1958 and 1990.

Hello was an interactive video Happening created in Boston as part of *The Medium is the Message,* an experimental television program produced by WGBH-TV. *Hello* explored the video and communications technologies that were newly emerging at the time, and their influence on human interactions. During the half-hour program, groups of people dispatched to various locations throughout Boston made contact with each other from four remote locations connected over a closed-circuit television network. Seeking their own images reflected back to them on a jumbled conglomeration of television monitors as well as the visages of familiar friends, the participants called out to one another, sending prescribed messages, such as "Hello, I see you," that were often not received by intended parties. Operating on the principles of randomness and chance that were prominent in his other Happenings, Kaprow acted as "director" of the program, manipulating the interactions from within a studio control room at the public television station. Creating disjunctive conversational flows by abruptly switching between the various video feeds, he emphasized the disruptive influence technology exerts over even the simplest communicative acts.

Kathy Kennedy

b. 1961 Gaspé, Quebec, Canada
Lives and works in Montreal
kathykennedy.ca

Kathy Kennedy is a sound artist with formal training in both visual art and classical singing. Kennedy works as a singer, performance artist, choral director, composer, and voice teacher. Her artistic practice involves the voice and its interface with technology. Her *Sonic Choreographies* series has been performed internationally, including at the inauguration of the Vancouver New Public Library and at Lincoln Center's Out-of-Doors Series. Her solo performances include a high level of improvisation over lush soundtracks of acutely mixed vocals and other sounds to create an immersive world of diverse voices. Kennedy is also involved in community-produced art, and is a founder of Studio XX, the digital media center for women in Canada, as well as the innovative choral groups for women, Choeur Maha and Esther. Together with artists Magali Babin, Nathalie Derome, and Daniel Mace, she created a twenty-eight-day CRTC-licensed community radio station, *Radio Jean-Talon,* in 2009. It focused on themes of neighborhood, culture, and storytelling and united often disparate cultural groups through radio. Kennedy also frequently gives lectures and workshops on listening skills, acoustic ecology, and vocal improvisation. She currently teaches electroacoustics and audio art at Concordia University in Montreal.

HMMM (2005)

Kathy Kennedy's multilayered performance project, *HMMM,* has been presented internationally since 2005. In each incarnation of *HMMM,* a group of participants hum extended tones for thirty minutes. Most are carrying portable radios, tuned to a broadcast of an earlier humming session. The sound of these many voices humming is like a sonic wash of soothing, organic tones across the urban soundscape. In some cases, merchants play the broadcast in their stores and restaurants. The sound is enveloping and omnipresent, and yet never loud in any place. People stroll through, experiencing constantly changing sonic mixes of vocal sound. The radio is generally used as an extension of the body in Kennedy's work—a bridge from one body to another. *HMMM* encapsulates her relationship with low-watt radio's fragility and physicality. Like a voice, it is ultimately individualistic and subject to so many kinds of suppression. Many ideas and exercises are drawn from the Deep Listening practice of Pauline Oliveros. In *HMMM,* citizens begin to interact with each other on the basis of sonic, nonverbal cues as opposed to the normal state of stasis from information overload. The habitual sidewalk becomes transformed and things become quieter as people begin to listen critically.

Tetsuo Kogawa

*b. 1941 Tokyo, Japan
Lives and works in Tokyo
anarchy.translocal.jp*

Tetsuo Kogawa is a performance artist who is widely credited with introducing free radio to Japan. Kogawa has taught countless workshops around the world showing people how to build their own FM transmitters with simple electronic components. A committed advocate of radical independent media, Kogawa crafts his political messages in multidisciplinary work combining criticism, performance, and activism. He has written over thirty books on radio art, media culture, philosophy, film, urban space, and micropolitics. Most recently, Kogawa combined the experimental and pirate aesthetics of the mini-FM (aka microradio) movement with Internet-streamed media. His many projects, which he describes under the umbrella *Radio Party*, combine transmitter workshops, radio art performance, airwave transmission, and streaming. Since 1995, Kogawa has authored the Website *Polymorphous Space*, devoted to media experiments of microradio, media technology, live streaming, and political art. He is a professor of media experiments in the Department of Communication Studies at Tokyo Keizai University and the director of the Goethe Archive Tokyo.

A Micro Radio Manifesto (2002, 2003, 2006)

In *A Micro Radio Manifesto*, Kogawa at once contextualizes the micro-radio movement within a historical framework and calls his readers to action. Kogawa writes:

> Today, our microscopic space is under technological control and surveillance. Our potentially diverse, multiple node polymorphous space is almost homogenized into a mass. Therefore we need [a] permanent effort to deconstruct this situation. In order to do this, to use a very low-power transmitter is worth trying. [A] small transmitter can be easily made by your own hands…. As a means to cover larger area[s], airwaves are wasteful and not ecological. Big radio is no more necessary. Sooner or later, large and global communication technologies will be integrated into the Internet. Radio, television, and telephone will become local nodes to it. … A new type of multimedia terminal linking to the Internet will appear. So it is the time when radio and television (and even telephone) must re-find their own emancipating possibility. Micro radio station[s] will re-find a possibility of getting-together space such as theatre[s] and club[s]. It will not reject global medium[s] but will use them as a linking and networking means.

Brandon LaBelle

b. 1969 Memphis, Tennessee
Lives and works in Berlin
errantbodies.org/labelle.html

Brandon LaBelle is an artist and writer working in sound, performance, and installation art since 1992. His work draws attention to the dynamics of sound as it is found within spaces, public events and interactions, and language and embodiment. Through a performative interaction with objects, found sound, and social dynamics, his work aims to unsettle existing situations to create forms of exchange. LaBelle's interest in site-specificity reflects a desire to consider the relationships and tensions between art and a broader social environment. Also a prolific author, his books include *Background Noise: Perspectives on Sound Art* and *Acoustic Territories: Sound Culture and Everyday Life.* His writings have also appeared in numerous books and journals, namely *Experimental Sound and Radio, Soundspace: Architecture for Sound and Vision,* and *Re-inventing Radio: Aspects of Radio Art.* For Errant Bodies Press, he co-edited the anthologies *Site of Sound: Of Architecture and the Ear, Writing Aloud: The Sonics of Language, Surface Tension: Problematics of Site,* and *Radio Territories.* The book *Radio Memory* documents his related installations, along with a CD of new work, making a small testament to the power of transmission.

Radio Flirt (2007)

Radio Flirt, a collaboration between Brandon La-Belle and James Webb, makes audible the secret narratives of buildings. Utilizing a series of wireless headphones and transmitters located throughout a building or environment, visitors are invited to follow traces of incomplete messages, hidden whispers, or trembling static that appear as an ambiguous and secret narrative. *Radio Flirt* is an intimate radio experience that explores the emotional geographies of listening. By working on-site, the artists strive to lace the work with site-specific reference, amplifying found details, drawing upon local legends, histories or mythologies, and creating narratives that bring into relief embedded details of the architecture and environment. Working with multiple transmitters all broadcasting on the same frequency, *Radio Flirt* creates a simultaneous and nonlinear audio guide, where each episode is nested within the building or location. Overall, the work plays with questions of sound, space, and the temporality of listening. By placing the work directly into the ears of visitors, sound is treated as an affective medium, generating encounters with the listener through tactile sound, voice, storytelling, and the ambiguity of multiple meanings. Using sound and transmission, *Radio Flirt* is an invisible interruption.

Sophea Lerner

b. 1969 Brighton, England
Lives and works in New Delhi
sophea.phonebox.org

Sophea Lerner is an Australian sonic media artist and broadcaster. Drawing on experience in group-devised physical performance and fifteen years of experimental radio and new media art, her collaborative art practice explores mediated temporal experience. Lerner's radio-making encompasses intricately composed radiophonic projects that are collectively devised, rapidly executed, semi-improvised live broadcasts. Community and creative networks are integral to collaborative aspects of her practice. From 2002 to 2007, Lerner taught media and sonic arts courses at the Center for Music and Technology in Helsinki. She has directed an experimental open-content FM/hybrid broadcast, *Project Ääniradio,* in Helsinki since 2004. She was the director of the Particle/Wave Festival of Hybrid Radio in 2005. In 2006, she was artist in residence at Sarai, New Delhi. Lerner has had numerous works commissioned and broadcast by ABC Radio Arts (Australia) and also has extensive experience with community broadcasting. Lerner's current research is focused on sound in public space, sustainable sonic arts practices in urban contexts, and participatory live radio practices. She is currently affiliated with Sarai, a program of the Center for the Study of Developing Societies in New Delhi, where she is engaged in practice-based research toward a doctor of creative arts at University of Technology, Sydney.

A Journey by Telephone (1995)

A Journey by Telephone explores the early history of the telephone, which, like radio, was imagined as a possible technology for communicating with the dead, a call which never got through among other missed calls, confessions, journeys, and dead ends. The lines and receivers themselves were the instruments through which an analog network was sounded out to gather these ghosts. The Wireless Telephone Ensemble was convened in Sydney to devise this project for FM broadcast throughout Australia. Members of the ensemble performed live in the studio following a score for telephones as instruments. Players interacted with other performers around Sydney and across the world, as well as timed connections with numerous automatic telephone systems. Also included were a variety of scripted and improvised materials and prerecorded answering machine messages gathered during devising workshops of the preceding months and embedded in a mix of telemetry sounds. *A Journey by Telephone* was performed and broadcast August 21, 1995, live from the Eugene Goossens Hall, ABC Ultimo, Sydney on *The Listening Room,* an acoustic art program on ABC Radio Classic FM.

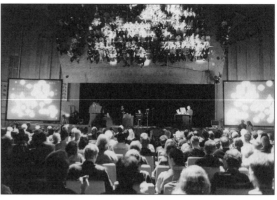

Golan Levin

b. 1972 New York, New York
Lives and works in Pittsburgh
flong.com

Golan Levin's artifacts and events explore supple new modes of reactive expression. Combining equal measures of the whimsical, the provocative, and the sublime in a wide variety of online, installation, and performance media, his work focuses on the design of systems for the creation, manipulation, and performance of simultaneous image and sound. Levin's projects form part of a more general inquiry into the formal language of interactivity and of nonverbal communications protocols in cybernetic systems. Through performances, digital artifacts, and virtual environments, often created with a variety of collaborators, Levin applies creative twists to digital technologies that highlight the human relationship with machines, make visible ways of interacting with each other, and explore the intersection of abstract communication and interactivity. Levin received undergraduate and graduate degrees from the MIT Media Laboratory, where he studied in the Aesthetics and Computation Group. Between degrees, he worked for four years as an interaction designer and research scientist at Interval Research Corporation (Palo Alto). Presently, Levin is director of the STUDIO for Creative Inquiry and associate professor of electronic time-based art at Carnegie Mellon University, where he also holds courtesy appointments in the School of Computer Science and the School of Design.

Dialtones (A Telesymphony) (2001)

Dialtones is a large-scale concert performance whose sounds are wholly produced through the carefully choreographed dialing and ringing of the audience's own mobile phones. As the exact location and tone of each participant's mobile phone can be known in advance, *Dialtones* affords a diverse range of unprecedented sonic phenomena and musically interesting structures. Moreover, by directing one's attention to the unexplored musical potential of a ubiquitous modern appliance, *Dialtones* inverts normative notions of private sound, public space, electromagnetic etiquette, and the fabric of the communications network that connects us. *Dialtones* begins with a brief preparation phase prior to its performance, during which the members of the audience register their wireless telephone numbers at a cluster of secure Web kiosks. In exchange for this information, the participants receive seating assignment tickets for the concert venue, and new ringtones are then automatically downloaded to their handsets. During the concert, audience members' mobile phones are brought to life by a small group of musicians, who perform the phones en masse by dialing them up with a specially designed, visual-musical software instrument.

LIGNA

Established 1997 Hamburg, Germany
Based in Hamburg

LIGNA is a free-radio group consisting of the media theorists and radio artists Ole Frahm, Michael Hueners, and Torsten Michaelsen. Since 1995, they have worked at the Freies Sender Kombinat (FSK)—a public nonprofit radio station in Hamburg—producing a biweekly program called *LIGNA's Music Box,* which asks the listeners to call in and play their favorite songs via the telephone. In numerous shows, interventions, and performances, LIGNA explores the effects of the dispersed radio voice and of radio as a means of dispersion in general. Their work often refers to remote possibilities of radio use in order to develop new formats of radio practices. Focusing on the reception side of radio, LIGNA explores tactics for turning the situation of reception into a performative intervention. Listening to the radio then becomes a collective production potentially bearing uncontrollable results. In addition to their *Radio Ballet* LIGNA's models of media usage include *Radio Concert for 144 Mobile Phones* (2003), which engages the radio listeners in a process of collective composition; *The Future of Radio Art* (2005), a monologue distributed over a pedestrian zone by means of hidden radios; *The New Man* (2008), theatre without actors, which engages the listening audience in a complex gestural interaction.

Radio Ballet (2002–2003)

Radio Ballet is a radio play produced for collective reception in public places. It gives the dispersed radio listeners the opportunity to subvert the regulations of the space. *Radio Ballet* took place in the main train stations of Hamburg (2002) and Leipzig (2003) Germany, both former public spaces that have been under private control of the German railway company since the mid-1990s. The station is controlled by a panoptic regime of surveillance cameras, security guards, and an architecture that avoids any dark and "dangerous" corners. The system of control keeps out every kind of deviant behavior. Those who sit down on the floor or start to beg are detected immediately and instantly expelled. *Radio Ballet* brought back these excluded gestures of deviant behavior into the main station. Around 500 participants—ordinary radio listeners—were invited to enter the station, equipped with cheap, portable radios and earphones. By means of these devices they could listen to a radio program consisting of a choreography suggesting permitted and forbidden gestures (to beg, to sit or lie down on the floor, etc.). Like ghostly remnants, the excluded gestures controlled public space and opened it for an uncanny and unbounded situation lasting the ninety minutes of the performance.

Kristina Lindström

b. 1976 Gothenburg, Sweden

Åsa Ståhl

b. 1976 Ljungby, Sweden
Live and work in Malmö
www.misplay.se

Åsa Ståhl and Kristina Lindström's joint artistic practice involves collaborations, stories, communication technology, and bodily experiences in public spaces including physical and digital platforms. Teaching and learning are integral parts of their creative efforts; they host workshops, write, and lecture on playful and non-anxious communication. Their collaboration started at the IT-research institute, the Interactive Institute, in 2004 with the art project *[visklek]*(2005)—the traditional children's game with worldwide equivalents ("Telephone" in English). In *[visklek]*, the artists employ network technologies and other channels of communication to create an ambiguous and open system for user appropriation. Since then, they have continued their practice-led artistic research concerning collaborative storytelling, processes, and structures for participation on different platforms. Their work includes soundwalks such as *Omvägar i ljud* (2007) and *Ljudstråk* (2006-2007), a sounding swing titled *Play in Reverse* (2007–2009), and their bicycle performance and installation, *Bike Circuit* (2009).

stitching together (2007–2009)

The project *stitching together* takes shape, as its name suggests, in a communal sewing circle. Tied to the idea that some text messages are digital detritus worthy of saving or transforming into the physical, the *stitching together* sewing circle stitches onto cloth the content of text messages provided by members of the public. These stitched textual fragments are then quilted together to create a larger narrative. Over twenty *stitching together* events have taken place since 2007 in Norway, Sweden, Mexico, and the U.S. Lindström and Ståhl write:

> Most of us have text messages in our mobile phones that we do not want to throw away. They are connected to places, situations, and people we love, hate, miss, and in any case have a relation to. In stitching together we invite you and other sms-users to share text messages and transform them into tangible and physical text messages made out of thread and fabric. We want to make it possible for you to make these intimate, digital treasures longer lasting and stitch together different techniques, different speeds, people of different ages, and different usage of communication channels.

Tony Martin

b. 1937 Knoxville, Tennessee
Lives and works in New York City and
Treadwell, New York
tonymartin.us

A founder of artworks using light, Tony Martin has created seminal new media works since the 1960s. In his works *The Well* (1969) and *Interaction Room* (1968), viewers influence the electronic systems that activate events between themselves and the sculpture or installed environment. Martin was awarded an NEA grant to develop *Vector Image Wall,* a constantly evolving electronically produced drawing made of spatial and moving lines of light that was shown in 1980 at PS1 Institute for Art and Urban Resources, New York. *Galaxy,* an artist Web project was commissioned by Electronic Arts Intermix in 2003. Originally a painter, Martin continues this practice, and his drawings and paintings have been exhibited internationally. Since 1962, Martin has simultaneously devoted himself to visual composing in time, using pure processes of light and projected imagery in motion. In his legendary visual compositions produced at the San Francisco Tape Music Center and Bill Graham's Fillmore West, Martin combined liquid projection, hand-painted 2 1/4 × 2 1/4 slides programmed for cross-dissolving, 16 mm film, and projected "pure" light in live performance. Providing an active role for the individual viewer within specific light environments, Martin has collaborated with Pauline Oliveros, Morton Subotnick, David Tudor, Anna Halprin, Merce Cunningham, and other composers and choreographers.

Light Pendulum (2009)

Light Pendulum is controlled by site-specific environmental conditions including light, sound, motion, and the viewer's positions and movements. *Light Pendulum* functions both as a stand-alone kinetic sculpture and as a temporal instrument for a setting inhabited by performers whose actions elicit responses from it. A five-inch diameter glass pendulum, which responds to the Earth's rotation and conditions of air movement by swinging, hangs suspended from the installation space ceiling by nylon string. A LED pin-spot installed at the top of the line illuminates the pendulum, the mirrored dish positioned beneath it, and the central space. Receptors and sensors are positioned at various places on and under the dish, functioning as photovoltaic cells and other current-producing and regulating components. The proximity, movement, and placement of viewers influence information derived from these sensors. Combined signals and circuits from them regulate three channels of audio along with three channels of ambient and projected visual imagery. These events derive directly from the participants' choice of stance and gestures. Thus, participants hear snippets of speech and changing music—a universe "turning the dial" and breaking in on them.

Kaffe Matthews

b. 1961 Essex, England
Lives and works in London
www.kaffematthews.net

Kaffe Matthews is a musician and sound artist who has been making new electroacoustic music with a system of self-designed software matrices through which she pulls and pushes different live sounds, since 1996. She performs with wide variety of instruments and sound sources, including violin and theremin, kite strings, NASA flight data, melting ice in Quebec, and vibrating wires in the West Australian Outback. She recently spent a month working with sharks and conservation scientists in the Galápagos Islands. Matthews established the collective research project *music for bodies* in 2006, making music to feel rather than just listen to through specialized sonic interfaces. With this practice she shifted to sonic furniture building, with *Sonic Bed London* (2006). The *Worldwide Bed* project aims to build twelve localized versions of the original *Sonic Bed* around the world. Thus far beds have been constructed in London; Shanghai; Taipei; Quebec; Stirling, Scotland; Marfa, Texas. In 2006, she was made an honorary professor of music at the Shanghai Music Conservatory in China and, in 2009, a patron of the Galápagos Conservation Trust shark project.

RADIO CYCLE 101.4-FM (2003)

RADIO CYCLE was a weeklong mobile stage and live radio station. It broadcast music, stories, and sounds chosen and made by visitors. The station's broadcast was distributed and amplified by teams of radio carrying cyclists who performed scores mapping out London's East End. Drawing parallels between Marconi's early wireless experiments and contemporary advanced communication technologies, *RADIO CYCLE* also served as an educational hub, providing interactive broadcasts and free guided workshops for participants who made music and choreographed cycling transmission maps. Matthews proffers:

> Imagine a bird's-eye view of Bow, East London. Imagine the shifting sound map that ebbs and flows with the passage of the day. Imagine a music that infiltrates that. Not just through several homes tuning into the same radio station at the same time, or a host of folk all being into the same CD at the same time. No. Imagine that piece playing from 50 small speakers, all moving through the streets in choreographed routes, individually, in small groups, or together. Quietly infiltrating the everyday noise of the city, like spiders, all in unison, maybe unnoticed, maybe coming together at some street corner to play some weird music or hear a story. Imagine that those sound pieces are made by you.

László Moholy-Nagy

b. 1895 Bácsborsód, Hungary; d. 1946
moholy-nagy.org

László Moholy-Nagy was a photographer, filmmaker, typographer, painter, sculptor, writer, graphic designer, stage designer, and teacher. He studied law in Budapest, and, soon after the outbreak of World War I, travel during his military service led him to the influential works of Russian Constructivists such as Kazimir Malevich, Naum Gabo, and El Lissitzky. His experimental attitude toward photography influenced the invention of a new technique he called the Photogram that involved layering objects over photographic paper exposed to light. The creative use of the shadow effect of objects over the paper produced photographs that resembled X-ray images. Moholy-Nagy landed in Berlin and joined the faculty of the Bauhaus school in 1923. During this time, he worked on kinetic sculptures and artifacts such as *Light-Space Modulator* (1928–30), which combined mechanical and electrical parts, light, color, and movement. Moholy-Nagy's artistic practices were based on his theory about the "New Vision" that he presented in detail in his book entitled *The New Vision*. His overall attitude toward arts was to be open to the use of technology as an integral part of the creative process. In 1937, Moholy-Nagy moved to Chicago to become the director of the New Bauhaus. Following the school's closing a year later, he joined together with other former faculty members to establish what became in 1944 the Institute of Design.

Telephone Pictures (1923)

While the majority of works characterized as the transmission arts genre make use of wireless technology, there is a notable history of telephone-based projects, which are indisputably aligned with the key ideas relating to transmission as an art form. For example, in Moholy-Nagy's *Telephone Pictures,* an idea is transmitted by one person and received by another. That the information may mutate in the process is significant. An accurate history of *Telephone Pictures* is difficult to ascertain, as there exist several conflicting accounts. In the artist's own recounting of the details a telephone is used to order five paintings from a sign factory. Both Moholy-Nagy, and the factory supervisor on the other end of the telephone, were equipped with identical graph paper. The artist then instructed the supervisor to draft the same image as his, using the graph paper's grid to identify where on the paper markings should be made. When the process was complete the supervisor's drawing was used to create the five enamel paintings requested by Moholy-Nagy. With *Telephone Pictures* Moholy-Nagy demonstrates an interest in the possibility of transmitting an artistic idea from one point of origin to another. Foreshadowing much of the contemporary discourse of the late twentieth century, here Moholy-Nagy explores issues of authorship in terms of concept versus fabrication, as well as the impact communication technologies was to have on the future at large.

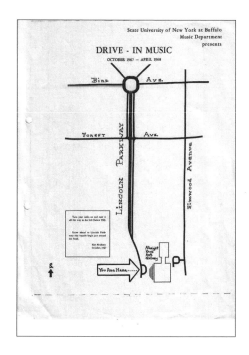

Max Neuhaus

b. 1939 Beaumont, Texas; d. 2009
max-neuhaus.info

Max Neuhaus was a percussionist and a pioneer in "sound installation," an expression that he purportedly coined. Neuhaus studied music at Manhattan School of Music, where he was exposed to experimental composers such as Henry Cowell, John Cage, Morton Feldman, and many others. His academic studies were followed by a professional and distinguished career as a percussionist with notable performances of Stockhausen's *Zyklus* and John Cage's *Fontana Mix.* Neuhaus experimented with the features and characteristics of percussive sounds and objects and the use of feedback, electronics, and other processes to amplify and modulate them. From the mid-1960s on, Neuhaus extended his practice in the areas of environmental sound and sound installations for public urban spaces, museums, and communities. Influential works in radio and transmission art include *Public Supply* (1966) and *Radio Net* (1977). Neuhaus was the first artist who through his practice (and theoretical standpoint) established sound as a dynamic entity that influences and implements the spaces it embraces. Neuhaus treated sound as independent art material and object. Important books documenting his work are *Max Neuhaus: Sound Works, vols. I-III,* and *Max Neuhaus—Times Square, Time Piece Beacon.*

Drive-in Music (1967–1968)

With *Drive-in Music,* Neuhaus breaks from his musical practices and begins his foray into sound installation, distinct from sound art in which performer and audience subscribe to conventional roles of maker and viewer/listener. Neuhaus installed twenty low-powered radio transmitters in the trees along a stretch of Lincoln Parkway in Buffalo, New York. As the transmitters were all tuned to the same frequency, people driving by heard different sets of sounds according to their speed, direction, weather conditions, and specific radio receiver. In his *Modus Operandi* text, Neuhaus describes the process:

> I decided to form the piece with a large number of these [transmitters]placed in different positions along a stretch of roadway, each one broadcasting a different continuous sound. Since the transmitters broadcast only a short distance I could shape the area covered by each sound by attaching an antenna wire and placing it in the shape I wanted that sound to occupy. It solved the accessibility/obligatory problem (a listener had to tune to the piece) and allowed a complex set of possibilities.

MATTHEW OSTROWSKI

Matthew Ostrowski

b. 1962 New York, New York
Lives and works New York City
ostrowski.info

Matthew Ostrowski has been active since the early 1980s, working in improvised music, electroacoustic composition, music theatre, and audio installations. An unreconstructed formalist with a continuing interest in density of microevents and rapid change, he has recently been most active exploring work in alternative controllers and multimedia installations. A graduate of Oberlin College and the Royal Conservatory in The Hague, he has worked in improvised music, theatre, multimedia installations, and electroacoustic composition. He has shared the stage with a diverse collection of musicians, including John Zorn, David Behrman, and a trio of Elvis impersonators. Ostrowski's work has been seen at festivals internationally. He has appeared on over a dozen recordings and develops custom software for musicians and installations. He recently premiered his electroacoustic work *Patterns of Changing Light* (2009) at Roulette in New York. His installation *Spectral City* (2007) was featured at the Dislocate festival in Yokohama, Japan. *A Theory of Meaning* (2006) is a radio work for synthesized voices and was created during a free103point9 artist residency at Wave Farm (Acra, New York). Ostrowski is active with the duo KRK, a collaboration with contrabassist George Cremaschi, and the audio/video trio Fair Use, specializing in sped-up versions of film classics.

atopia: levigation and apophenia (2004–2007)

An installation for downloaded data, *atopia: levigation and apophenia* creatively mediates the abundance of information available on the World Wide Web. The project is comprised of a Web-crawler operating in real time that selects from a list of starting URLs and progresses through every possible link connected to those pages—theoretically, an infinite number of sources. All of the data is downloaded onto a host computer and displayed both visually and sonically. The aural element returns the data to the bitstream in the form of sound and interprets all file types as if they were audio samples. This flattening is a stark reminder that however one may interpret the information received, it is ultimately only strings of ones and zeroes. As the files are being heard, the corresponding Web pages—disassociated from the links and instructions that create the impression of unity—are displayed and they assemble and disassemble themselves in a constantly shifting collage. Ostrowski conceives of the Web as an atopia, or nonexistent place devoid of an objective reality as locale or terminus. The work *atopia: levigation and apophenia* aims to decenter individual experience of the Web in order to bring awareness of the ways in which this technology permeates daily life and its experience.

147

Otto Piene

b. 1928 Bad Laasphe, Germany
Lives and works in Cambridge, Massachusetts and
Düsseldorf, Germany

Otto Piene is a German painter, sculptor, and environmental artist who has made artworks emphasizing the interplay of light, space, and movement for over fifty years. Piene's first *Grid Pictures* were stenciled painting patterns created using halftones of a single color (yellow, gold, silver, or white). They were shown in 1957 at his Düsseldorf studio. The pulsating patterns and hints of shadow prevalent in the *Grid Pictures* reflected the development of an interest in the link between nature, technology, and art that influenced subsequent experimentation in a variety of forms. His interest in nature came to the forefront of Piene's creative practice with his oil and smoke paintings, sky events, and kinetic air and light works. With Aldo Tambellini, he produced the experimental television program *Black Gate Cologne* (1968). In 1957, Piene, Heinz Mack, and Günther Uecker founded the arts group ZERO. The group published a journal under the same name from 1957 to 1961, and held numerous ZERO exhibitions from 1961 to 1966, including *ZERO-Lichtraum* (1964), a collaborative project presented at *Documenta 3* in Kassel, Germany. Piene co-founded the international ZERO Foundation, which houses the ZERO archives and documents and photos from related artists, in 2008. From 1974 until 1993, Piene was the director of the Center for Advanced Visual Studies at the Massachusetts Institute of Technology.

Electronic Light Ballet (1969)

Electronic Light Ballet combines themes from both Piene's light ballet and helium sculpture series. Created as part of the experimental television programs produced by WGBH-TV in Boston, *Electronic Light Ballet* presents a synesthetic experience involving light, air, and gases. Two images' sources are superimposed over one another: live documentation of a woman suspended above the WGBH parking lot, and a kinetic grid composed of morphing, colored dots. The helium sculpture—comprised of 800 feet of helium-inflated transparent polyethylene tubing in seven loops attached to the young woman via a network of ropes and parachute harnesses—was developed when Piene was a fellow at MIT's Center for Advanced Visual Studies. The woman slowly ascends into the air attached to a set of hot-air balloons, which are controlled from the ground. Illuminated via colored floodlights, the slowly developing, ethereal nighttime scene of the floating woman provides a surreal backdrop for the geometrical dot grid reminiscent of Piene's earlier multi-bulb light sculptures and events. In contrast to the helium sculpture's subdued pacing, the brightly hued light presentation resembles gas flares liquefying into morphed shapes that move among each other on the screen.

The Political Spectrum (2006)

Julian Priest

b. 1968 United Kingdom
Lives and works in Whanganui, New Zealand
julianpriest.org

Julian Priest is an artist and independent researcher living in New Zealand and working internationally. A co-founder of the early wireless free network community *Consume.net* in London, Priest became an activist and advocate for the free networking movement and pursues wireless networking as a theme in fields of arts, development, and policy. Priest has commented extensively on radio spectrum policy and co-founded the policy intervention group OpenSpectrum UK to advocate an open spectrum in the public interest in Europe and the UK. Since 2005, Priest has developed an artistic practice around participatory and collaborative forms. His works are exhibited internationally. Priest is currently focused on the physical and cultural boundaries between technology and the environment. He is director of the Green Bench project room in Whanganui, New Zealand and serves as a board member of the Aotearoa Digital Arts Trust.

The Political Spectrum explores radio spectrum regulation. The piece was performed during the *Waves* exhibition at the National Museum of Art in Riga, Latvia in August and September 2006. A six-meter whiteboard is used to represent the radio spectrum as an infinitely rewriteable medium for any possible communication or interaction. The museum represents "National Jurisdiction"; the curators represent "The Government"; the artist, Julian Priest, is "The Regulator"; and the visitors are the "The Public." Starting with a blank whiteboard, a data set is hand-drawn in a grid. The drawing contains a textual analysis of the European Radiocommunications Office (EFIS) frequency allocation tables of countries in the Baltic region. Each standardized name of a radio user group is ranked in a graph, depending on how many times it appears in the database so that the piece displays the relative successes of different groups in securing frequency allocation in different countries. In Riga, the public was invited to draw on the work in specific regions defined as the "The Regulator." As the *The Political Spectrum* develops through audience participation, the regulation gives way to freedom of expression and the public makes the white space its own.

Michelle Rosenberg

b. 1973 Manchester, England
Lives and works in New York City
michellerosenberg.com

Michelle Rosenberg is an artist and architect whose participatory installations investigate the manner in which people interact with sound. In a series of work called *Dynamic Headphones,* Rosenberg modifies portable headphones and creates acoustic headphones that reflect and filter live sound. These projects highlight sounds in the environment that may previously have gone unnoticed. *Auricles* (2005), was exhibited at Socrates Sculpture Park and free103point9 Wave Farm (Acra, New York). A series of mobile parabolic sound reflectors, one *Auricle* amplified lower frequencies such as traffic sounds to listeners standing in the focus point of the curve, while another amplified voices as well as leaves rustling in the wind, and a rambling stream on the Wave Farm property. In other installations, Rosenberg incorporates game calls and other noisemakers to animate objects and situations. Several of these public installations allow controlled communication with wildlife. Rosenberg attended the Skowhegan School for Painting and Sculpture in Maine and graduated from the Rhode Island School of Design with a bachelor of fine arts and bachelor of architecture. She recently lectured on the history of listening devices for Dorkbot-NYC at Location One in New York City.

Whistle Wall (2009–2010)

With *Whistle Wall,* Michelle Rosenberg embeds whistles in existing environments, integrating them into walls and other architectural features to create installations using the production of sound to facilitate physical, spatial, and social experiences. Visitors are provided with straws and invited to blow into wall-mounted face plates similar in appearance to electrical or data/phone receptacles. Blowing into the round-holed wall plates results in a whistling sound out of one of the many square-holed wall plates. Each sound produced has a different pitch and comes from a distinct location in relation to the body of the participant. Used alone, the whistle sounds map the physical parameters of the exhibition space. The difference between the location of the input of breath and output of sound is testament to the movement of breath through the inside of the built wall—creating an unfamiliar intimacy as the displacement of breath is understood and transmitted through sound. Used simultaneously with others, the wall introduces a social dynamic as the whistle sounds become a tool for communication or improvisational music. This interchange is directed by the whims of the participants, whose actions create a network of breath-powered, abstract tones.

Stephanie Rothenberg

b. 1967 Newark, New Jersey
Lives and works in Buffalo, New York and
New York City
pan-o-matic.com

Stephanie Rothenberg is an artist and educator creating provocative interactions that question the boundaries and social constructs of manufactured desires. Through participatory performance, installation, and networked media, her work investigates the mediation of the physical, analog body through the digital interfaces of commodity culture. Adopting the role of cultural anthropologist, the medium of the techno-sphere itself becomes a laboratory for raising critical questions about the public's interpersonal relationship to technology and its broader socio-political implications. In 2001, Rothenberg started "PAN-O-MATIC"—derived from panorama and automatic—as a conceptual framework for collaborative projects. She has lectured and exhibited in the U.S. and internationally. Rothenberg received her master's in 2003 from the Department of Film, Video, and New Media at the School of the Art Institute of Chicago. She is currently associate professor of visual studies at SUNY Buffalo, where she teaches courses in communication design and emerging practices.

Zero Hour (2005, 2008)

Zero Hour is a participatory radio performance that transforms city streets into a laboratory for experiments in subliminal communication. Using a storefront or public space as a control base station containing a Ramsey FM25B transmitter and TM100-Tru-Match FM broadcast antenna, a live broadcast is transmitted to the audience outside on the street through specialized headgear in the form of tinfoil hats outfitted with radio receivers and wireless microphones. These DIY devices allow the audience to eavesdrop on sounds culled from historic airtime propaganda, local radio stations, public transport service announcements, and the surrounding environment, while simultaneously redirecting their navigation through the urban landscape. The tinfoil hat, a homemade contraption popularized in 1930s science fiction and still used today, is believed to thwart hazardous mind-control rays emitted by aliens, the government, the military, and random evildoers. Used as a tool to *détourne* participants from the typical ways they navigate familiar public spaces, *Zero Hour* becomes a platform for reflecting on how public information impacts daily behaviors and shapes value systems.

Teri Rueb

b. 1968 Longmont, Colorado
Lives and works in Buffalo, New York and
New York City
terirueb.net

Teri Rueb is an artist whose work engages digital, architectural, and traditional modes of production using sound and wireless transmission media. Emerging from a practice founded in site-specific public art, Rueb has created GPS-based interactive sound installations since 1996. Her interactive soundwalks, sculptures, site-specific installations, and scholarly writings traverse the terrains of media, fine and performing arts, environmental art and design, architecture, landscape, and urbanism. In both practice and theory, Rueb promotes an ecological approach to interface art and design that emphasizes the deeply intertwined natures of art, science, technology, and the environment. Rueb has received numerous grants and commissions from institutions including the Edith Russ Site for Media Art, the Banff Center for the Arts, and the Boston Institute of Contemporary Art. She has lectured and presented her work internationally. Rueb was the recipient of a 2008 Prix Ars Electronica Award of Distinction in the Digital Musics category for her project *Core Sample.* Currently a professor of media study at SUNY Buffalo, Rueb is also the founder of Open Air Studio (Brooklyn, New York) and is a doctoral candidate at the Harvard University Graduate School of Design, where her research addresses constructions of landscape, the body, and subjectivity in mobile network culture.

Core Sample (2007)

Core Sample is a GPS-based interactive soundwalk and corresponding sound sculpture that evokes the material and cultural histories of Spectacle Island. The piece engages Boston Harbor's landscape as bound by the Boston Institute of Contemporary Art building on the downtown waterfront and Spectacle Island, a site that served as the city dump for over a century and was recently reclaimed as a landfill park visible off the coast. The two sites function dialogically: questioning what is seen versus what is not seen, what is preserved and recorded versus what is suppressed and denied. Visitors to the island borrow small computer and headphone units equipped with GPS and wander the island to hear sounds inspired by the island's complex material and cultural history. With over 250 sounds spatially and thematically organized according to elevation, the sounds play back automatically as the GPS senses the visitor's movement in the landscape evoking a metaphoric core sample that extends from the earth's core to the cosmos. Open cell headphones allow blurring to occur between actual and pre-recorded ambient sound as abstract sounds, field recordings, satellite radio samples, and musical compositions are sparsely punctuated with occasional passages of spoken word.

Willoughby Sharp

b. 1936 New York, New York; d. 2008
sharpville.ning.com

Willoughby Sharp was an American curator, author, publisher, media artist, and teacher. Sharp studied at Brown University, the University of Paris, and Columbia University before embarking on his first experimentations with film in 1967. That year, he created a number of films in 8 mm, Super 8, and 16 mm. Shortly after, Sharp began using video; he produced video sculpture, performance, installation work, and television programs. Sharp's work promoted the avant-garde, privileging the artist's view over that of the critics. His video work was influential in garnering wider audience attention for the work of many emerging and established artists of his time. *Videoviews* (1970–1974), a series of interview videos, presented Sharp's conversations with artists such as Bruce Nauman (1970), Joseph Beuys (1972), Vito Acconci (1973), and Chris Burden (1973). His interest was in communicating "through all available media" the work and ideas of artists he respected. This intention was demonstrated in more than twenty exhibitions he curated, including *Earth Art* (1969), *Air Art* (1968–1969), *Body Works* (1970), and *Videoperformance* (1974). With Liza Bear, Sharp co-published *Avalanche,* the acclaimed New York arts magazine, from 1970–1976. In his unpublished manuscript *Toward the Teleculture* (1967–2007), Sharp advocated for teleculture as a disembodied form of the global networked interchange of creative ideas and artifacts.

Send/Receive Satellite Network: Phase II (1977)

Send/Receive Satellite Network: Phase II was among the first live bi-directional artists' video exchanges to take place via satellite transmission. Organized by Sharp—with Liza Bear, Keith Sonnier, Duff Schweninger, and Paul Shavelson—as a demonstration of satellite technology's potential artistic uses, *Send/Receive Satellite Network: Phase II* resulted in a three-day transcontinental exchange between New York City and San Francisco. Transmission occurred between the NASA Ames Research Center in Mountain View, California, an ad hoc mobile satellite receiver and military infrared video system set up at the Battery Park City landfill, and a Manhattan Cable system downlink located in the Rector Street subway station in New York City. The artists conducted a discussion concerning the impact of new technologies on art, interspersed with live performances displayed on a split screen. An estimated 25,000 viewers witnessed the event, which was shown live on cable television in both San Francisco and New York. The teleconference resulted in a relatively disorganized display of the new satellite technology, but the process of creating the experimental demonstration was considered paramount in the organizer's aesthetic concerns.

Satellite Jockey (2005)

In *Satellite Jockey,* Rick Silva uses Google Earth software as a DJ or VJ would use turntables or a video mixer in live performance. Silva manipulates streaming landscapes and glitchy satellite imagery into live multimedia mixes and installations. A clever and effective use of GPS satellite imagery, *Satellite Jockey* performances are constantly refreshed, as Google expands and updates their Google Earth capabilities. As an installation, *Satellite Jockey* runs in playback mode accompanied by Silva's minimal electronica soundtrack. *Satellite Jockey* encompasses both the painterly and poetic qualities associated with landscape and travel, while simultaneously evoking more critical concerns around globalization and surveillance.

Rick Silva

b. 1977 São Paulo, Brazil
Lives and works in Calgary, Alberta, Canada
ricksilva.net

Rick Silva is a multifaceted digital media artist who has created as Rick Silva, Abe Linkoln, DJ Rabbi, and Cuechamp, among others. He received a bachelor's in film from the University of Colorado in 2001. His post-graduate work was at the European Graduate School in Switzerland and the University of Colorado-Boulder, where in 2007 he received a master's in digital art. In 2007–2008, he was visiting professor of digital media at the University of Georgia-Athens and is currently a permanent instructor of first-year studies/digital media and technology at the Alberta College of Art and Design, Calgary. Silva's artwork has been exhibited in festivals and museums on five continents. A recognized pioneer in new media art, his work has been written about in *The New York Times* and featured on *The CBS Evening News.* Silva has received grants and commissions from Turbulence, the National Endowment for the Arts, Rhizome.org, and the Whitney Museum of American art. He has performed his work live internationally.

Eva Sjuve

b. 1960 Sweden
Lives and works in New York City
moolab.net

Eva Sjuve is an artist, composer, and researcher whose work combines sound and performance with mobile technologies. She develops interfaces that reveal hidden structures within the intersection between the wireless sphere and the real and imagined worlds. Her projects are intended for networks targeted for audio and mobility in hardware and open-source software. One project, *audioTagger* (2007), uses sonic snapshots taken with mobile phones to create a map of everyday urban sounds from New York, Zürich, and Berlin. *GO Karamazov* (2007) wirelessly transmits information for auditory systems. It was commissioned by New Composers Series for *White Noise ll,* and used as part of a performance at PERFORMA07 in New York. *Ghost Scraper* (2009) is a solar-powered, networked apparatus used to search for sonic traces of ghosts and ether voices in the urban environment. Sjuve founded moolab, a collaborative research platform for emerging technologies with an emphasis on wireless platforms. Her work has been included in media festivals and museums throughout the world. Sjuve holds a master's degree from the interactive telecommunications program at New York University, and a double master's degree in art theory and theatre/film from Lund University, Sweden.

Fake Radio (2002)

Fake Radio is a digital interface, a musical instrument and a sound sculpture. Fake Radio is based on the concept of radio as an apparatus for reception in the wireless sphere, but here the sound is transmitted and not received. The audio is generated by a microcontroller, programmed to manage interaction with twelve channels of sound. *Fake Radio* can either be used in standalone mode with an internal speaker and headphones, or it can be connected to a computer and its sounds further processed using real-time audio software. For live performance, *Fake Radio* has been used with the software Max/MSP as an interactive composition for digital sound synthesis, digital sound processing, and sampling. The idea of pure sound as an electromagnetic transmission is the core concept of *Fake Radio.* The basic sounds are created using frequency modulation (FM) synthesis. The composition includes the dynamics of polyrhythm, tempo, time stretch, time reversal, and variations in sound and silence—in this work referred to as fluctuations of time cracks.

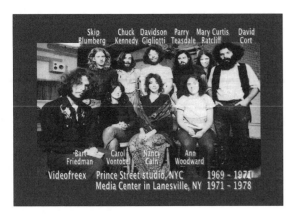

Skip Blumberg, Chuck Kennedy, Davidson Gigliotti, Parry Teasdale, Mary Curtis Ratcliff, David Cort

Bart Friedman, Carol Vontobel, Nancy Cain, Ann Woodward

Videofreex Prince Street studio, NYC 1969 - 1971
Media Center in Lanesville, NY 1971 - 1978

Videofreex

Established 1969 New York, New York
Concluded 1978

Videofreex was a pioneering video collective. For nine years they produced several thousand videotapes, installations, and multimedia events and trained hundreds of videomakers in the brand-new video medium. The first members of the group met at the Woodstock music festival in 1969 (where members recorded what happened away from the stage in the muddy, temporary counterculture community). There were ten founding members: David Cort, Parry Teasdale, Mary Curtis Ratcliff, Nancy Cain, Chuck Kennedy, Skip Blumberg, Davidson Gigliotti, Carol Vontobel, Bart Friedman, and Ann Woodward. Ultimately, dozens more participated in the collective. After an attempt to develop a new kind of television show—ironically, for CBS—the group built a multicamera studio and editing room and had weekly underground video screenings in their loft in the burgeoning SoHo neighborhood of New York City. That studio was home to frequent collaborations within the downtown community of early videomakers and members of the alternative culture, avant-garde art scene, and radical political movements of the 1970s. In 1971, Videofreex relocated to Maple Tree Farm, a seventeen-bedroom former rooming house in the Catskill Mountains of upstate New York, and launched the first pirate TV station, Lanesville TV.

Lanesville TV (1971-1978)

Lanesville TV was the first, and possibly only, pirate television station, beginning with transmission experiments in Manhattan. Instructions for making your own TV transmitter, written by Videofreex's Parry Teasdale and Chuck Kennedy, are included in Abbie Hoffman's *Steal This Book*. Lanesville TV was ultimately the progenitor of hundreds of licensed low-power TV stations, based on an FCC-commissioned report by Teasdale and former TVTV member Michael Couzens. The more than 1,000 videotapes in the Videofreex archive serve as a record of Videofreex and Media BU.S.'s (the nonprofit incarnation of the group) upstate collective life and work, their friends and neighbors, the issues they were thinking about, their artistic urges, and the alternative lifestyle they were living. Media Bus produced two single-channel TV shows (available through Electronic Arts Intermix) that document and showcase the day-to-day life at Lanesville TV. *Probably America's Smallest TV Station* (1975) and *Greetings From Lanesville* (1976), made in conjunction with the Video Television Review at WNET, are compilations of the collective's work, as well as a portrait of the Lanesville community. In 2001, the video data bank at the Art Institute of Chicago began assembling an archive of the Videofreex body of work, collecting videotapes from basements and attics where they had been stored for decades, restoring them, and making them available for viewing. The archival collection of Videofreex titles consists of around 1,400 videotapes on a variety of formats, many of which are obsolete. At present over twenty-five titles are available, several of which are tapes produced at Lanesville TV.

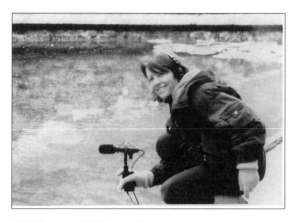

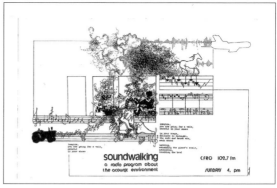

Hildegard Westerkamp

b. 1946 Osnabrück, Germany
Lives and works in Vancouver
www.sfu.ca/~westerka

Hildegard Westerkamp is an artist, composer, and scholar whose work focuses on environmental sound and acoustic ecology. After completing her music studies in the early 1970s, Westerkamp joined the World Soundscape Project under the direction of Canadian composer R. Murray Schafer at Simon Fraser University in Vancouver. Her involvement with this project activated her deep concerns about noise and the general state of the acoustic environment and also changed her ways of thinking about music, listening, and sound-making. Vancouver Co-operative Radio's founding during the same time provided an invaluable opportunity to record, experiment with, and broadcast the soundscape—practices that permeated all her subsequent work. By focusing the ear's attention to details both familiar and foreign in the acoustic environment, Westerkamp draws attention to the inner, hidden spaces of the environment. The majority of her compositional output deals with aspects of the acoustic environment: with urban, rural or wilderness soundscapes; with the voices of children, men and women; with noise or silence; music and media sounds; and the sounds of different cultures. Her compositions have been performed and broadcast in many parts of the world. Westerkamp is a founding member and currently active on the board of the World Forum for Acoustic Ecology (WFAE).

Soundwalking (1978–1979)

Westerkamp is an important and influential pioneer in the international practice of "soundwalking." Her detailed explanations and instructions for conducting Soundwalks are made available online in her essay "Soundwalking," originally published in *Sound Heritage* in 1974 and revised in 2001. Westerkamp writes:

> *Soundwalking* was a weekly one-hour programme on Vancouver Co-operative Radio in 1978–1979. With tape recorder and microphone I went into environments such as the quiet winter landscape of the nearby mountains, where my footsteps, my voice and the snow falling from trees were the loudest sounds. Or I went to a shopping mall, a factory or a park, to the harbour or to a Henry Moore metal sculpture called Knife Edge, to a residential area located under the flightpath, to the beach on a foggy day, or simply through the streets of Vancouver. It was a first attempt of a programme that listened into the community of Greater Vancouver. It did not report about it. It brought the community's soundscape into listeners' homes and, vice versa, placed listeners' ears into the soundscape of their community. The radio listener was partaking in the microphone's discovery of the soundscape.

Robert Whitman

b. 1935 New York, New York
Lives and works in Warwick, New York
whitmanlocalreport.net

Robert Whitman is prolific in the area of multi-media theatre pieces. His non-narrative works are rich in visuals and sound, incorporating actors, film, slides, and evocative props in environments of his own making. Whitman's theatrical and per-formance-based works often take place in nontra-ditional, even raw and abandoned spaces, where unique architecture as found, or transformed, and is central to the event. Temporality in multimedia is a concurrent thread in Whitman's body of work at large. Throughout his career, he has collaborat-ed with engineers and scientists and incorporated new technologies into his work. Whitman co-founded, along with engineers Billy Klüver and Fred Waldhauer and artist Robert Rauschenberg, Experiments in Art and Technology (E.A.T.), a foundation that provided artists with access to engineers and new technology. In 1966, Whitman was among the artists who worked with engineers and scientists from Bell Telephone Laboratories to create performance works for *9 Evenings: The-atre & Engineering* at the 69th Regiment Armory in New York, where seven automobiles on the Armory's huge floor projected film, over-the-air television programs, and closed-circuit televi-sion projections of live performances and actions. In 1972, Whitman produced a telephone/radio piece, the first in an ongoing series of telecommu-nications works that he has produced since that time.

NEWS (1972–2002); *Local Report* (2005)

The first iteration, titled *NEWS,* was broadcast live over radio station WBAI in New York City. Thirty people, assigned to different locations within in a city or area, were instructed to call in at five-minute intervals with a description of what they saw at that specific moment. The incoming calls were placed directly on the air as they came in. The artist's only intervention was ending the call when "the caller has produced a coherent image." Ninety calls over a thirty-minute period com-prised the final work. The news reports capture the nature of a specific place and time, reveal-ing it to audience and participants alike. *NEWS* was performed in Houston, Minneapolis, and other cities over a two- to three-year period, dur-ing which participants used pay phones to call in their reports. In subsequent iterations of this *NEWS,* Whitman made use of the most current technology available. In 2002, he worked with cell phones in Leeds, England; the cell phone calls were broadcast in real time on large speakers in a public square in the town. The latest version of Whitman's telephone/broadcast series is *Local Re-port,* comprised of five performances on succes-sive weekends in the summer of 2005, centered at shopping malls in Trumbull, Connecticut; Holm-del, New Jersey; Burlington, New Jersey; Kings-ton, New York; Easton, Pennsylvania. Thirty lo-cal residents used programmed video cell phones to generate short video films and sound reports from places they visited. Documentation of the five sound and video reports is available on the *Local Report* Website.

Bart Woodstrup

b. 1973 Sycamore, Illinois
Lives and works in Chicago
bartwoodstrup.com

Bart Bridger Woodstrup's work explores processes for the conversion of data from the meteorological spectrum into sound and image. He is especially intrigued by weather modification techniques that mitigate adverse climatological events, and his work is an investigation into the relationship between environmental issues and new technology, with an emphasis upon the cultural integration of these tools and their use for ecological stewardship. Woodstrup's goals are to understand and manipulate the aesthetics, semiotics, and narratives of various time-based media. This research takes the form of traditional musical composition, real-time interactive audio/video performance, multimedia installation, and networked experience. Such works include *Climate Control* (2007), an orgone-powered Cloudbuster simulator and *Sound Seeds* (2006), small, green-powered sound devices capable of synthesizing and transmitting sound for use in a live audio performance system. Woodstrup regularly performs live and records video blogs under the moniker Vodstrup, and was a founding member of Pauline Oliveros's improvisational telepresence ensemble Tintinnabulate. In his free time, Woodstrup proudly describes hacking solar powered LED lawn lamps, dreaming of ways to carbon-neutrally power his plethora of electronic gadgets, and taking long walks with his pet, Rutt Etra.

Gathering Lore (2008)

Gathering Lore uses real-time sensor data from a locally installed weather station to interface with a database of imagery, iconography, and text. Data retrieved from the weather station is visualized and sonified in real time using a computer interface and custom software. Reflecting on humankind's impoverished knowledge of and ever-increasing distance from the natural environment, the piece addresses the vital need to understand and adapt to the changing climate of the world. Inspired by reports during the Asian tsunami of 2004 that many animals possessed a sixth sense that warned them of the coming calamity and sent them searching for higher ground, *Gathering Lore* proposes that any trace of this sense possessed by humans is revealed in folklore such as "Red sky at night, sailor's delight; red sky in the morning, sailor take warning." Folklore based on observation and experience is in essence a dialogue with nature. It is a conversation in which humans are losing fluency, and perhaps even affinity for, as electronic systems for gathering environmental information and an increasing reliance on electronic sensation dull the remnants of humankind's sixth sense. A bridge between technology and these historical and cultural folklores, *Gathering Lore* was included in *Off The Grid* at The Neuberger Museum of Art in Purchase, New York, an exhibition co-organized by free103point9.

Chronology of Works

Velimir Khlebnikov, *The Radio of the Future,* 1921

Arseny Avraamov, *Symphony of Factory Sirens,* 1922

László Moholy-Nagy, *Telephone Pictures,* 1923

Hans Flesch, *Zauberei auf dem Sender,* 1924

Walter Benjamin, *Radio Scripts for Children,* 1929–1933

Bertolt Brecht, *The Lindbergh Flight,* 1929

Walter Ruttmann, *Wochenende,* 1930

Ezra Pound, *The Testament of François Villon,* 1931

F.T. Marinetti and Pino Masnata, *La Radia,* 1933

Orson Welles and The Mercury Theatre, *The War of the Worlds,* 1938

Antonin Artaud, *Pour en finir avec le Jugement de Dieu,* 1947

Pierre Schaeffer, *La Coquille à planètes,* 1948

John Cage, *Imaginary Landscape No. 4,* 1951

Lucio Fontana, *Television Manifesto of The Spatial Movement,* 1952

Wolf Vostell, *TV For Millions,* 1959–1963

Ray Johnson, *New York Correspondance School,* 1962

Jean Tinguely, *Radio Skulptures,* 1962

Delia Derbyshire, *Doctor Who Theme Music,* 1964–1973

Marshall McLuhan, *Understanding Media: The Extensions of Man,* 1964

Paul Pörtner, *Schallspielstudie,* 1964

Karlheinz Stockhausen, *Telemusik,* 1966

Maryanne Amacher, *City Links,* 1967–1990

Max Neuhaus, *Drive-in Music,* 1967–1968

Ernst Jandl and *Friederike* Mayröcker, *Fünf Mann Menschen,* 1968

Allan Kaprow, *Hello,* 1969

Otto Piene, *Electronic Light Ballet,* 1969

Ted Victoria, *Solar Audio Window Transmission,* 1969–1970

Raindance, *Raindance: Media Primers,* 1970–1971

Douglas Davis, *Electronic Hokkadim,* 1971

VALIE EXPORT, *FACING A FAMILY,* 1971

Videofreex, *Lanesville TV,* 1971–1978

Juan Downey, *Three-Way Communication by Light,* 1972

TVTV (Top Value Television), *The World's Largest TV Studio,* 1972

Robert Whitman, *NEWS; Local Report,* 1972–2002; 2005

Chris Burden, *TV Ad: Through the Night Softly,* 1973

Keith Sonnier, *Scanners (Quad Scan),* 1975

Nam June Paik, *Documenta 6 Satellite Telecast,* 1977

Willoughby Sharp, *Send/Receive Satellite Network: Phase II,* 1977

Aldo Tambellini, *MOONBLACK (Homage to Leonardo),* 1977

Joel Chadabe, *Solo,* 1978

Hildegard Westerkamp, *Soundwalking,* 1978–1979

Alison Knowles, *Bohnen Sequenzen,* 1982

Nicolas Collins, *Devil's Music,* 1985

Peter d'Agostino, *TransmissionS: In the WELL,* 1985–1990

Antoni Muntadas (in collaboration with Hank Bull), *Cross-Cultural Television,* 1987

Christof Migone, *Danger in Paradise,* 1987–1994

Richard Kriesche, *Radiozeit,* 1988

Eric Leonardson, *Sounds From Chicago,* 1988–1992

Eduardo Kac, *Interfaces,* 1990

Gregory Whitehead, *Pressures of the Unspeakable: A nervous system for the city of Sydney,* 1991

Judy Dunaway, *Duo for Radio Stations,* 1992

Scanner, *Scanner 1/Scanner 2,* 1992–1993

Joyce Hinterding, *Aeriology,* 1995–2009

Sophea Lerner, *A Journey by Telephone,* 1995

Janek Schaefer, *Memory Museum,* 1996

Akin O. Fernandez, *The Conet Project: Recordings of Shortwave Numbers Stations,* 1997

Robert Adrian X, *Radiation,* 1998–2008

William Basinski, *Shortwavemusic,* 1998

Christian Jankowski, *Telemistica,* 1999

Joshua Fried, *RADIO WONDERLAND,* 2000–ongoing

Gregory Green, *M.I.T.A.R.B.U. (mobile Internet, television and radio broadcast unit),* 2000

Kristin Lucas, *Involuntary Reception,* 2000

Intermod Series, *Selected Transmission Projects,* 2000–2005

Ambient Information Systems, *Broadbandit Highway,* 2001–2006

Matthew Burtner, *Studies for Radio Transceiver,* 2001

Kabir Carter, *Shared Frequencies,* 2001–2005

Paul DeMarinis, *Walls in the Air,* 2001

Michael Iber, *INTEGER (INTErnet GEnerated Radio),* 2001

Golan Levin, *Dialtones (A Telesymphony),* 2001

Wolfgang Staehle, *2001,* 2001

August Black, *UserRadio,* 2002

Tetsuo Kogawa, *A Micro Radio Manifesto,* 2002–2006

Marc Leclair, *My Way,* 2002

LIGNA, *Radio Ballet,* 2002–2003

Patrick McGinley, *Framework,* 2002–2010

Mendi Obadike and Keith Obadike, *The Sour Thunder,* 2002

Eva Sjuve, *Fake Radio,* 2002

Kaffe Matthews, *Radio Cycle 101.4-FM,* 2003

Michelle Nagai, *EC(h)OLOCATOR,* 2003–2004

APO33, *Inter-section Radio,* 2004

Damian Catera, *Radio deComposition,* 2004

Tianna Kennedy, *Stubblefield's Black Box: An Intricate Game of Position,* 2004

Emmanuel Madan, *FREEDOM HIGHWAY,* 2004

Todd Merrell, *Nagual,* 2004–2007

Matthew Ostrowski, *atopia: levigation and apophenia,* 2004–2007

Irvic D'Olivier, *SilenceRadio.org,* 2005–ongoing

Melissa Dubbin and Aaron S. Davidson, *Last & Lost Transmissions,* 2005

The Dust Dive, *Asleep or Awake Walk,* 2005

Sarah Kanouse, *Don't Mourn,* 2005–2007

Kathy Kennedy, *HMMM,* 2005

Tarikh Korula, *Chop 10,* 2005

LoVid, *Ether Ferry,* 2005

Raphael Lyon, *Psicklops,* 2005

Joe Milutis, *Airspace,* 2005

neuroTransmitter, *12 Miles Out,* 2005

Stephanie Rothenberg, *Zero Hour,* 2005–2008

Rick Silva, *Satellite Jockey,* 2005

Rirkrit Tiravanija, *Untitled 2005 (the air between the chain-link fence and the broken bicycle wheel),* 2005

Sarah Washington, *Mobile Radio,* 2005–ongoing

Myke Dodge Weiskopf, *At The Tone,* 2005

Shaina Anand, *Khirkeeyaan,* 2006

Jeff Feddersen, *EarthSpeaker,* 2006–2007

Sawako Kato, *2.4GHz Scape,* 2006

Negativland, *It's All In Your Head FM,* 2006

Étienne Noiseau, *Le son de l'amour,* 2006

Julian Priest, *The Political Spectrum,* 2006

Anthony Ptak, *The End of Music,* 2006

Radio Ruido/Tmm Mulligan, *Triangulation,* 2006–2010

Leslie Sharpe, *SG4L (Sending SGLLLL),* 2006

31 Down Radio Theater, *Canal Street Station,* 2007

Giancarlo Bracchi, *Steaming Meaning,* 2007–2009

Matt Bua, *Sing Sun Room,* 2007

Carrie Dashow, *The 13th Screen,* 2007

EcoArtTech, *Frontier Mythology,* 2007

Simon Elvins, *Public Radio,* 2007

Evidence, *Receiver,* 2007

Kristen Haring, *Morse Code Knitting,* 2007

Brandon LaBelle, *Radio Flirt,* 2007

Latitude/Longitude, *Solar Filters/Mother Evening,* 2007

Kristina Lindström and Åsa Ståhl, *Stitching Together,* 2007–2009

John Roach and James Rouvelle, *Trailhead,* 2007

Teri Rueb, *Core Sample,* 2007

Knut Aufermann, *Lee de Forest night loops,* 2008

Matthew Biederman, *SCATTER!,* 2008

Cross Current Resonance Transducer (CCRT), *Circular Spectrum Analyzer,* 2008

Anna Friz, *Respire,* 2008

Ann Heppermann and Kara Oehler, *Chorus of Refuge,* 2008

Linda Hilfling, *FJERNSTYRING,* 2008–2010

Ralf Homann, *Digital Folklore,* 2008

Andrew O'Connor, *Frequent Mutilations,* 2008

Garrett Phelan, *At what point will common sense prevail,* 2008–2013

Bart Woodstrup, *Gathering Lore,* 2008

Erik Belgum, *"The_City" Battery,* 2009

Alexis Bhagat, *Instructions for Listening to Radio,* 2009

Justin Downs, *Will o' the wisp,* 2009

Masaki Fujihata, *Simultaneous Echoes,* 2009

Brett Ian Balogh, *Noospherium,* 2009

Tony Martin, *Light Pendulum,* 2009

Terry Nauheim, *Propagation Seems Good Here Tonight,* 2009

Ian Page, *The End of Television,* 2009

Michelle Rosenberg, *Whistle Wall,* 2009–2010

The Video Gentlemen, *BYOTV,* 2009

Lázaro Valiente, *The Police Car Quartet,* 2009

Radio Cegeste, *Radio d'Oiseaux,* 2009–ongoing

Steve Bradley, *CAST,* 2010

Max Goldfarb, *Deep Cycle,* 2010

Sabine Gruffat and Bill Brown, *The Bike Box,* 2010

Zach Layton, *Megawatt Mind,* 2010

Zach Poff, *Radio Silence,* 2010

Tom Roe, *The Worst Hour of the Year,* 2010

BIBLIOGRAPHY

Adrian X, Robert and Gerfried Stocker, eds. *Zero—The Art of Being Everywhere*, Graz, Austria: Steirische Kulturinitiative, 1993.

Arnheim, Rudolph, *Radio*, trans. Margaret Ludwig and Herbert Read, London: Faber and Faber, 1936.

Augaitis, Daina and Dan Lander, eds. *Radio Rethink: Art, Sound and Transmission*, Banff, Canada: Walter Phillips Gallery, 1994.

Becksteiner-Rasche, Astrid, *Quantitativ: Richard Kriesche*, Graz, Austria: Leykam Verlag, 2008.

Bhagat, Alexis and Lize Mogel, eds. *An Atlas of Radical Cartography*, Los Angeles: Journal of Aesthetics and Protest Press, 2008.

Braga, Newton C., *Pirate Radio and Video: Experimental Transmitter Projects*, Boston: Newnes, 2001.

Buchloh, Benjamin H, and Judith F. Rodenbeck, *Experiments in the Everyday: Alan Kaprow and Robert Watts—Events, Objects, Documents*, New York: Columbia University Press, 1999.

Cage, John, *Silence: Lectures and Writings by John Cage*, Middletown, Connecticut: Wesleyan University Press, 1961.

Chadabe, Joel, *Electric Sound: The Past and Promise of Electronic Music*, Englewood Cliffs, New Jersey: Prentice Hall, 1996.

Coe, Lewis, *Wireless Radio: A Brief History*, North Carolina: McFarland and Company Inc., 1996.

Collins, Nicholas, *Handmade Electronic Music: The Art of Hardware Hacking*, London and New York: Routledge, 2009.

Crook, Tim, *Radio Drama*, London and New York: Routledge, 1999.

Crow, Barbara, Michael Longford, and Kim Sawchuk, eds. *The Wireless Spectrum: The Politics, Practices, and Poetics of Mobile Media*, Toronto: University of Toronto Press, 2010.

d'Agostino, Peter, *The Un/Necessary Image*, New York: Tanam Press, 1982.

———, *Transmission: Toward a Post-Television Culture*, Thousand Oaks, California: Sage Publications, 1995.

d'Agostino, Peter and Antonio Muntadas, eds. *The Un/Necessary Image*, New York: Tanam Press and Cambridge: The MIT Press, 1983.

Davis, Douglas, *The Five Myths of Television Power or Why the Medium is Not the Message*, New York: Simon & Schuster, 1993.

Douglas, Susan J, *Listening In: Radio and the American Imagination*, New York: Times Books, 1999.

Druckery, Timothy, ed. *Ars Electronica: Facing the Future: A Survey of Two Decades*, Cambridge: The MIT Press, 1999.

Dunifer, Stephen and Ron Sakolsky, eds. *Seizing the Airwaves: A Free Radio Handbook*, San Francisco: AK Press, 1998.

Experiments in Art and Technology, *Some More Beginnings: An Exhibition of Submitted Works Involving Technical Materials and Processes*, New York: Experiments in Art and Technology, 1968.

Felton Felix, *The Radio Play*, Great Britain: Sylvan Press Ltd, 1949.

Fisher, Margaret. *Ezra Pound's Radio Operas. The BBC Experiments, 1931-1933*, Cambridge: The MIT Press, 2002.

Fowler, Gene and Bill Crawford, *Border Radio*, Austin: University of Texas Press, 2002.

Goldberg, Ken, ed. *The Robot in the Garden: Telerobotics and Telepistemology in the Age of the Internet*, Cambridge: The MIT Press, 2001.

Gregory, Danny and Paul Sahre, *Hello World: A Life in Ham Radio*, New York: Princeton Architectural Press, 2003.

Grundmann, Heidi, Elizabeth Zimmerman, et al., eds. *Re-inventing Radio: Aspects of Radio Art*, Frankfurt/Main: Revolver, 2008.

Haring, Kristin, *Ham Radio's Technical Culture*, Cambridge: The MIT Press, 2006.

Hawes, Robert, *Radio Art*, London: The Green Wood Publishing Company, 1991.

Hilmes, Michele and Jason Lovigio, ed. *Radio Reader: Essays in the Cultural History of Radio*, London and New York: Routledge, 2002.

Jansen, Eric Granly and Brandon LaBelle, eds. *Radio Territories*, Los Angeles and Copenhagen; Errant Bodies Press, 2007.

Johnson, Nicholas, *How to Talk Back to Your Television Set*, Toronto: Atlantic Monthly Press, 1967.

Kahn, Douglas and Gregory Whitehead, eds. *Wireless Imagination: Sound, Radio, and the Avant-Garde*, Cambridge: The MIT Press, 1992.

Kahn, Douglas, *Noise Water Meat: A History of Sound in the Arts*, Cambridge: The MIT Press, 1999.

Kaprow, Allan, *Essays on the Blurring of Art and Life*, Berkeley: University of California Press, 1993.

Kester, Grant H., *Conversation Pieces: Community and Communication in Modern Art*, Berkley: University of California Press, 2004.

Khlebnikov, Velimir, *The King of Time: Selected Writings of the Russian Futurian*, Cambridge: Harvard University Press, 1985.

Klüver, Billy, Julie Martin, and Barbara Rose, *Pavilion: Experiments in Art and Technology*, New York: E,P, Dutton and Co., Inc, 1972.

Knowles, Alison, *Spoken Text*, New York: Left Hand Books, 1993.

LaBelle, Brandon, *Background Noise: Perspectives on Sound Art*, New York: The Continuum International Publishing Group Ltd., 2006.

LaBelle, Brandon and Steve Roden, *Site of Sound: Of Architecture and the Ear*, Santa Monica, California: Smart Art Press, 1999.

Ladd, Jim, *Radio Waves: Life and Revolution on the FM Dial*, New York: St, Martin's Press, 1991.

Lewis, Tom, *Empire of the Air: The Man Who Made Radio*, New York: Harper Collins, 1991.

Manovich, Lev, *The Language of New Media*, Cambridge: The MIT Press, 2002.

McLuhan, Herbert Marshall, *Understanding Media: The Extensions of Man*, New York: McGraw Hill, 1964.

McLuhan, Herbert Marshall, *The Gutenberg Galaxy*, Toronto: University of Toronto Press, 1962.

McLuhan, Herbert Marshall and Quentin Fiore, *The Medium is the Massage: An Inventory of Effects*, New York: Bantam Books, 1967.

——, *War and Peace in the Global Village*, New York: Bantam Books, 1968.

McLuhan, Herbert Marshall and Wilfred Watson, *From Cliché to Archetype*, New York: Viking, 1970.

Mehlman, Jeffrey, *Walter Benjamin for Children: An Essay on His Radio Years*, Chicago: University of Chicago Press, 1993.

Milutis, Joe, *Ether: The Nothing that Connects Everything*, Minneapolis: The University of Minnesota Press, 2006.

Migone, Christof, *Aural Cultures*, Toronto: YYZ, 2004.

——, *S:ON: Sound in Contemporary Canadian Art*, Montreal: Artexte, 2003.

——, *Writing Aloud: The Sonics of Language*, Los Angeles and Copenhagen: Errant Bodies Press: 2001.

Museum Moderner Kunst Stiftung Ludwig Wien and Susanne Neuberger, *Nam June Paik: Exposition of Music, Electronic Television, Revisited*, Köln, Germany: Walther König, 2009.

Neumark, Norie, Ross Gibson, and Theo van Leeuwen, eds. *Voice: Vocal Aesthetics in Digital Arts and Media*, Cambridge: The MIT Press, 2010.

Penny, Simon, ed. *Critical Issues in Electronic Media*, Albany, New York: State University of New York Press, 1995.

Perloff, Marjorie, *The Futurist Moment: Avant-Garde, Avant Guerre, and the Language of Rupture*, Chicago: The University of Chicago Press, 1986.

Popper, Frank, *://art,of,the,electronic,age*, London: Thames & Hudson Ltd, 1993.

Radio CORAX, *Radio Revolten: Restival Zur Zukunft Des Radios*, Halle, Germany, 2006.

Ruggiero, Greg, *Microradio & Democracy: (Low) Power to the People*, New York: Seven Stories Press, 1999.

Scholder, Amy and Jordan Crandall, *Interaction: Artistic Practice in the Network*, New York: Distributed Art Publishers Inc., 2001.

Sconce, Jeffrey, *Haunted Media: Electronic Presence from Telegraphy to Television*, Durham & London: Duke University Press, 2000.

Shamberg, Michael and Raindance Corporation, *Guerrilla Television*, New York: Henry Holt & Company, Inc., 1971.

Shanken, Edward, *Art and Electronic Media*, London: Phaidon Press, 2009.

Shapiro, Peter, *Modulations: a History of Electronic Music Throbbing Words on Sound*, New York: Caipirinha Productions Inc., 2000.

Slate, Sam J, and Joe Cook, *It Sounds Impossible: The hilarious story of radio broadcasting from the beginning to the future*, New York: The Macmillan Company, 1963.

Smite, Rasa and Daina Silina and Armin Medosch, *Waves: Electromagnetic Waves as material and medium for arts*, Acoustic Space #6 RIXC The Center for New Media Culture, Riga, Latvia, 2006.

Smite, Rasa, *Spectropia: Illuminating investigations in the electromagnetic spectrum*, Acoustic Space #7 RIXC The Center for New Media Culture Riga, Latvia, 2006.

Strauss, Neil and Dave Mandl, eds. *Radiotext(e)*, New York: Semiotext(e), 1993.

Teasdale, Parry D., *VideoFreex: America's First Pirate TV Station and the Catskills Collective That Turned It On*, Hensonville, New York: Black Dome Press, 1999.

Tesla, Nikola, *The Tesla Papers: Nikola Tesla on Free Energy & Wireless Transmission of Power*, ed. David Hatcher Childress, Kempton, Illinois: Adventures Unlimited Press, 2000.

Tetlon, Zeke, *The Complete Manual of Pirate Radio*, Tucson: See Sharp Press, 1993.

Thompson, Nato and Gregory Sholette, eds. *The Interventionists: User's Manual for the Creative Disruption of Everyday Life*, North Adams, Massachusetts: Mass MoCA Publications, 2004.

Walker, Jesse, *Rebels on the Air: An Alternative History of Radio in America*, New York: New York University Press, 2001.

Weiss, Allen S., ed. *Experimental Sound & Radio*, Cambridge: The MIT Press, 2000.

———, *Phantasmic Radio*, Durham, North Carolina: Duke University Press, 1995.

Williams, Raymond, *Television: Technology and Cultural Form*, Hanover, New Hampshire: University Press of New England, 1974.

Wilson, Peter Lamborn, *Pirate Utopias: Moorish Corsairs & European Renegadoes*, Brooklyn, New York: Autonomedia, 1995.

Wilson, Stephen, *Information Arts: Intersections of Art, Science, and Technology*, Cambridge: The MIT Press, 2002.

Yoder, Andrew and Earl T, Gray, *Pirate Radio Operations*, Port Townsend, Washington: Loompanics Unlimited, 1997.

———, *Pirate Radio: The Incredible Saga of America's Underground, Illegal Broadcasters*, Solana Beach, California: HighText, 1996.

the artist. Courtesy the artist. 91. Courtesy Bill Milosz. Courtesy Brennan McGaffey. 92. Courtesy Joseph Gallus Rittenberg. 94. Courtesy David Sosno. Courtesy the artist. 95. Courtesy Bonnie Marranca. Courtesy the artist. 96. Courtesy Arlene Walters. Courtesy Charlie Simokaitis. 97. Courtesy the artist. Courtesy Jim Drain. 98. Courtesy the artist. Courtesy Diana Shearwood. 99. Courtesy Toomas Thetloff. Courtesy the artist. 100. Courtesy Crys Cole. 101. Courtesy Kenta Nagai. Courtesy Eric Cohen. 102. Courtesy Irvic D'Olivier. Courtesy the artist. 103. Courtesy the artist. Courtesy the artist. 104. Courtesy Electronic Arts Intermix (EAI), NY. 105. Courtesy the artist. Courtesy Matthew Packer. 106. Courtesy Leonard Wett. 107. Courtesy Alvin Langdon Coburn. 108. Courtesy Robin Luz. Courtesy the artist. 110. Courtesy the artist. Courtesy the artist. 111. Courtesy the artist. Courtesy the artist. 112. Courtesy Ferran Cremades. 113. Courtesy the artist. Courtesy the artist. 114. Courtesy Carl Van Vechten. 115. Courtesy Heidrun Lohr. 119. Courtesy Julien Jourdes. Courtesy Christina Latimer. 120. Courtesy PaVoL Safko. Courtesy Manu Luksch. 121. Courtesy the artist. Courtesy the artist. 122. Courtesy Ashley Hunt. Courtesy the artist. 123. Courtesy Kirsten Sanft. Courtesy the artist. 124. Courtesy the artist. Courtesy the artist. 125. Courtesy the artist. Courtesy the artist. 126. Courtesy Electronic Arts Intermix (EAI), NY. 127. Courtesy Stephanie Dolrenry. Courtesy free103point9. 128. Courtesy the artist. Courtesy the artist.129. Courtesy Kenji Morita. Courtesy the artist. 130. Courtesy Jim Reiman and the artist. Courtesy of the artist, Kinz Tillo Fine Art New York, and Lightbox LA. 131. Courtesy the artist. Courtesy the artist. 132. Courtesy Kristoffer Gansing. Courtesy the artist. 133. Courtesy Ray Johnson Estate and Richard L. Feigen & Co. Courtesy Ray Johnson Estate and Richard L. Feigen & Co. 134. Courtesy Carlos Fadon. Courtesy the artist. 135. Courtesy Allan Kaprow Estate and Hauser & Wirth. Courtesy Electronic Arts Intermix (EAI), NY. 136. Courtesy the artist. Courtesy Design Postimage inc. 137. Courtesy M. Asada. Courtesy Susanna Neidermayr. 138. Courtesy the artist. Courtesy James Webb and the artist. 139. Courtesy the artist. Courtesy the artist. 140. Courtesy Anne Jackson. Courtesy Ars Electronica Festival, Linz. 141. Courtesy Eiko Grimberg. Courtesy Eiko Grimberg. 142. Courtesy Tao G. Vrhovec Sambolec. Courtesy the artist. 143. Courtesy Tom Artin. Courtesy Galen Joseph-Hunter. 145. Courtesy Lucia Moholy and The Metropolitan Museum of Art/Art Resource, NY. 146. Courtesy Silvia Neuhaus. Courtesy Silvia Neuhaus. 147. Courtesy Sophie Klerk. Courtesy the artist. 148. Courtesy Lothar Wolleh. 149. Courtesy Sophie Klerk. Courtesy the artist. 150. Courtesy the artist. Courtesy the artist. 151. Courtesy the artist. Courtesy the artist. 152. Courtesy the artist. Courtesy the artist. 153. Courtesy Pamela Seymour Smith. 154. Courtesy the artist. Courtesy the artist. 155. Courtesy Karin Karl-Eriksdotter. Courtesy the artist. 156. Courtesy the artist. 157. Courtesy Peter Grant. Courtesy Liliane Karnouk. 158. Courtesy Anne Olivia Le Cornec and Julie Martin. Courtesy Anne Olivia Le Cornec and Julie Martin. 159. Courtesy Jayeeta Chowdhury. Courtesy the artist.

About the Authors

Galen Joseph-Hunter has served as executive director of free103point9 since 2002. Over the past thirteen years she has organized and curated numerous exhibitions and events internationally, including *Video Jam* (2001), co-curated with Michael Rush, at the PBICA, Florida; *Airborne* (2005), in collaboration with the New Museum, New York City; *Spectral Garden* (2006), free103point9, Wave Farm, Acra, New York; *[silence]*(2007), co-curated with Dylan J. Gauthier, at Gigantic ArtSpace, New York City; and *Off The Grid* (2008), co-curated with Tianna Kennedy, Tom Roe, and Jacqueline Shilkoff, at the Neuberger Museum of Art, Purchase, New York. Joseph-Hunter has worked at the video art organization Electronic Arts Intermix since 1996.

Penny Duff blurs the distinctions among scholarship, creative practice, and community development in her work and research. Her scholarly and creative work has been published in academic journals and popular music magazines alike and has been received at academic conferences and arts festivals internationally, including the International Association for the Study of Popular Music, Megapolis Audio Art and Documentary Festival, Conflux City Festival for Psychogeography, and the Critical Animals creative research symposium at the This is Not Art festival in Newcastle, Australia. Duff earned an MA in Media Arts with Dean's Commendation from The New School in 2009. She lives in Chicago, where she studies arts administration and policy at the School of the Art Institute of Chicago.

Maria Papadomanolaki is a Greek artist working primarily with sound in the context of phonography, audience-centered performance pieces, and radio art. Papadomanolaki received the Alexander S. Onassis Public Benefit grant for emerging artists in 2008, which supported her studies in digital music and sound art in the UK. Her paper, "Radio as the voice of community, locality, interactivity and experimentation," presented at the Cyprus University of Technology and the ECREA Radio Research Section 2009 conference, appears in the forthcoming volume Radio Content in the Digital Age. Papadomanolaki resides in New York City, where she works as a freelance artist and serves as transmission art archivist and NYC public program assistant for free103point9.